Motion Picture Camera Data

D0088561

MEDIA MANUALS

TV CAMERA OPERATION
Gerald Millerson

BASIC TV STAGING
Gerald Millerson

THE USE OF MICROPHONES
Alec Nisbett

YOUR FILM & THE LAB
L. Bernard Happé

TV SOUND OPERATIONS
Glyn Alkin

TV LIGHTING METHODS
Gerald Millerson

16mm FILM CUTTING
John Burder

USING VIDEOTAPE
J. F. Robinson, & P. H. Beards

THE ANIMATION STAND
Zoran Perisic

SCRIPTWRITING FOR ANIMATION
Stan Hayward

THE SMALL TV STUDIO
Alan Bermingham, Michael
Talbot-Smith, John Symons, & Ken
Angold-Stephens.

THE LENS IN ACTION
Sidney F. Ray

THE LENS & ALL ITS JOBS
Sidney F. Ray

MOTION PICTURE CAMERA &
LIGHTING EQUIPMENT
David W. Samuelson

MOTION PICTURE CAMERA
TECHNIQUES
David W. Samuelson

MOTION PICTURE CAMERA DATA
David W. Samuelson

EFFECTIVE TV PRODUCTION
Gerald Millerson

SCRIPT CONTINUITY & THE PRO-
DUCTION SECRETARY
Avril Rowlands

CREATING SPECIAL EFFECTS FOR
TV & FILMS
Bernard Wilkie

LOCAL RADIO
Barrie Redfern

Forthcoming titles

Sound Recording & Reproduction
Basic Film Technique
Macrophotography

Motion Picture Camera Data

David W.
Samuelson

Focal Press · London

Focal/Hastings House · New York

🅱🇱 **British Library Cataloguing in Publication Data**
Samuelson, David W.
 Motion picture camera data. – (Media manuals).
 1. Moving-picture cameras
 I. Title II. Series
 778.5'3'028 TR880

ISBN (excl. USA) 0 240 50998 6
ISBN (USA only) 0 8038 4718 1

Printed in Great Britain by A. Wheaton & Co. Ltd., Exeter

Contents

Introduction

During the course of a career a cameraman will undoubtedly be required to use makes of cameras of varying vintages, probably most of which will come to him without instruction manuals.

The mechanisms of high quality film cameras have a remarkable longevity. It is no exaggeration to state that throughout the world there are cameras in regular day-to-day use, the movements of which were made fifty or more years ago and which are still taking pictures of an image quality and steadiness which compares favourably with the latest models. The durability of these mechanical masterpieces has greatly exceeded the availability of the original instruction manuals.

Equally there are new cameras today which are supplied either from the manufacturer or a camera rental company without instruction manuals because the professional crews who use them are expected to know them or to learn by word of mouth.

This book sets out to fill these gaps as well as to describe, albeit briefly, the wide range of cameras currently available and in general use by professional cinematographers.

No camera incorporates every virtue though some go a long way towards it. Cameras must be chosen for a particular task. The basic features of each camera must be considered. ie: the film gauge it uses, its quietness, image steadiness, maximum speed, any special facilities it incorporates such as inshot shutter adjustment, features for hand-holding, reflex or TV viewfinding, motor control systems (which these days are virtually small computers), its weight or practicability for use on location, etc. all have to be known and considered. This book sets out to help the cameraman choose the most suitable tools for the job and to assist him in their use.

Almost 90 marques of camera are included, from the latest and the most sophisticated to those that are quite old but still in regular use.

The Super 8 cameras described are the most advanced of that gauge and conform most nearly to the requirements of professional usage.

A bad workman blames his tools and this may be true if for no other reason than that it diverted his concentration from the task of creating.

A good workman will bless his tools for it makes it possible for him to be more creative than he could have been with inferior means.

Acknowledgements

In writing my two previous books in this series I have thanked the many people in the cinema production industries who over the years have contributed to my knowledge of film technology generally and made these books possible. In the case of this particular volume I wish to emphasise my gratitude to those members of the camera maintenance department of Samuelson Film Service Limited who patiently explained to me all the most intimate details of the wide range of cameras included in this book. Thanks in particular are due to Karl Kelly, Bill Woodhouse, Guy Green, Marshall Martin, Derek Lee, Jim Austin, Bert Cayzer, Alex Culley, Tony Farrow, Sid Twyman and Frank Hyde, to Guy Townerie in France, Mike Brandt in Israel, John Harrison in South Africa and Peter Backhouse and Roger Hope in Australia and to all the other members of the department. A more dedicated group of camera maintenance engineers there never were.

In the course of researching this book I have received help from every camera manufacturer of whom I have asked information. While I can honestly claim to have shot film professionally with almost all of the cameras I have written about, there are instances when it was necessary to quote from available sources and in these cases what is written here is a distillation of makers' specifications and instruction manuals.

While most of the artwork in this book is derived from original photographs taken by myself or supplied by Samuelson Film Service Limited, some are based on illustrations from catalogues and manuals. I would, therefore, like to thank the following companies for their co-operation in allowing me to quote and copy where necessary:
Aäton, Arnold & Richter, Bach Auricon, Beaulieu Camera, Bolex International, Canon, Cinema Products, Eclair, Gordon Audio Visual, John Hadland, Mitchell Camera, Panavision, Photosonics, Redlake Laboratories and Teledyne Camera Systems.

I also wish to thank Peter West, a fellow cameraman/author who checked the page proofs and made many helpful and knowledgeable suggestions.

And Victor Mardon, late of British Movietone News, in whose camera workshop and under whose guidance, way back in 1947, I first started mucking about with cameras.

When all else fails, read the instructions.

General Camera Information

Camera orientation
The description 'left' and 'right' side of a camera is as seen from the rear.

Camera serial numbers
Individual cameras may always be identified by a serial number which is either engraved on the camera body, or on a plate attached to it. The location of serial numbers is not always obvious especially when they are hidden by a cover or component or are inside the camera. A knowledge of where numbers are to be found is particularly necessary when passing through international custom posts.

In-field maintenance
Modern cameras require little day-to-day maintenance other than being kept scrupulously clean inside and out and the application of correct oil in correct places at correct intervals. This is particularly important on cameras running at 100fps or faster, which can require lubrication before every run.

Wipe exterior of camera clean and dry if it has been exposed to water or dust. Blow or brush away sand, dust, chips of film and snow from crevices.

Remove any marks from optical surfaces with cleaning solution and soft tissue. Use a sable hair brush to remove dust. Do not clean surfaces which are already clean; it can only cause damage. Do not blow on any steel surface with moist breath; it causes corrosion. Small amounts of dust on a mirror shutter, inside a lens or viewfinder optics are best left alone.

Lubrication must be done exactly as recommended in the maker's handbook.

Cameras equipped for com-mag sound recording should be checked for dirt and emulsion build-up on recording heads. Fall-off in sound recording quality may be due to poor film contact with the magnetic head, heads in need of demagnetising (de-gaussing), over- or under-modulation, panning and/or tilting the camera sharply while recording, or the camera drive belt or magazine take-up belt or clutch being set too tightly. Sometimes recording is satisfactory but playback is malfunctioning.

GENERAL CAMERA INFORMATION

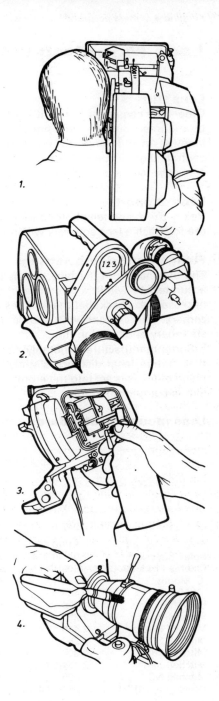

1. Camera orientation as seen by the cameraman.

2. The serial numbers of certain makes of camera are quite hidden away.

3. Using aerosol to blow dirt away from inside camera.

4. Using brush to clean dirt away from exterior of camera.

Lens Mounting Information

Lens turrets

Older type cameras have multi-lens turrets which enable several lenses to be mounted on a camera simultaneously for rapid interchange of focal lengths. An additional advantage of a rotatable turret is that a lens may be centred slightly above or below the normal optical axis to correct vertical convergence, particularly of architectural subjects.

Lens support

Heavy zoom and telephoto lenses must be given additional support. Failure to attach a lens squarely will impair focusing and may cause damage.

Flange focal depth settings

The distance from the face of lens mount to the film plane must be set accurately to within a tolerance of 0.001in (0.025mm) minus. It may be necessary to check that the film lies flat in the gate as it runs through the camera. This is done with a collimator, comparing the results between stationary and running film.

Some manufacturers, notably Aäton and Arnold & Richter, always set their flange focal distance slightly minus so that, if anything, the best plane of focus is set into the emulsion and any curvature or dishing of the film is compensated for.

Lens mounting standards

Cameras	Flange focal depth in.	Flange focal depth mm.	Mount internal diameter in.	Mount internal diameter mm.
Aaton	1.575	$40.00^{-0.005}_{-0.015}$	1.968	50.00
Arriflex	2.047	$52.00^{-0.005}_{-0.015}$	1.614	41.00
Bolex 'C' Mount*	0.817(0.690)	20.76(17.53)	1.00	25.40
Bolex Bayonet*	1.041(0.914)	26.46(23.23)	2.362	60.00
Cinema Products CP16	1.500	38.1	1.875	47.625
'C' Mount	0.690	17.53	1.00	25.40
'D' Mount	0.484	12.29	0.625	15.88
Eclair	1.890	48.00	1.811	46.00
Panavision	2.250	57.15	1.950	49.53
Mitchell BNC	2.420	61.47	2.687	68.25
Mitchell S35	2.250	57.15	1.650	41.91
Mitchell 16	0.900	22.86	1.687	68.25
Mitchell SPR*	2.424(2.420)	61.57(61.47)	2.687	68.25
Mitchell NC	1.695	43.05	1.812	46.025
Photosonics 1PD**	1.063(2.047)	27.00(52.00)	1.614	41.00

* These are actual distances. The optical distance, after allowing for the effect of reflex prism or pellicle, is given in parenthesis.

** To the face of the prism block. The optical distance is given in parenthesis.

LENS MOUNTING INFORMATION

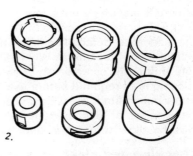

1. Testing camera flange focal depth with dial gauge.

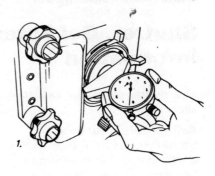

2. Set of flange focal depth collar gauges used to test lenses off camera by use of a collimator.

3. Off-set type 3-lens turret (Arriflex 16St).

4. Support system used to attach a very heavy lens to the camera.

Shutter, Gel Filter and Aperture Information

The shutter times the exposure, the filter colours it and the aperture shapes it.

Adjustable shutters

Some cameras have shutters that may be adjusted to give shorter exposure times either to reduce the exposure or to ensure a sharper picture of a fast moving object. Most adjustable shutters may only be reset while the camera is stationary but a few may be adjusted while the camera is running. This permits exposure to be altered in-shot without affecting the lens characteristics (depth of field, zoom focal length setting, etc), or to create a fade or a mix 'in-camera'. When using a camera equipped with an adjustable shutter the cameraman or assistant should always check the shutter opening is as required before use. When using a camera with shutter set below maximum it is a wise precaution to stick a piece of camera tape on the eyepiece or lens aperture ring to act as a reminder that a difference must be allowed for when setting the exposure.

Checking and cleaning gates and apertures

Gates, apertures and film channels must be checked and cleaned at frequent intervals.

Gelatine filter holders

Some cameras have a holder for placing a gelatine filter between the lens and film plane. This facility should be used with caution bearing in mind that any dirt, oil, scratch, finger mark or other blemish throws a shadow on the film. The closer a filter is to the film the sharper the shadows.

Gelatine filters, like any other optical material refract light and, in effect, move the lens focus backward by approx. one-third of the filter thickness, ie: about 0.0015in. (0.04mm), sufficient to affect the focus of a wide angle/wide aperture lens and to cause a wide aperture zoom lens to shift focus throughout its range. This may cause trouble with a lens of 9 or 10mm focal length or shorter, particularly at full aperture.

Super 16 alignment

Many 16mm cameras may be specially manufactured or modified for Super 16 cinematography by moving the optical centre of the lens to one side, widening aperture, re-marking viewfinder ground glass and relieving any part of the camera or mags. which might scratch the increased picture area.

Hard masking

Some 35mm cameras may have a facility for fitting 'hard mask' aperture plates conforming to 1.66 : 1, 1.75 : 1 or 1.85 : 1 rather than the standard 1.37 : 1 Academy ratio to ensure the film is projected as intended by the makers.

SHUTTER, GEL FILTER AND APERTURE INFORMATION

1. Cameras described in this book which have adjustable shutters:
Cameras with shutters adjustable while the camera is running or stationary:
35 mm: Cinema Products XR35, Mitchell NC, BNC, BNCR etc. and S35R, Panavision PSR and Panaflex, *16 mm*: Bolex H16 RX–5, SB and SBM Mitchell 16, *Super 8*: Beaulieu 4008, Canon 814 XL and 1014 Electronic.

Cameras with shutters adjustable only while camera is stationary: *35 mm*: Arriflex 35IIBV, Eclair CM3, Camematic, GV35; *16 mm*: Eclair NPR, GV16, Photosonics (optional).

Cameras with interchangeable shutter blades of various openings:
35 mm: Arritechno; *16 mm*: Milliken, Mitchell Sporster 164 Photosonics, Redlake, Hadland, Wollensock.

2. Effect of gelatine filter placed between lens and film. A. Lens; B. Lens mounting flange on camera; C. Filter (exaggerated width);
D. Point where light that had not been refracted by the filter would focus on film plane; E. Modified plane of focus. Lens must therefore be shifted forward by about one-third the thickness of the filter to compensate.

3. Super-16 negative area. A. Area of 1.75: 1 image within a normal 16 mm frame (shaded); B. Area of 1.75: 1 image within a Super-16 frame. (Image area increased by approximately 60 per cent.)

4. Removing the aperture plate from a 35 mm camera to check cleanliness is a regular routine in feature film productions.

Effect of shutter change on exposure

200° Shutter		175° Shutter	
200°	Full	175°	Full
160	−1/3 stop	150	−1/3 stop
130	−2/3 "	120	−2/3 "
100	−1 "	90	−1 "
80	−1.2/3 "	75	−1 1/3 "
60	−1 2/3 "	60	−1 2/3 "
50	−2 "	45	−2 "
		37	−2 1/3 "
Note: 200° shutters will		30	−2 2/3 "
not close		22	−3 "
down beyond 50°		18	−3 1/3 "
		15	−3 2/3 "
		11	−4 "

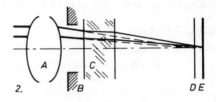

2.

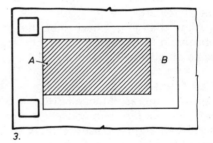

3.

4.

Viewfinder Information

The camera operator usually sees an image on the ground glass screen somewhat larger than the picture area. Etched markings, sometimes called the viewfinder reticle, show him the precise limits.

Ground glass markings

Ground glasses may not only be marked with the limits of the projector aperture corresponding to the aperture plate fitted to the camera but may also be marked for the type of presentation for which the film is primarily intended. For instance, a camera with an academy aperture plate fitted may also be marked for 1.85 : 1 presentation. Similarly 2.35 : 1 anamorphic frame, may also be marked for 2.2 : 1 70mm projection. TV 'transmitted' and 'safe action' areas are also frequently marked.

Ground glass changing

The ground glass focusing screens of many cameras are interchangeable to select format and picture limit markings.

When changing a ground glass it is advisable to put a soft cloth beneath the camera to prevent chipping should the glass be accidentally dropped. The ground surface of a ground glass should always face the camera lens (except the Beaulieu). Fibre optic screens are placed with the engraved reticle towards the lens.

After changing, check that the ground glass is seated properly by observing the image from a wide angle or zoom lens when focused by scale on a known distance.

Cut frame

Certain cameras, (Mitchell BNC and S35R etc.) have a facility for placing a cut frame of film immediately in front of the viewfinder ground glass to accurately align two scenes intended for subsequent combination printing on an optical printer. Frames must be cut extremely accurately, with a Mitchell frame punch of which separate types are available to suit reflex and non-reflex cameras.

18

1. Typical ground glass projected area markings:
A. 35 mm 2.35 : 1 anamorphic;
B. 35 mm 2.35 : 1 anamorphic with 2.2 : 1 70 mm projection; C. 35 mm full frame; D. 35 mm full frame with Academy; E. 35 mm Academy with 1.66 : 1; F. 35 mm Academy with 1.75 : 1; G. 35 mm Academy with 1.85 : 1; H. 35 mm Academy with TV transmitted corners and TV safe area; I. 16 mm Academy with TV transmitted corners and TV safe action; J. 16 mm Super 16 (1.75 : 1) with Super 16 1.85 : 1.

2. A frame punch, punched frame and punched film.

Film and Magazine Information

Film winding

Daylight loading refers to film supplied on daylight loading spools.

Rolls of film refers to 16 or 35mm film supplied on 2in. (50mm) plastic cores; 1200ft. rolls of 16mm film have 3in. (75mm) cores.

'B' wound 16mm film refers to rolls of film which, when viewed with loose end coming off in a clockwise direction, are emulsion in and have a single row of perfs. on the far side. All 16mm cameras take 'B' wound single perf. film except high speed cameras which require double perf. Double perf. may be used in any 16mm camera except when recording com-mag or com-opt sound.

Magazine loading

Wound film must be loaded into a magazine in total darkness. With darkrooms check that the door is locked and that the light cannot be switched on accidentally. With changing bags carry out the operation in a shady place.

When attaching a loose end of film to a take-up core, set the core in the mag. with the slit facing the direction of rotation so that the film end 'hooks' into position. Bend the film acutely, or even bend it double to make sure it is secure and wind on several turns to bind the end in position. With daylight loading spools make sure the spool flanges are not bent. Test it with a piece of doubled-up film or run it along a flat surface and observe.

Core adaptors

Most 16mm film mags. have centre spindles suitable for daylight spools onto which adaptors for roll wound film are fitted. Great care should be taken when unloading such mags. to ensure that the metal adaptor is not accidentally removed when sending film to the laboratory. The chances of it being returned are remote. Apart from being expensive it renders a mag. useless, except for spool loading film, until a replacement is obtained.

Loop and gate protectors

Mags. with pre-loaded film loops normally have loop protectors available to use when film is loaded but is not fitted to camera. Mags. which incorporate the back pressure plate must have a cover plate fitted when the mag. is not on the camera, whether film is loaded or not. Cameras also should always have an aperture plate in position when no mag. is fitted.

FILM AND MAGAZINE INFORMATION

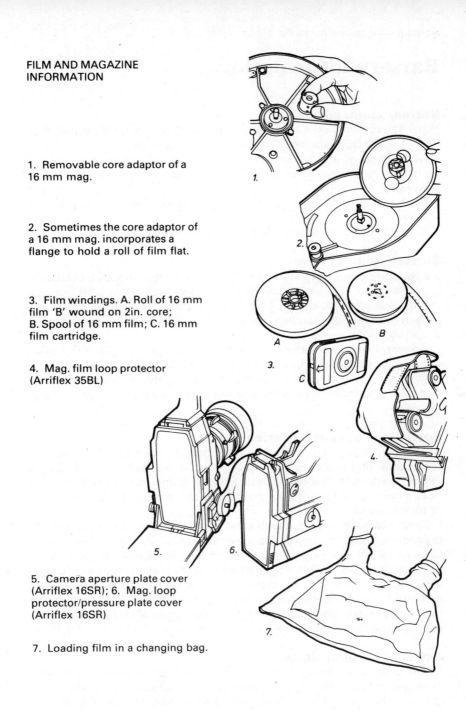

1. Removable core adaptor of a 16 mm mag.

2. Sometimes the core adaptor of a 16 mm mag. incorporates a flange to hold a roll of film flat.

3. Film windings. A. Roll of 16 mm film 'B' wound on 2in. core; B. Spool of 16 mm film; C. 16 mm film cartridge.

4. Mag. film loop protector (Arriflex 35BL)

5. Camera aperture plate cover (Arriflex 16SR); 6. Mag. loop protector/pressure plate cover (Arriflex 16SR)

7. Loading film in a changing bag.

Battery Information

Battery connections
Many 12v cameras are fitted with a four pin XLR Canon plug connected:
Pin 1 – 12v DC negative (-) power supply to camera.
Pin 2 – Pilotone and sync marker, connected to pin 2 of 3 pin Canon plug on battery case (there must be a 68 ohm resistance in each battery case between pins 1 & 2).
Pin 3 – Pilotone and sync marker to pin 1 of 3 pin Canon plug as above.
Pin 4 – 12v DC positive (+) to camera.
Note it is most important to check that polarity is not reversed.

Battery running times
If a battery is regularly undercharged, by even a small amount, eventually it becomes very discharged. Additionally, nickel cadmium batteries constantly discharge naturally. Under warm conditions unused batteries require frequent recharging. Below 0°C a charge is held almost indefinitely.

If a nickel cadmium battery is regularly discharged only slightly before recharging it will develop a memory for this condition and may fail to deliver its full capacity subsequently. It is necessary, therefore, to ensure that at least occasionally nickel cadmium batteries are discharged to 1 volt per cell.

Portable lead acid batteries
Sealed lead acid battery cells may be of the jelly-electrolyte type (usually rectangular and made up in multi-cell blocks) are manufactured using a wound electrode technology similar to nickel cadmium cell. Lead acid cells have a nominal voltage of 2 volts per cell compared with a 1.2 volts per cell of nickel cadmium.

Certain cameras are fitted with small capacity battery packs attached to the camera body. The approximate amount of film which may be expected to be run at 24fps from such a battery when fully charged, in good condition and warm are shown. If the battery is not fully charged, is a little aged and if it and/or the camera is cold, then the running time is less. Such batteries have little enough capacity when new but because of their short running time are more likely to be overdischarged than larger batteries and in consequence prone to premature failure.

Battery charging times
Nickel cadmium batteries should not be charged (unless by special methods) at a rate faster than 10 per cent of their capacity. This means that at best 10 hrs. should be allowed, and 15 to be sure. At C/10 rate batteries cannot be overcharged. Charging under cold conditions takes longer.

BATTERY INFORMATION

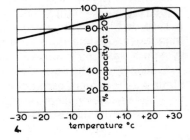

1. 12v battery connections. A. 4 pin Canon pin 1 12v –; pin 2 pulse in; pin 3 pulse in; pin 4 12v +. B. 3 pin Canon pin 1 pulse out; pin 2 pulse out; pin 3 not used.

1.

2. Maximum duration of discharge that may be expected of a fully charged nickel cadmium battery in good condition at 20° C (68° F). $^1/c$ = a discharge rate equal to the capacity of the cell. Note how the voltage remains fairly constant until a given point when it drops sharply.

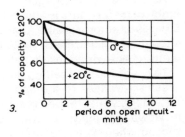

2.

3. Self-discharge to be expected of a nickel cadmium battery stored in cold and warm conditions. Note how a cell stored in cold conditions will retain a charge longer than when warm. A number of cells connected in series as a battery will discharge more rapidly than a single cell.

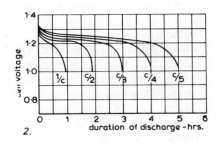

3.

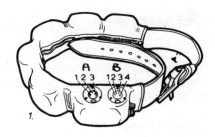

4. Comparative effeciency of nickel cadmium batteries at various temperatures.

4.

23

French chic in camera design.

Aäton 7

Lightweight, exceptionally quiet 16mm camera especially suited to hand-held operation. Features include provision for integral TV viewfinder, single or double system sound and easy adaptation to Super 16.

Description

Positive clamp and locking ring (miniature Mitchell BNCR) lens mounting. Adaptors available for standard or steel bayonet Arriflex, Eclair or Nikon-mounted lenses.

The camera may be converted from standard 16 to Super 16 by moving the optical centre horizontally 1mm and changing the aperture plate and ground glass.

Cameras may be fitted with 172.8°, 175° or 180° shutters.

Spinning mirror reflex viewfinder system. Eyepiece rotates 360° and horizon is set erect by turning knob 1B (on late models this is automatic). Eyepiece may be positioned on other side of camera for left-eye viewing.

Motor, 12v, 24/25fps, crystal controlled, and (cameras after No. 150) 6, 12, 16, 18, 20, and 28fps variable speeds; draws approx 1.2amps. A 1.2Ah battery (sufficient for three film mags.) clips on the camera side. Battery may be remote from camera by extension cable. Batteries wired for Eclair 16NPR or Arri 16BL etc. are also suitable. Camera electronics are protected by 5 x 20mm 5amp fuse located behind knob 3M.

A completely discharged battery may be recharged in 5–6 hrs. if the ambient temperature is above 40°F (5°C). Charger operates off 110 or 220v, 50 or 60Hz automatically. After battery is plugged into charger green lamp should light. If not, check 5 x 20mm 0.1amp fuse inside charger. If red lamp lights, check wiring inside battery.

To check 24/25fps setting remove motor ring (1H) and rubber inner ring. Brass screw seen in the appropriately marked hole must be changed if necessary. Variable speeds set by turning speed change switch. Red lamp in viewfinder lights up when camera runs off-speed, flashes once per second when battery charge is low. Yellow lamp lights when camera is running normally.

Clip-on 400ft. (120m) film mags. take film on 2in. (50mm) cores or 100ft. (30m) daylight loading spools. Footage remaining indicator on supply left side of each magazine.

Mags. incorporating single system com-mag recording system (sound is recorded level with picture image), may be used in place of normal magazines. Camera may be supplied with a modified viewfinder optical system for attaching miniature CCTV camera in place of clip-on battery.

Available electronic accessories include Aaton phase corrector for filming a TV screen, external slave unit for filming to playback and EBU time code or Aäton clear figure sync marking systems.

Camera serial number on plate left front of camera body.

AÄTON 7

1. Aäton camera with Zeiss Distagon 12 mm T1.3 lens. A. Viewfinder position lock; B. Viewfinder orientation control; C. Lens lock lever; D. Square rod lock; E. Remote start/stop switch; F. Remote start/stop switch connection; G. Motor with inching knob in centre, H. Motor ring.

2. Aäton camera with Zeiss Vario-Sonnar 10–100 mm T3.1 zoom lens. A. Battery adaptor unit; B. 12v 1.2Ah battery.

3. A. Mag. lock lever; B. Aperture plate; C. Mag. drive; D. Mag. locks; E. Diopter adjustment; F. Red and yellow warning lights; G. Battery panel attachment screw; H. Start/stop switch; I. Electronic accessory plug; J. Battery panel; K. Battery connection; L. Battery lock-in screw; M. 5 × 20 mm, 5amp fuse; N. Variable speed control switch; O. Alternative position (later models) for 'A'.

4. Aäton camera with TV viewfinder module. A. TV camera; B. Camera start/stop switch; C. Power socket on camera; D. Battery unit; E. TV unit connection; F. TV control unit.

5. Aäton TV control unit. A. 48/50/60Hz switch; B. Vertical centering adjustment; C. Vertical amplitude adjustment; D. Horizontal amplitude adjustment; E. Black level adjustment; F. Negative/positive switch; G. Focal adjustment; H. White level adjustment (for negative image only); I. Power socket; J. Camera-to-control socket; K. Scanning inversion switch; L. Power from VTR/off/power from batteries switch; M. VTR remote control; N. Sound-out socket; O. Monitor-out socket; P. Video-out socket; Q. Control-to-VTR socket.

Aäton 7 Loading

Aäton 7 mags. are co-axial and incorporate drive and take-up sprockets. Film loops are housed entirely within mag. Unexposed film is housed in left compartment.

Loading magazines

Lock footage counter by turning indicator counter-clockwise. Open left side of mag. (viewed from rear) by turning lock downwards. Ensure interior is clean and free of emulsion dust.

In total darkness release core lock mechanism (1H) by squeezing both sides inwards, press roll of core wound film (if wound emulsion in, with end coming off clockwise) over spindle and press centre (IG) to lock film in position. Push a short length of film through slot (1A) into take-up compartment keeping film on left side of guide roller. Close lid, lock securely and re-set footage counter by turning clockwise.

Daylight loading 100ft. (30m) spools may be loaded after removing centre core adaptor from mag. Footage counter must be left locked.

Unlock and remove lid on take-up side (lifts off at about 135°) and can-up any exposed film. Remainder of operation may be completed in the light.

Open both guide shoes (3E and 3G) by pressing central buttons (3F). Pull out short length of film, thread through to outside of mag. via upper guide and back through lower aperture below pressure pad. Pull through about 20in. (50cm) of film laying it to left of top roller (3B), over centre roller (3C) and locate under top sprocket (3D). Close top guide shoe. Measure out 14 frames of film (around two fingers held together sideways) and flatten film on pressure plate so that two similar sized loops are formed inside mag. Thread film and lower sprocket and close guide shoe. Pass film below lower roller and secure end onto take-up core in an anti-clockwise direction, emulsion in. Tighten film and lock by pressing centre button.

Replace mag. lid by matching hinges at 140°open.

Putting magazine onto camera

Hold mag. square to rear of camera, rest front below aperture plate and push in until a click is heard. Pull to double check it is secure.

Removing magazine from camera

Hold camera with left thumb on mag. lock lever (5D). Push lever forward and remove mag. with right hand. Check that aperture plate is clean and lateral pressure guide free.

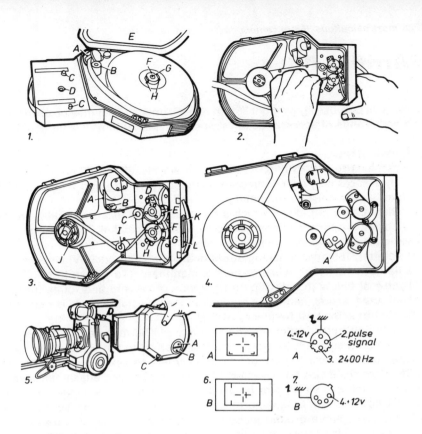

AÄTON 7 LOADING

1. Aäton 7 mag. supply side: A. Film entry slot; B. Guide roller; C. Mag. lock knob; D. mag. drive; E. Hinged lid; F. Film supply centre; G. Centre release; H. Lock release.

2. Aäton 7 mag., take-up side, measuring film loop.

3. Aäton 7 mag., threading path: A. Film entry guide; B. Guide roller; C. Guide roller; D. Upper sprocket; E. Upper guide shoe; F. Guide shoe release; G. Lower guide shoe; H. Lower sprocket; I. Guide rollers; J. Take-up core; K. Frame pressure pad; L. Claw pressure pad.

4. Aäton 7 mag. fitted with com-mag sound recording facilities: A. Sound heads.

5. Attaching mag. to camera: A. Footage counter lock; B. Footage indicator; C. Take-up lid lock; D. mag. lock lever.

6. Alternative ground glasses: A. Academy with TV corners and centre cross; B. Super 16 with Academy corners, large Super 16 centre cross and small Academy centre cross.

7. Electronic accessory output sockets: A. pin 1 earth (ground), pin 2 pulse signal, pin 3 2400Hz, pin 4 12v + power input socket; B. pin 1 earth (ground), pin 4 12v +, (pins 2 & 3 not connected).

27

A most ubiquitous 35mm camera, first introduced in 1938.

Arriflex IIC

General purpose lightweight 35mm reflex camera which may be used with a wide range of accessories for almost all types of film making.

Description

Three-lens turret, Arriflex type mounts set closely together. Three 25–75mm lenses may be mounted simultaneously. Wide angle, telephoto and zoom lenses must be mounted individually.

Single claw pull-down which also steadies and locates the film. Interchangeable aperture plates: Academy, anamorphic, full, Techniscope and various wide screen formats available.

Shutter, 165° fixed opening or optional variable (model BV) type adjustable from 165° to 0° while camera is stationary. (To adjust, press firmly knob just below thumb grip on right side of camera and rotate inching knob until desired setting as marked on the adjustable blade is reached.) Optimum 24fps HMI frequency 51.7Hz.

Spinning mirror reflex viewfinder system. The mirrored shutter has a blacked-out segment to reduce the flicker effect to the cameraman. This must be allowed for when setting the camera to film a practical TV set. Standard fixed position eyepiece. Periscope eyepiece attachment available for left eye viewing or for viewing from alternative angles (see Arri 16ST accessories). De-anamorphoser available for shooting 'scope'.

Interchangeable ground glasses, any format. To change, loosen (not remove) locking screw, pull out ground glass with thumbnail, bent paper clip or special tool. Insert replacement etched side towards mirror, tighten screw.

Interchangeable 24 or 25fps crystal controlled, governed, variable and high speed 80fps battery motors, mains sync (24 or 25fps) motors and single shot animation motors are available. (Reversible motors should be checked for being set as required.) 16v battery motors draw 3amp at 24fps, 32v high speed motors draw 3½amp at 70fps. High speed operation possible only with camera having specially modified and adjusted gate pressure plate (Model HS) and high speed motor. Mains motor available for 110, 220, 240v/50 or 60Hz supplies.

Displacement type mags. 400ft. (120m) reversible and 200ft. (60m) non-reversible capacity. A 1000ft. (300m) model also available. Footage remaining counter on individual magazines. Tachometer on rear of camera; 50 or 60Hz Pilotone generators, for cable sync, integral with tachometer.

Accessories available include sync marker light system, sound proof blimp, crystal controlled motor, intervalometers, side-mounting motor adaptor plates, matteboxes and sunshades, heavy lens supports, TV viewfinder and weatherproof, heated and noise reducing barneys.

Camera number engraved on front of camera body above taking lens.

ARRIFLEX IIC

1. Arri IIC with 400ft. mag., bellows mattebox, wild motor.
A. Filter height control;
B. Mattebox release; C. Mag. release; D. Turret locking screw;
E. Turret-rotating lever; F. Lens release; G. Focus control;
H. Viewfinder closure; I. 'On/off' switch; J. Reverse switch;
K. Power socket; L. Camera door release; M. Mag. door release;
N. Diopter adjustment and lock.

2. Arri IIC with 200ft. mag., metal mattebox and governed speed motor. A. Footage remaining indicator; B. Tachometer;
C. Inching knob.

3. 120S blimp. A. Inching knob;
B. Focus and aperture scale window; C. Focus knob;
D. Pilotone socket; E. Power socket; F. Remote switch socket;
G. Fuses; H. Footage counter window; I. 'On/off' switches;
J. Thermal overload switches.

4. 120S blimp. A. Aperture control;
B. Alternative footage counter window; C. Focus control;
D. Aperture and focus scale window.

5. 120S with zoom lens blimp front extension. A. Angenieux 10 × 25 mm zoom lens.

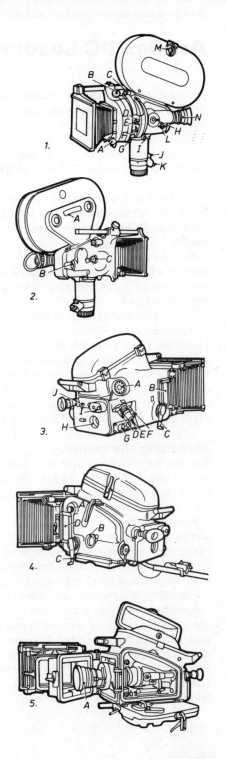

Start by taking elementary precautions.

Arriflex IIC Loading

Before removing mag. lid prior to loading check that no film remains from previous usage. Remove lid, check inside is dust free, swing counter arm to right until engaged.
. Remove sealing tape from around can and, in darkness, remove film from can and black bag. Remove short piece of tape securing end of roll and dispose of safely. For ease of loading, trim film using a special template.

Hold roll of film so that end comes off towards centre of left side of mag. Feed end between rollers and over sprocket until it emerges through left light trap. To help film through turn gear at bottom of mag. Place film in mag.

Pull out enough film to wrap around exterior of mag. as far as raised line to form a film loop approx. 54 perfs. long. Push loose end of film back into mag. through right light trap, easing its passage, if necessary, by rocking the bottom gear.

Attach film end to take up emulsion in. Core rotates clockwise (opposite to Panavision and Mitchell). If mag. has a permament take-up centre the end of the film should be attached by opening the spring-loaded slot. If the mag. uses film cores the end of the film should be bent over, securely fixed in the cut-out and wound on several turns. Return counter-arm, replace mag. lid, lock and double check that it is secure all round. In the light, check that loop is correct size and emulsion is outwards. With a small piece of camera tape note mag. contents for reference.

Threading the camera
Remove camera door, turn mag. locking knob (at top front of camera) in an anti-clockwise direction and pull out. Remove mag. aperture cover plate, if fitted. Inch camera until claw is in fully withdrawn position. Open film gate and check that aperture is clean and free from hairs.

Pass film loop through aperture at top of camera. Push mag. downwards and backwards making certain that film is not trapped between mag. and camera body and ensure that take-up drive gears mesh correctly. If necessary, camera may be inched slightly to ease meshing. Lock mag. in position by releasing locking knob and turning clockwise.

Place film in gate coincident with guide lines engraved on camera body behind film, forming a top loop of film approx. 15 perfs. long. Press film against aperture plate and inch camera until claw engages in a perf. Close gate and inch through a few frames of film checking that movement is free and that loops are correctly formed. Run a short burst of film to test; replace camera door and lock securely turning knob to 'Z'. Check camera speed, adjusting rheostat beneath motor as necessary. Reset footage counter (blimp only).

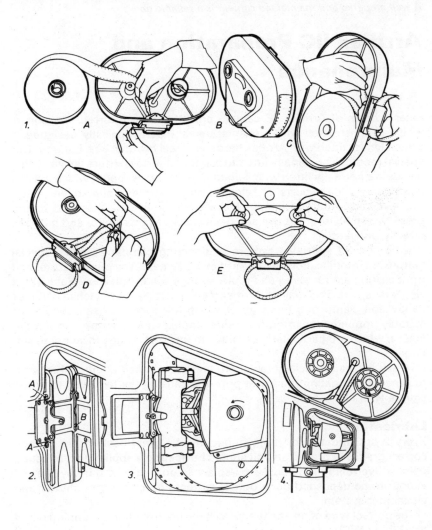

ARRI IIC LOADING

1. A. Feed film between rollers; B. Measure loop length to raised line; C. Form loop; D. Attach film end to take-up; E. Tighten up loose film.

2. Open gate to check. Complete gate assembly may be removed by loosening two screws (A). Retract claw (B).

3. Thread film, engage claw, close gate.

4. Film threading path (200ft. (60m) mag.)

A well prepared and maintained camera is a reliable one.

Arriflex IIC Preparation and Maintenance

Later models of Arriflex IIC camera are fitted with a turret, one port of which is constructed with a stainless steel insert especially designed to accept lenses fitted with Arriflex hardened steel bayonet lens mounts. This special mount is principally fitted to zoom and wide aperture lenses. Other lenses are normally fitted with standard Arriflex lens mount which may be used in any of three ports. To release a steel bayonet mounted lens, press top lever and rotate lens anti-clockwise. To release a standard mount press two small levers above and below lens towards centre and pull lens directly outward.

A number of specialist camera engineering companies make special 'hard-front' modifications to the Arriflex IIC camera. The original turret and front casting are removed and replaced by a solidly attached plate with a single lens port. This may be Arriflex steel insert type, or Mitchell BNCR or Panavision clamp ring types all of which are especially satisfactory for suitably mounted anamorphic, wide angle, wide aperture and zoom lenses, which are particularly sensitive to incorrect flange focal depth settings.

Heavy lenses (especially telephoto and zoom) need additional support to prevent elongating the turret port and causing the lens axis to be off square with film plane.

Lubrication

Every 2 or 3 months, or more frequently if a great deal of film is shot, correct grades of grease and oil should be sparingly applied to lubricating points. Over-oiling may cause oil splashes on film or a thin layer of oil vapour to be deposited upon optical surfaces of lens, mirror shutter and viewfinder system.

The correct type of oil and grease will ensure trouble-free running down to −22°F (−30°C).

To lubricate claw mechanism remove camera door and cover protecting cam mechanism inside camera. Apply a little grease to hard fibre claw guide where it runs inside eccentric and oil to two holes in centre of claw mechanism.

To lubricate mechanism, cover plate must be removed from right of camera. To do this, inch camera until mirror is in an open position, remove motor by undoing appropriate screws and remove rear cover by tilting it forwards and sliding over shutter mechanism.

Under no circumstances should movement or shutter be dismantled. Lubrication of shutter bearing is not necessary. Other sliding surfaces and bearings should be lightly greased with special grease supplied by camera manufacturer.

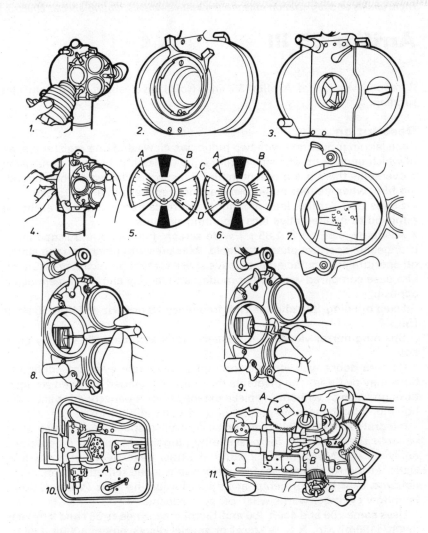

ARRIFLEX IIC PREPARATION & MAINTENANCE

1. Standard 3-lens turret with one 'steel bayonet' type port. 2. Panavision hard front conversion. Modification to take a Mitchell BNCR mounted lens is similar but slightly larger. 3. Samcine hard front conversion. Takes Arri standard or steel bayonet mounted lenses, incorporates lock to hold lenses positively in position. 4. Adjustable shutter of BV model. 5 & 6. Shutter angle may be read according to the colour of the adjacent edge of the reflex mirror shutter segment: A. Black line; B. Red line; C. Black scale (outer); D. Red scale (inner). 7. Typical setting: 120° shutter opening as seen through lens port. 8. Before removing ground glass, retaining screw must be turned 90° anti-clockwise. 9. Removing ground glass with bent paper clip. A special Arriflex tool or thin nose pliers may also be used. 10. Points to be lubricated every 15–20,000ft. (5–6000m): A. claw cam and B. intermediate gear to be greased, C. trunnion and D. pivot block, to be oiled. 11. Grease gears A, B, C and D sparingly.

High speeds and registration pins are imperative when shooting special effects.

Arriflex 35 III

A refined version of Arriflex 35 line. Noise level about 50dB with film running.

Description

Register pin movement with two pull-down claws and one register pin, all of which engage on one side of film only. Unlike Mitchell and Panavision movements there is a moment in film transport cycle, used when threading film, when neither pull-down claw nor register pin are engaged.

Single port Arriflex lens mounting. Entire camera front may easily be removed to fit alternative lens mounting systems.

Academy, 1.66 : 1 & 1.85 : 1 wide screen, full-frame and scope interchangeable aperture plates available. Rear pressure plate made to stand-off aperture plate sufficiently to leave space for film, reducing pressure on film base compared with earlier models and largely eliminating emulsion deposit.

Fixed opening 180° shutter. HMI frequency 48 or 60Hz at 24fps, 50 Hz at 25fps.

Spinning mirror viewfinding system, stops automatically in view position.

Camera doors with straight through or pivotable eyepiece configurations may be fitted. The pivotable may be interchanged between straight-through (with or without eyepiece extension) or a periscope for shoulder holding. Interchangeable ground glasses compatible with IIC.

Integral 12v motor. 24/25fps crystal controlled speeds, 6–50fps stepless variable speeds. 6–100 fps possible by plugging in special module and applying 24v. Motor draws 2.5amp at 24fps. Reverse running possible. Optional control accessories include variable speed remote control, external sync, sync transformer, phase shifter for filming 50Hz TV etc. A signal lamp in viewfinder warns when off sync speeds.

Uses same 200 and 400ft. (60 and 120m) magazines as 35 I and II models (500ft. (150m) with B & W stock) or special displacement 1000ft. (300m) type (which cannot be used on earlier cameras).

Additional accessories include 4 or 6.6in. sq. matteboxes, carrying handle, shoulder support, hand-grips, TV viewfinder, follow-focus system, EBU time-code, etc.

Operation

To thread film in camera inch movement by turning knob in centre until arrow is aligned with index mark. Film may then be slipped in position, located by slight further inching, and gate closed.

To reset footage/meterage counter press 'read' and 'reset' buttons simultaneously.

Protective shrouds fitted around rear element of some Zeiss Speed lenses must be removed to avoid damaging Arri III mirror shutter.

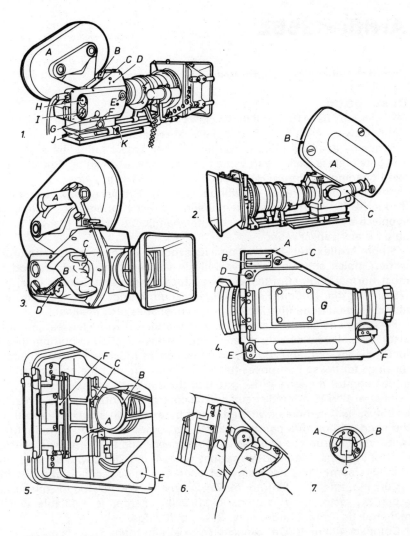

ARRIFLEX 35 III

1. A. 400ft. (120 m) mag; B. Mag. release; C. Accessory slide; D. Focal plane and tape hook; E. Handgrip attachment point; F. Variable speed control; G. Remote start socket; H. Accessory socket; I. Inching knob; J. Intermediate plate; K. Bridge plate and support rods. 2. A. 1000ft. (300 m) mag.; B. Loop measuring mark; C. Camera door with pivoting magnifier. 3. A. Detachable carrying handle; B. Detachable hand-grip; C. Camera run switch; D. Accessory switch plug. 4. A. Footage (meterage) counter display; B. fps display; C. fps display button; D. Footage counter reset button; E. Camera 'run' switch; F. Door release, G. Door with 'straight-through' viewfinder. 5. A. Inching knob; B. Arrow set pointing to index mark; C. Double pull-down claws; D. Single register pin; E. Digital display memory battery; F. Aperture plate retaining plate. 6. Inching camera to secure film while threading. 7. A. 5 amp fuse; B. Spare fuse; C. 24–25 fps switch.

Arriflex 35BL

Compact, lightweight, 35mm feature film camera.

Description

Mk I cameras have four pull down claws (two on each side), the Mk II has a single claw on each side. Both have dual register pins.

Academy aperture plate is standard, other aspect ratios are available. The gate plate is easily removable for checking and cleaning. Shutter 180° fixed opening. Optimum HMI frequency 48 or 60Hz at 24fps.

Spinning mirror reflex viewfinder system. Eyepiece may be rotated through 125° with horizon remaining correctly orientated. Extension eyepiece available for tripod use. Interchangeable ground glasses available for any aspect ratio.

Single Arriflex steel bayonet type lens mount. Lens blimps for minimum camera noise emission are available in various sizes to accommodate most normal and zoom lenses. Fixed focal length lens blimps take 3in. (75mm) or 4in. (100mm) square filters, zoom blimps 6.6in. (177mm) sq. filters. Non-blimped filter holders and sunshades also available.

Focusing and aperture control (and in the case of zoom lenses, zooming also) are by levers on side of lens blimp. Strips attached to blimp indicate focus, diaphragm (and zoom) positions. Lenses must be fitted with adaptor rings for linkage purposes (take care to ensure that the correct strip is in position for the lens in use and that the markings are accurate).

Integral 12v DC printed circuit crystal controlled motor may be run at 24 or 25fps. Mk I cameras switched on/off by extension switches placed on the hand grip or on a pan handle. Mk II also has switch on camera. Mk I motor may be run at 5 to 30fps variable speeds and to 100fps with special control systems, modified magazines and 24 and 36v power supply. 14v supply is sometimes necessary for operation in cold conditions or with 1000ft. magazine. Mk II motor maximum speed is 50fps (100 fps to special order ex. factory). An automatic 110/220v charger is available which recharges in 7 hrs. Motors draw 3½amp at 24fps.

Compact 400 or 1000ft. capacity co-axial film mags.

A footage counter is set on side of camera. Later versions have a digital read-out type. 'Footage remaining' indicator on all magazines.

A tachometer is set on side of camera.

A sync marker light is standard.

Optional accessories include an emergency battery to camera cable to run camera by-passing camera electronics, variable speed control to run camera at 5–30fps, high speed cable to run Mk I camera off three x 12v batteries to 100fps, external sync unit for filming to playback or off a TV recorder, phase shifter for filming a TV screen, a digital electronic film speed indicator, a camera balance plate and a heavy lens support bracket. 24/60, 24/50 or 25/50fps/Hz Pilotone output for cable sync.

Camera serial number engraved on right side.

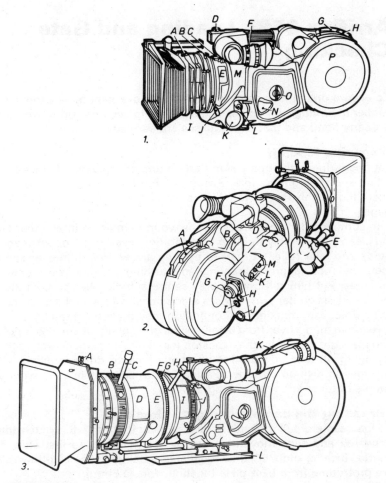

ARRIFLEX 35BL

1. 35BL Mk 1. A. Mattebox release latch; B. Handle and lock for *f*-stop ring; C. Universal lens blimp; D. Standard mattebox attachment point; E. Lens setting window; F. Diopter adjustment; G. Mag. loading loop length mark; H. Mag. locks; I. Filter stages; J. Focus handle; K. Tachometer; L. Footage counter and reset button; M. Film plane mark; N. Manual inching lever; O. Door lock; P. 400ft. (120m) mag. (take-up side). 2. 35BL Mk II with blimp for Cook Varotal 5 × 20 zoom lens, extension eyepiece and 1000ft. (300m) mag. A. Two 6 × 5in. filter slides; B. Focus strip; C. Focus control lever; D. Focus window; E. Zoom limit stops; F. Zoom drive gear; G. Zoom strip; H. Zoom control lever; I. Zoom/aperture window; J. Aperture control ring; K. Extension eyepiece; L. Balance slide and lens support bars; M. 1000ft (300m) mag. (take-up side). 3. 35BL Mk 1 with zoom blimp. A. Mag. cover lock, supply side; B. Supply footage indicator; C. Tape hook; D. Zoom blimp release; E. Start/stop button; F. Socket for bridge plug, high speed and emergency operation cable; G. Short-circuit plug; H. Pilotone socket; I. Socket for electronic accessories; J. Power socket; K. Mode selector switch; L. Fuse holder; M. 'Out of sync' buzzer volume control.

Always double check correct focus strip is fitted to lens blimp.

Arriflex 35BL Loading and Gate Checking

• To ensure optimum quietness check that movement moves freely on its rubber mountings, blimp housing seals are intact, right side cover plate is properly fitted and that heavy lenses are correctly supported.

Magazine loading

Lay magazine with supply side (large number) upwards. Remove lid by lifting and sliding mag. lock. Swing film footage counter arm clear. Note check thoroughly that no torn film remains in film guide runners (see next page).

In complete darkness check film is wound emulsion in and that end is cut cleanly, preferably through a perforation. Feed into slot between loop guide and idler roller as marked by long arrow. Help film over sprocket teeth by rocking drive coupling and turning anti-clockwise until film emerges. Put film roll onto supply centre spindle, replace mag. lid and secure. Film counter arm releases automatically. Provided there is no film to be unloaded, remainder of operation may be done in the light.

Remove mag. cover from take-up side, pull out about 9in. (22cm) of film and measure to loop length indicator. Insert film into slot in take up throat, engaging on take up sprocket by gently inching drive coupling until it emerges in take-up chamber. Fasten film to collapsible core, wind on a couple of turns and replace mag. lid.

Threading the camera and gate checking

To load camera pull movement release lever (bottom left, inside camera) outwards and slide movement out by ¾in. (18mm) to first stop. Turn knurled inching knob (5C) until red marks are aligned and pull-down claws are protruding from back plate by about $\frac{1}{16}$in. (1.5mm).

Slide loaded mag. firmly into place and turn locking lever clockwise to Z C (close) position. Arrange film according to inscribed markings and slide mechanism closed until it clicks in locked position. Turn buckle switch anti-clockwise to set. Inch camera while door is open. Lock camera door closed. Set footage counter to zero. Use lever on door to inch camera when power is not connected.

To check gate and clean aperture plate, slide movement back as for camera loading and then pull the release lever a second time when movement may be retracted a further ¼in. (6mm). (Note it is not possible to attach or remove magazine with movement in this second position.) To avoid damage, camera should be inched to withdraw claws and to fully open shutter.

To remove aperture plate proceed as above, place forefinger in indentation at bottom of plate, gently push plate upwards by about $\frac{1}{16}$in. (1mm) and remove from lower end. Before replacing ensure there is no dirt under plate or on camera seating.

38

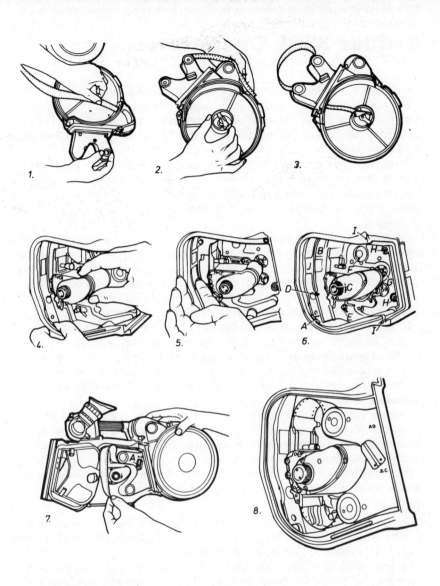

ARRI 35BL LOADING

1. Offer unexposed film into right side of mag., 2. Measure loop length to mark on mag. top, 3. Form loop end, attach film to take-up in left side, 4. To retract movement and open gate, press release lever, 5. To release aperture plate for inspection, press from bottom upwards and remove carefully, 6. Movement set for film loading in forward open position, A. Release lever; B. Aperture plate; C. Inching knob and index mark; D. Film locating pin; E. Buckle switch; F. Mag. drive; G. mag. lock socket; H. Mag. location points; I. Mag. retaining dovetail slides; J. Aperture mask and gelatine filter holder access, 7. Offering mag. to camera with lock lever (A) set to AO, 8. Film laced, gate closed and mag. locked in position.

Arriflex 35BL Operation

Check that motor is set to run at 24 or 25fps as required.

For normal operation bridge plug must be in position in top socket of rear panel and mode selector switch set to correct speed and Pilotone frequency. Mode selector switch may also be set to 'L' to test indicator start mark lamps and 'out of sync' buzzer.

A red indicator light will be seen in viewfinder and 'out of sync' buzzer sounds (from camera 35020) to warn operator when running off speed. Buzzer also sounds when sync marker light operates and when buckle switch trips. May be switched off or toned down by potentiometer on side of camera.

Electronic system is protected by two tiny fuses. A 15amp fuse is on lower of two printed circuit boards. On cameras pre-35060 upper circuit board must be unscrewed and swung clear to gain access. Another fuse protects the drive control circuit. On cameras pre-35020 an 0.5amp fuse is on left of lower circuit board. On cameras from 35021 a 0.75amp fuse is on side of camera between mode switch and buzzer potentiometer.

To replace defunct signal lamps, retract movement, position shutter clear of aperture, remove aperture plate and pull-out lamp carrier.

A kit of spare fuses and signal lamps is available from manufacturer.

Take care when replacing rear cover plate to ensure that no wires are pinched and sealing gasket is properly replaced. Failure will cause increased noise.

Camera speeds of 5 to 50fps may be achieved by the use of a variable speed control attachment and speeds of up to 100fps on Mk I cameras by a special camera to battery cable, a 36v 10Ah DC power supply and adding special guide rollers to film magazines.

Sychronising with a TV screen to eliminate frame bar is done by use of a 'phase advance accessory' (50Hz 25fps operation only).

Ground glass

To change ground glass, remove lens, fully open shutter, insert special withdrawing tool or bent paper clip into small eyelet at front of ground glass and release by pulling down slightly.

When replacing, check cleanliness, check seating by pulling gently forward and as a double check on accuracy, put a short focus lens on to camera and visually check focus on infinity at full aperture.

Lubrication

Felt pad wicks which oil movement cams must be lubricated at intervals of 60,000ft. (6–8,000ft. after high speed running). Remove magazine and plate covering mechanism, inch camera to reveal lubricating holes in cross shafts, apply small quantity of camera oil to wicks. Do not over-oil.

Cleaning magazine film guides

At very frequent intervals remove magazine film guide covers and check that no broken-off chips of film are lodged in film guide runners.

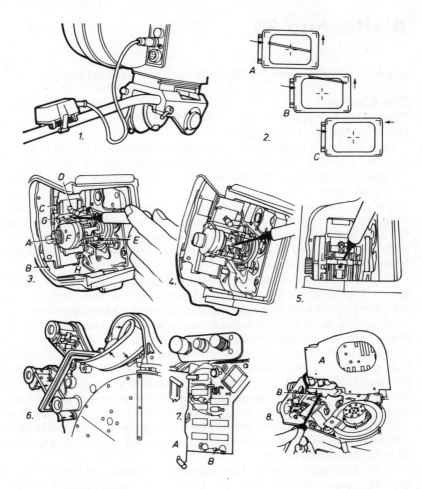

ARRI 35BL OPERATION

1. TV phase advancer accessory. Remote 'on/off' switch, variable speed control and emergency control are similar. 2. Sequence of eliminating TV frame bar as seen in the viewfinder:
A. Bar shows prominently; B. After pressing button on phase advancer, bar moves upwards; C. Cease pressing when bar is equally out at top and bottom of picture. 3. Lubricating registration pin guide wick. (Mk I and II models): A. Inching knob; B. Movement release lever; C. Aperture; D. Gate pressure pad; E. Cam followers (to be lightly lubricated by brush), F. Transport mechanism in retracted position (cover removed); G. Oil applied to registration pin guide wick by syringe type oiler; H. Buckle switch.
4. Lubricating wick inside rear cross shaft (Mk I only). 5. Lubricating wick inside front cross shaft (Mk I and II). 6. Covers removed from magazine film guides to check channels for film chips (arrowed). 7. Position of 5amp fuse on Mk I cameras: A. upper circuit board unscrewed and displaced to one side to give access to lower board, B. 15amp power fuse. 8. Position of 15amp power fuse on Mk II cameras: A. upper circuit board hinged upwards, B. 15amp power fuse.

Arritechno 35

A specialist 35mm camera principally used for industrial filming.

Description

Type 90 has a double pull-down claw and a register pin on one side of the film only. Maximum speed 90fps.

Type 150 has a double pull-down claw, a register pin on either side of film and a special lubrication system. Maximum speed is 150fps.

Focal plane shutters 172°. Shutters with smaller openings may be fitted to special order.

Arri steel bayonet lens mounting. Arri mounted lens suitable for 35mm usage may be fitted. Because the camera has a simple flat shutter blade set close to the focal plane, lenses with a shorter back mechanical clearance than usual may be used. The standard lens port may be exchanged for one of larger diameter.

As the camera is intended for use in fixed positions a viewfinder is only required for setting-up and fine focus purposes. For this, the film mag. may be replaced with a ground glass screen and a boresight magnifier.

Integral DC printed motor with various control systems available to give single shot, pre-selected frame sequences or continuous running at any speed up to 90 or 150fps. Run up times to maximum speed is 0.35 and 0.6 secs. respectively, the motors drawing up to 120 or 340W. 150fps may only be used for a maximum length of run of 21secs. (200ft. (60m) of film) after which the camera must be rested for 5 mins. High speed runs at lesser speeds may run for pro-rata longer takes with lesser intervals in-between.

Special 200ft. (60m) and 400ft. (120m) mags. with preformed loops, which are attached to the camera without the need for threading are used with the Arritechno camera.

Footage remaining counters on magazines indicate for normal thickness film (AZ) or thin polyester base film (PE).

Exact speeds are selected electronically. A tachometer attachment for calibration purposes available as an extra accessory.

Lubrication, which is very important on any high speed camera, is done from a central position by the use of special lubricating cartridges. Arritechno 90 with red mechanism plate does not require cartridge lubrication but should be relubricated every 200,000ft. (60,000m). Arritechno 150 with red mechanism plate does not need third lubrication cartridge.

Available extras include synchronisers to run two cameras for continuous exposure of a subject, electro-optical pulse generator, data, time and other information superimposition, remote footage elapsed read-out and an attachment for mounting camera about lens axis.

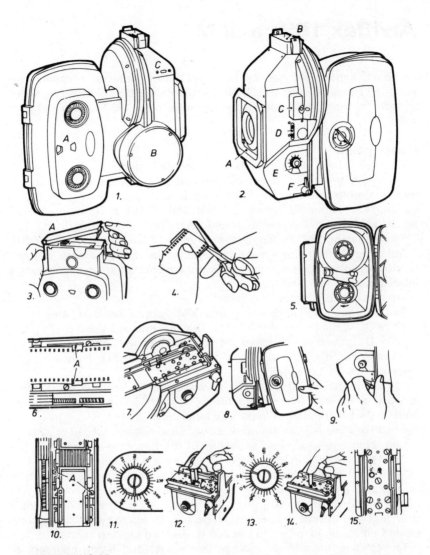

ARRITECHNO 35

1. A. Footage counter; B. Motor; C. Override switch. 2. A. Camera attachment flange; B. Electric connector socket; C. Speed limiter; D. Lens lock; E. Inching knob and index marking; F. Mag. lock. 3. Mag. loading. A. Attach loop former. 4. Trimming end of film through perforation. 5. Mag. film path. 6. Camera loading. A. Check film held by two spring pins and loops symmetrical. 7. Knob left turned until register pin protrudes, 8. Attaching mag. 9. Locking mag. 10. To clean mag. throat, remove two screws (A) and remove pressure plate. 11. To lubricate type 150 camera turn knurled knob (B) to 0°. 12. Injecting special grease from two cartridges (A) pressed into holes marked 0° on aperture plates. 13. Knob (D) turned to 110°. 14. A third grease cartridge pressed into hole marked 110°. 15. To lubricate type 90 turn knurled knob to 0° and press grease cartridge into hole marked 0°.

Arriflex 16St and M

Compact, lightweight general purpose 16mm cameras, normally used wild. 16ST may be used with 100ft. (30m) internal daylight loading spools or external mags. 16M takes external mags. only. 16ST is also known as 16S.

Description

Cam driven single pull-down claw and single register pin.

Divergent three-lens turret permits mounting wide angle and long lenses simultaneously. On later models one port accepts Arri steel bayonet-lock mounted lenses (ST MkI S/B). Takes all Arriflex standard lenses and/or steel bayonet mounted where later type turret fitted.

Fixed opening 180° shutter. Optimum 24fps HMI frequencies 48 or 60Hz.

Spinning mirror reflex viewfinder. Eyepiece at rear of camera. Automatic closing light trap and periscope finder attachment are available extras. Interchangeable ground glasses.

Interchangeable motors available:

8v DC variable speed (5–48fps) reversible, draws 3amp at 24fps.

8/12v DC variable speed (52–55fps) draws 3amp at 24fps.

8/12v DC governor controlled (24 or 25fps), draws 1.6amp.

All cameras after No. 19522 and those fitted with TTL exposure meter systems require 12v supply.

12v DC quartz crystal (24 or 25fps) variable (8–50 fps) and single frame, forward or reverse. (Note if this motor is used 16ST torque motors and built in start mark system must be connected to 8v.)

42v 50 or 60Hz AC synchronous, 24 or 25fps, operate off 110 or 220v AC via transformers which also supply 8v DC to mag. take-up motors.

Arri 16ST takes 100ft. daylight loading spools internally or 200 or 400ft. (60 or 120m) displacement type mags. fitted with removable torque take-up motors. The 16M takes 200 or 400 ft. displacement or co-axial type mags. with gear driven take-ups. 16M mags. look similar to but not interchangeable with 16BL magazines. Mags. may be loaded with film on cores wound emulsion in, or on 100 or 200 ft. daylight loading spools.

Tachometer, mechanical footage (meterage) and frame counters on camera rear, footage remaining indicator on interchangeable mags.

Optional factory installed accessories include Pilotone generator, TTL exposure meter, auto-slating, and modifications necessary for Super 16.

Camera serial number engraved lower front right side.

In-field maintenance

Lubrication should be done sparingly every 16–20,000ft. (5–6,000m). A recommended lubricant must be applied with a special oil pen which depresses steel balls protecting the oil channels.

Frequently check that small strips of rubber which form light seals between mag. and camera are intact and in position on each 16ST mag.

ARRIFLEX 16St & M

1. Arriflex 16St 100ft. (30m)
daylight loading mode. The
camera illustrated has TTL
exposure meter, and is a 12v
model. A. Standard bellows
mattebox; B. Off set 3-lens turret;
C. 'On/off' switch; D. Mag. aperture
cover.

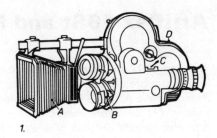

1.

2. Arriflex 16St with 400ft. (120m)
mag. A. detachable torque take-up
motor; B. film tightening knobs;
C. mag.; D. motor attachment
knobs; E. Footage remaining
indicator; F. Additional take-up
motor electrical connection;
G. Tachometer; H. Footage and
frames elapsed; I. Pilotone outlet;
J. Interchangeable motor;
K. Motor speed adjustment;
L. Motor direction control;
M. Motor inching control;
N. Power connection; O. Universal
mattebox.

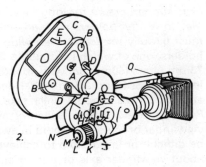

2.

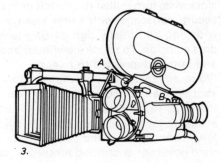

3. Arri 16M with 400ft. (120m) mag.
A. Mag. release; B. 'On/off' switch.

3.

4. 16M with 1200ft. (360m) mag.
(Avoid laying loaded 1200ft mag.
on its side.)

4.

Arriflex 16St and M Accessories

The Arri 16ST and M cameras have a wide range of accessories available which can greatly increase their scope.

Blimps make Arri 16ST and M cameras truly studio quiet.

Built-in TTL exposure meter.

Interchangeable ground glasses various markings available include full frame projection, TV, 1.85 : 1 etc.

Interchangeable motors see previous page

Lens extension tubes for macro and close-up cinematography

Lens support cradle for long focal length and zoom lenses.

Mattebox filter holders have an extending bellows type sunshade (which must be fully retracted when wide angle lenses are used) and two filter holders, one of which is rotatable. The standard model, which takes 60 x 75mm filters (50mm sq. with adaptors) is suitable for use with fixed focal length lenses from 12.5mm focal length upwards. For wide angle and wide aperture lenses a model which takes two 100mm sq. filters must be used.

Periscope viewfinder attachment makes it possible to apply left eye to viewfinder or to use a camera in awkward positions that would otherwise be difficult or impossible to achieve. When eyepiece is cranked, rotated about viewfinder axis or turned outwards the image remains erect and correctly orientated, when rotated about the cross axis the image rotates.

To attach periscope, remove eyepiece from camera by turning ring clockwise, turn milled ring to left until two red dots are opposite single dot, secure periscope with same locking ring, attach eyepiece to periscope with ring and finally tighten ring turning clockwise until two single red dots coincide. To rotate viewfinder about cross axis ring must be loosened and button depressed to release.

Phase advancer for use with crystal control motor. Used to set camera shutter open period in sync with line scanning when filming a TV screen (50Hz, 25fps). Mechanical phase advance for sync motors and 144° shutter available for kinescoping 60Hz TV systems.

Single shot adaptor and control system gearbox which fits between standard governor controlled motor and camera. By use of an intervalometer system may be triggered at regular intervals or intermittently with an auxiliary shutter to prevent film fogging between exposures.

Pistol hand grip and shoulder supports with trigger.

Viewfinder with automatic light trap opens and closes as operator's eye is applied.

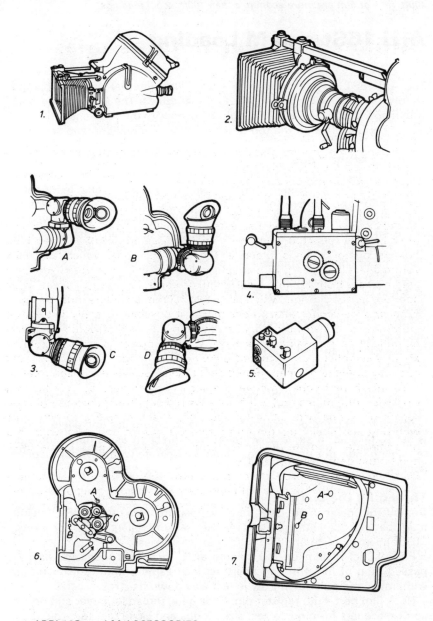

ARRI 16St and M ACCESSORIES

1. 16St blimp. 2. Universal mattebox. 3. Periscope viewfinder: A. Outwards; B. Upwards; C. Downwards; E. Offset for left eye operation. 4. Single frame gear. Set as shown gives 0.42 sec. exposure. 5. Crystal controlled motor. 6. 16St lubrication points every 30,000ft. (10,000m): A. Intermediate counter gear; B. Roller; C. Intermediate shutter gear. 7. 16M lubrication points every 30,000ft. (10,000m): A. Intermediate counter gear; B. Intermediate shutter gear.

Arri 16St and M Loading

The Arri 16ST may be used with 100ft. (30m) internal daylight loading spools, or 200 or 400ft. (60m or 120m) magazines. The 16M is used only with mags. If internal daylight spools are used with the 16ST check that the mag. aperture plate on the top of the camera is in position and secure.

Loading magazines

Open mag. lid and set left pressure roller into inoperative position. If spool loading film is to be used in magazine set right pressure roller in inoperative position and remove core adaptors. If using rolls check core adaptors are in position and a spare core is to hand if required. Hold film (wound emulsion in) with end coming off in a clockwise direction. Pass loose end of film through left channel of magazine and pull down a short length. Place roll or spool on spindle and re-set pressure roller.

Pass film end back into mag. through right channel and wind onto take-up spool or core in a clockwise direction (emulsion in). Secure firmly and wind on a few turns.

Arri 16M mags. incorporate film feed sprocket making it necessary to measure out sufficient film to form the correct size loop before threading film back into mag. and attaching to collapsible centre core. The 200ft. Arri M mag. has a hinged type lid. Once loaded, film may be tensioned by turning knobs on rear of mag. in contra-directions according to engraved arrows. After loading double check that mag. lid is securely closed and latch is turned to 'C' or 'Z' before exposing to light.

Attach take-up motor to rear of 16ST mags. before use and check that it is set to take-up in same forward/reverse direction as camera. Footage remaining indicator on the mags. does not operate with daylight loading spools.

Threading the camera

Remove or open camera door, remove aperture from top of 16ST if using mag. loading, open film gate and release pressure rollers below sprockets. Check aperture plate and film guides for cleanliness.

Place spool of film on top spindle of ST or attach magazine having passed loop of film through aperture. Inch camera until register pin is withdrawn and pull-down claw is half way down its stroke.

Hook film perf. onto register pin, close gate, thread film over and under sprocket rollers forming correct sized loops and close pressure rollers.

If using spool loading attach film to spool to take up emulsion-in in a clockwise direction.

Connect battery to camera, (and additional external earth (ground) to take-up motor) run a little film to check all is well, close camera door, run film to run out fogged section and check camera speed. Zero footage counter.

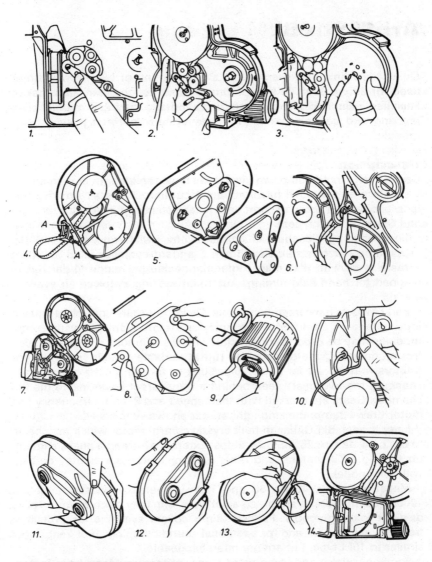

ARRI 16St AND 16M LOADING

1. Before loading check gate and pressure plate are clean. 2. Thread film in gate and close pressure rollers. 3. 16St camera with internal 100ft. daylight spools. 4. Daylight spools may also be used in 16St mag. A. Rubber light sealing strips (always check they are serviceable). 5. Before use, attach torque motor to 16St mag. 6. Method of passing film into 16St camera. 7. 16St film loading path with 400ft. (120m) rolls. 8. After loading, tighten loose film. 9. Check mag. and motor are set to correct direction. 10. Attach additional earth (ground) connection to 16St mag. torque motor. 11. Means of measuring loop length of 16M 400ft. (120m) mag. 12. Measuring loop length of 16M 200ft. (60m) mag. 13. 16M mag. preformed loop. 14. 16M film loading path.

Arriflex 16BL

Quiet, hand-held single or double system sound or wild 16mm camera used for all types of TV film production and documentary film making. Facilities include Pilotone generator, automatic start and manual scene marking and connections for a single system (com-mag) sync sound module.

Description

Cam driven single pull-down claw and single register pin movement.

Single port Arri steel bayonet lens mounting. Takes all Arri mounted lenses except for those of short back focal distance (principally wide angle and Cooke Kinetal types).

Fixed opening 180° shutter. Optimum 24fps HMI frequency 48 or 60Hz.

Spinning mirror reflex viewfinder. Standard eyepiece fixed at side of camera level with film plane. Interchangeable periscope finder recommended for hand-held filming. Automatic closing eyepiece an available extra.

Early models have interchangeable 12v DC governor controlled and various voltage AC 24 or 25fps synchronous motors. Various crystal control modules may be used in conjunction with the DC motor. By external control modules DC motors may be run at variable speeds from 5–50fps. (Motors may be set for 24 or 25fps/50Hz or for 24fps/60Hz operation by changing the two gears seen behind a transparent cover inside the film chamber. Gears are marked with their speed and Pilotone frequency.) DC motor draws 3amp. Blinking light at rear shows sync speed.

Later model, BLEQ, has in-built crystal control motor which may be set to 6, 12, 24, 48 or 6.25, 12.5, 25, 50fps. External sync and a phase shift unit for filming a TV monitor and other electronic accessories may be used with this model.

Magazines: 200, 400ft. (60 and 120m) reversible displacement and 1200ft. (360m) non-reversible co-axial type. Film may be core wound or on daylight loading spools. Padded blimp covers available for protection from the evironment and for additional sound blimping. 16BL mags. look similar to 16M type, but are not interchangeable.

Footage counter and tachometer at rear of camera. Mags. have footage remaining indicator which is correct for B & W filmstock. (10 per cent should be deducted for colour.)

TTL exposure meter is an optional extra.

Single system com-mag recording module and amplifier is an available accessory. Amplifier has manual control and automatic gain and inputs for two microphones. Sound advanced 28 frames.

Serial number engraved on camera right side.

ARRIFLEX 16BL

1. 16BL with 400ft. (120m) mag., periscope finder and zoom lens blimp. A. Blimp front release; B. Focus scale; C. Focus control; D. Zoom control; E. Aperture control; F. Lens blimp lock; G. Camera door lock; H. Viewfinder release.

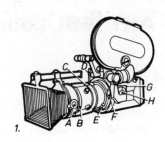

2. 16BL. A. Auto start mark indicator lamp; B. Operation indicator lamp; C. Manual start mark indicator lamp; D. Earphone jack; E. Manual start mark connection; F. Pilotone and auto start mark socket; G. Power connection; H. Forward/reverse switch; I. Footage counter reset; J. Footage counter; K. Tachometer; L. Inching knob; M. Sound amplifier connection; N. Focal plane indicator; O. Start button; P. Footage remaining.

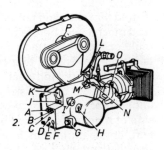

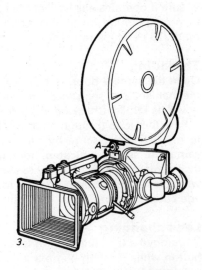

3. 16BL with standard viewfinder and 1200ft. mag. A. Mag. release. (Note 1200ft mag. once loaded, should not be laid on their sides during transporation and storage.)

4. 16BLEQ crystal control model. A. Switch for sync/pre-select/variable speeds; B. Speed for pre-select control; C. Footage counter reset; D. 'Off speed' warning; E. Electronic accessory socket; F. Emergency connector; G. Power socket.

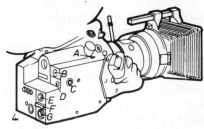

51

Arri 16BL Loading and Lens Changing

Magazine loading

Open mag. check inside is free of emulsion dust. Filmstock must be wound 'emulsion-in' and 'B' wound if single perf. Trim film end through centre of a sprocket hole and at right angles for ease of loading. If using rolls ensure core adaptors are in place, if using daylight loading spool wound films, remove mag. core adaptors.

Hold film with end coming off in clockwise direction and thread end into feed mechanism before placing roll on left spindle. Film may be wound on male or female slotted cores. A collapsible core is normally fitted on the take-up side. Ensure that core adaptors are left in mag. after use. Gently turning mag. driving gear will ease film through mag. throat.

Measure out correct size loop by laying film along outside edge of mag. until it reaches first of two marks (43 perfs.). It is then fed back into right side of mag. and secured onto take-up centre or spool in clockwise direction, emulsion in. Set footage indicator lever and roller. Close mag. lid securely and wind on a little film by turning mag. drive gear to take-up to ensure it operates easily. Tighten up any film slack. When loading film for com-mag 'sound on film' operation a longer loop measured to second mark (76 perfs.) is required.

Threading

Open the camera door, remove mag. aperture cover, open gate and inch mechanism until register pin is withdrawn and pull-down claw is half-way down its stroke. Check aperture for freedom from hairs etc.

Pass film loop through aperture. Place mag. on camera inclining gently to mesh gears. Secure by turning front knob clockwise, form loops in camera to size as indicated, hook film perf. onto register pin, close gate, inch camera, connect battery to camera and run a little film to check all is well. Close camera door and run to check or set camera speed. Zero footage counter. Never try to inch camera while it is running.

Lens changing

To remove a lens blimp, turn locking ring to 'lose' and push lens release button while rotating blimp anti-clockwise until it can be detached.

To attach set red dot on locking ring to 'lose', slide into camera (rotating clockwise slightly to engage zoom lens in steel bayonet mount) until a slight click is heard. Turn locking ring clockwise to 'fix'.

To fit a fixed focal length lens, open blimp front, remove filter holder, set focusing lever to infinity, swing out aperture drive, turn lens focusing ring to infinity, press button on side of camera, insert lens, engage focus drive in left lens focus ear, engage aperture drive. Insert holder with optical flat or filter and close front, attach aperture scale ring. To remove lens reverse above process.

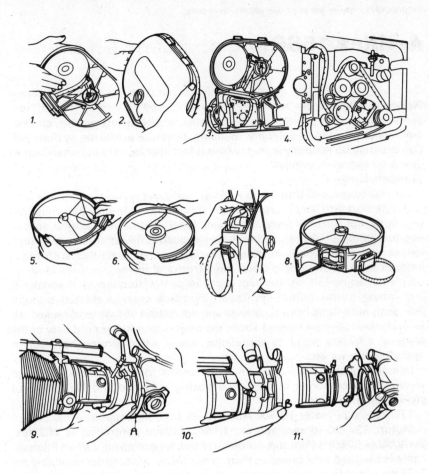

ARRI 16BL LOADING

1. Measuring loop length for silent or sep-mag. operation.
2. Measuring loop length for com-mag. loading.
3. Silent or sep-mag. loading path.
4. Com-mag loading path: A. recording heads.
5. 1200ft. (360m) mag. loading, measuring normal 36 perf. loop.
6. Measuring com-mag. loop.
7. Forming 19 perf. cross-over chamber loop.
8. Mag. loaded prior to closing cross-over chamber lid and replacing mag. cover.
9. To release zoom lens and blimp assembly, turn lock ring (A) anti-clockwise.
10. Press lens release button (B).
11. Remove lens directly outwards from camera.

Arriflex 16SR

Compact, lightweight, quiet, versatile camera for all types of 16mm filming. Facilities include an eyepiece which may be viewed from almost every conceivable position, built-in exposure measuring system, co-axial quick change mag. possibility of using time code marker system etc. Camera may be supplied with or without facilities for fully automatic servo operated exposure control.

Description

Multi-link single pull-down and register pin movement.

Single port Arri steel bayonet lens mounting. Takes all Arri mounted lenses except those of very short back focal length. Lenses with special aperture control linkage needed if auto-exposure device to be used. Such lenses cannot be used on other cameras. Lenses are fitted with focus indexes marked at 'three o'clock' seen from the front.

Fixed opening 180° shutter. Optimum 24fps HMI frequency, 48 and 60Hz.

Spinning mirror reflex viewfinder. Eyepiece may be rotated through 360° with automatic horizon orientation correction. It may also be swivelled outwards 25° and rotated about the optical axis to the right side of the camera, a facility which is sometimes useful when filming from car or aircraft windows etc.

Interchangeable fibre-optic viewing screen for all formats. Optional viewfinder accessories include auto-closing eyepiece and 9in. (225mm) viewfinder extension.

TTL exposure meter 16–500 ASA (13–28 DIN) film speeds.

Motor: 12v DC (draws approx. 1.1Ah). Crystal controlled at 24/25fps. Switchable 50/60Hz Pilotone, auto-start mark (operates only when Pilotone cable is plugged into camera). Plug-in electronic accessories available for 5–75fps variable speeds, sync to external source and phase control for filming a TV screen. Camera must not be used on a tripod head with a screw stud more than ¼in. (7mm) long.

Blinking light at camera rear indicates camera running (changes to a continuous light when out of sync).

Magazine: 400ft. (120m) co-axial quick change type. Footage/meterage shot counter and automatic footage remaining indicator on each mag.

Optional accessories include universal hand-grip with three position camera switch, (off, exposure control and camera run, may be set to exposure control only or exposure control and camera run). Standard hand-grip which has a camera run switch only (main camera switch must be set to exposure control) and auxiliary hand-grip which may be mounted on left side of camera, a mattebox of the bellows type suitable for all lenses including 8mm wide-angle and zoom, and a pan handle extension switch, (main camera switch must be put in exposure measuring position when this accessory is used), a camera balance plate for supporting heavy lenses, production type mattebox (takes 100mm.sq. filters), zoom control motor, TV viewfinder, underwater housing, etc.

ARRIFLEX 16SR

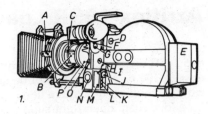
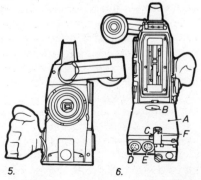

1. Arriflex 16SR with universal bellows mattebox, Zeiss Vario Sonnar 10–100mm T3.1 zoom lens, 'on-board' 12v 1.2A battery: A. Provision for 2 × 4in. sq. filters, rear one rotatable; B. Lens index mark; C. Focus grip; D. Footage exposed counter; E. Battery; F. Film speed setting; G. Fps setting for exposure meter; H. Manual inching slot; I. Electronic test (inching) button; J. Camera control lever 'off' position; K. Exposure measuring position; L. 'Run' position; M. Safety cover; N. Flange for left hand grip; O. Lens release; P. 'Manual/automatic' exposure control switch,

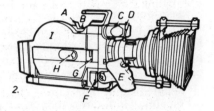

2. A. Mag. release lever; B. Mag. safety lock; C. Removable, adjustable eyepiece; D. Zoom lever; E. Standard hand-grip and camera 'run' button; F. Electronic connection for hand-grip 'run' button; G. Film plane mark and cover over full frame start marking lamp; H. Mag. cover lock; I. Film supply compartment.

3. Camera with Zeiss Vario Sonnar zoom lens, circular sunshade and viewfinder set on right side of camera. 4. Zeiss Vario Sonnar zoom lens showing auto-diaphragm operating plungers (A and B). Because of these plungers this lens may only be used on suitable SR cameras.

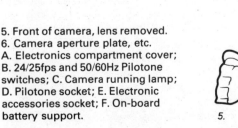

5. Front of camera, lens removed. 6. Camera aperture plate, etc. A. Electronics compartment cover; B. 24/25fps and 50/60Hz Pilotone switches; C. Camera running lamp; D. Pilotone socket; E. Electronic accessories socket; F. On-board battery support.

55

Arriflex 16SR Loading

Arri 16SR mags. may be loaded with up to 400ft. rolls of core wound film or with 100 or 200ft. spools of daylight loading filmstock which must be wound emulsion-in, double perf. or 'B' wound single perf.

To load mag. open right supply side of mag. (1), check for cleanliness, check core adaptor is in position if using core wound film, if necessary remove adaptor if using daylight loading film for first time. Swing guide (footage indicator) arm clear, (and in total darkness if using core wound) position film with end coming off anti-clockwise in direction of arrow.

Push loose end of film (which should be cut through centre of a perf.) into mag. feed slot until it emerges. The film should run very easily (2). Release and properly engage guide arm (core wound only), (3). Close lid and lock. If necessary remove exposed film from left side by releasing collapsible take-up core, and can-up. The remaining operations may be completed in the light.

Pull end of film down to loop length marker at base of mag. (4). Slide it down along curved guide in take-up slot until plastic drive gears start moving, (5). Turn drive gear in direction of arrow until sufficient film emerges to attach to take-up core or daylight loading spool (6). Wind on a few turns in a clockwise direction and tighten film by holding drive gear. If using core take-up, release film guide arm. Set footage exposed counter (13). Close lid and lock.

Slide centre of large film loop under retaining hooks (7), distributing an equal amount of film either side of the guide plate (8). Use loop protecting covers when mag. not on camera (9).

Attaching and removing the magazine from camera

Engage top of mag. into locating guide at top of camera, and hinge downwards until lock clicks into position (10). Move safety lever to lock position, press red 'test' knob on left side of camera to engage perforations (11).

To remove mag. move safety lever to open position, press release lever and lift rear of mag. upwards until it can be pulled out of locating guide and removed from camera body.

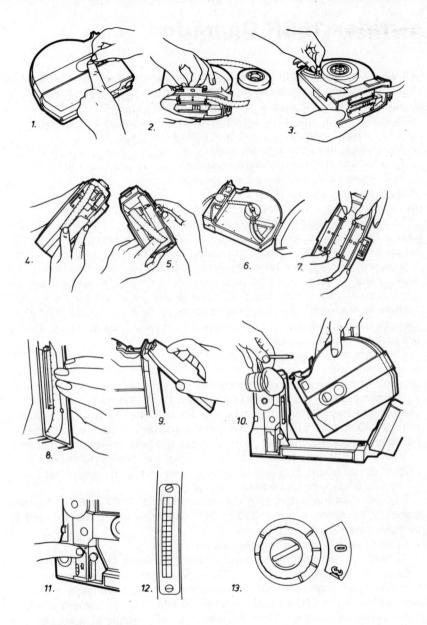

ARRI 16SR LOADING

1. Open mag. supply side. 2. Feed film through. 3. Reset film guide (rolls only). 4. Measure loop. 5. Form loop. 6. Attach end to take-up. 7. Slip film under clips. 8. Form equal size loops, 9. Attach loop protector. 10. Attach mag. to camera from top downwards. 11. Press test button to inch. 12. Footage (meterage) remaining indicator. 13. Footage (meterage) shot counter.

With a highly automated camera a cameraman can concentrate on content.

Arriflex 16SR Operation

To attach a steel bayonet mounted lens to camera, hold lens with white focus index line facing exposure meter, engage focus ear of fixed focal length lens, or an ear on the aperture control of a special zoom lens, into a slot in the driver ring (1A) which encircles the rear end of a lens. Push gently forward until seated and turn clockwise to secure.

To remove, turn lens anti-clockwise pressing right release button (1B).

To attach or remove standard mounted lenses press both buttons.

With power connected, camera stops with mirror in view position. To inch, press red button (12A) marked 'test'. To inch without power connected turn coin slotted knob (6A); fold out flap on later model.

To set TTL exposure meter to correct sensitivity set film speed ASA/DIN rating by turning upper knurled knob (2A) and to exposure by setting larger centre knob (2B) to camera speed (fps). For fully automatic exposure control with a lens equipped with automatic diaphragm control, press locking key (1P page 55), turn lens iris control ring to 'A' and set camera control switch to central position. Lens is always at full aperture when camera is stationary (for focusing) and stops down automatically when camera runs. Exposure can be returned to manual operation by turning iris ring to required aperture.

The standard (5) hand-grip (optional) has a start/stop switch only (5A) and is preferable for use with lenses not equipped with auto-diaphragm control (when using main camera switch must be set to central position).

The camera may be powered by a small 12v 1.2Ah battery attached to the camera base behind the mag. (7). These batteries will run approximately 2400ft. (720m) in warm conditions and less in cold, when aged or not fully or recently charged. Normal capacity 12v batteries may be used.

10amp fuse of early models located in electronic compartment at rear of printed circuit board, (10) and on later models on top of camera base with 10 and 0.75A spares embedded in cover.

Five-pin Pilotone outlet plug (7A) is connected; 1, 50 or 60Hz Pilotone signal, 2, common ground, 3, 12v DC positive, 4 and 5 are bridged to complete start mark lamp circuit.

Camera switch has three positions viz:

'O' (12B) ... all systems off, auto-diaphragm lenses set to full aperture.

Exposure measuring (12C) ... TTL exposure meter on, lenses may be stopped down manually and auto-diaphragm lenses will stop automatically according to TTL exposure reading. Start (12D) ... camera will run.

An overload switch (12F) disconnects power supply if load exceeds 4.5amp, re-sets automatically after a few seconds if cause removed.

The universal hand-grip (4) (optional extra) has three position plunger type switch (4A) which operates in a similar manner or may be pre-set to switch to exposure control and start or to exposure meter only. To remove, switches on equipment must be set completely to 'off'.

To remove, grip must be set to 'off'.

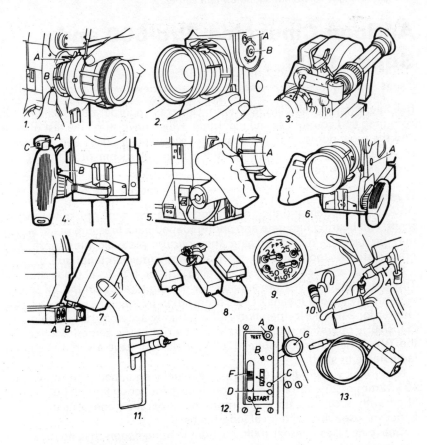

ARRIFLEX 16SR OPERATION

1. Removing Arri bayonet mounted lens. A. Aperture control in slot of driver ring. B. Release button. 2. Removing Arri standard mounted lens — two release buttons are pressed. A. Film speed setting; B. Fps setting.
3. Extension viewfinder for use when camera is tripod or dolly mounted.
4. Universal hand-grip. A. three-position release; B. Lock to restrict plunger when using lens which does not have automatic diaphragm; C. Pivoted lever on underside may be rotated to make control operate exposure control and automatic diaphragm only. 5. Standard hand-grip: A. 'Start/stop' button. Note lever of lenses with auto-diaphragm must be set to 'close' if this handle is used. 6. Auxiliary hand-grip on left side. A. Manual inching slot or D ring.
7. On-board battery mounting. A. Pilotone socket; B. Accessories socket.
8. Charging system for two batteries. 9. Method of selecting crystal speed and Pilotone output modes. 10. Fuse (A) at rear of electronics panel near power connector. 11. Removing start mark lamp. 12. Main camera switch.
A. Electronic inching button, B. Off position; C. Measure exposure position; D. Start position; E. Electronic overload switch; F. Switch travel restriction for use with lenses not equipped with auto-diaphragm; G. Camera run control.
13. Electronic accessory which plugs into rear of camera, and fits on to pan handle. Available accessories include remote control switch, variable speed control, external sync, phase control and multiple camera operation/remote control.

The 'grand-daddy' of 16mm sound-on-film cameras.

Auricon Cinevoice, Pro-600 and Super 1200

Reliable, rugged, self-blimped 16mm cameras, incorporating facilities for com-mag and com-opt sound recording, which have stood the test of time and the most demanding newsreel use. Mechanism plates and recorders of Auricon origin or design form the basic elements of many 16mm cameras sold under other labels.

Description

All Auricon models and their derivations have the same pull-down movement, ball bearing film gate and spring-loaded back pressure plate, which may be easily removed for gate and aperture plate cleaning. (Use only orange stick or tooth pick etc. to clean away emulsion build-up.)

Standard cameras have fixed opening 173° or 175° focal plane shutter. Those designated TV–T are suitable for filming directly off the TV screen without any special means of synchronisation by having a very exact 144° shutter for 24fps/60Hz operation and a similarly accurate 180° opening for 25fps/50Hz operation (the camera must be run at the same frequency as the TV). Certain Auricon Super 1200 models may have a variable shutter (adjustable in shot).

Non-reflex viewfinding. Cameras are usually equipped with Angenieux 10 x 12mm or 20 x 12mm reflex zoom lenses for action filming but may be fitted with a camera door incorporating a parallax compensating side finder for use with fixed focal length lenses.

Cinevoice takes internal 100ft. daylight loading spools, has no means of eye-focusing lenses. Pro-600 takes 400 or 600ft. external magazines, may have a facility to swing lens turret 180° to a ground glass focusing position. Super 1200 takes 400, 600 or 1200ft. magazines, has facility for interposing a ground glass focusing screen between lens and film plane to check focus. (Necessary to use 3in. cores on take-up side of 1200ft. magazines.)

Cameras in original state have 110 or 220v 60 or 50Hz AC synchronous motors which may be operated either directly off the mains supply or from a battery via a suitable power pack which converts 12v DC to 110v AC.

Cinevoice models modified to take 400ft. (120m) external magazines may have a governed speed motor and run off 12v DC.

Footage shot counters at rear of 600 and 1200 models.

Certain models have built-in thermostatic controlled internal heaters.

All cameras may be equipped for com-mag sound recording by plugging a 'Filmmagnetic' sound recording and monitor head into the camera body and using a companion amplifier.

All models have several oil holes (outlined in red) in the camera body and magazines which should be attended to frequently.

Serial number and TVT shutter information on plate at rear of camera.

See CP-16 Loading and Operating page 98 for further information.

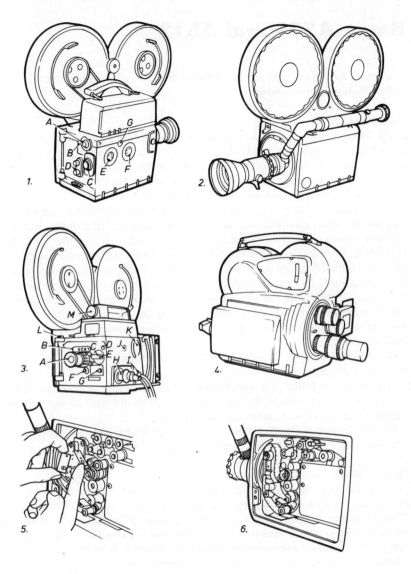

AURICONS

1. Auricon Pro-600. A. Camera running lamp; B. Footage and frame counter; C. Voltmeter; D. 'On/off' switch; E. Power socket; F. Sound socket; G. Power on lamp. 2. Pro-600 with Angenieux 10 × 12 mm, (12–120 mm) f 2.2 reflex zoom lens. 3. Auricon 1200. A. Focusing eyepiece; B. Footage and frame counter; C. Rack over bar; D. Off button; E. On button; F. Power lamps; G. Shutter clear plunger; H. Sound connector; I. Power connector; J. Optional monitor jack; K. Shutter adjustment knob; L. Buckle trip; M. Camera running warning or voltmeter. 4. Auricon Cinevoice. 5. Removing gate pressure plate from Pro-600. 6. Threading path Pro-600, Filmagnetic mode.

Bauer A508 and A512

Intelligent cameras incorporating many features not available on professional 16 and 35mm cameras.

Description

A508 fitted with non-interchangeable Bauer Macro-Neovaron f1.8 7.5–60mm 8 : 1 zoom lens, A512 fitted with non-interchangeable Schneider Macro-Variogon f1.8 6–70mm 12 : 1 zooms lens. Otherwise the cameras are similar. Both lenses have a macro focusing facility to focus to zero range. Two-speed power zoom with manual override.

TTL exposure control, aperture setting shows in bottom of viewfinder. To operate aperture manually open flap at front top of camera and turn knurled wheel according to scale seen in viewfinder. Centre knob and close flap to restore automatic exposure. Additionally (when both the camera and subject are absolutely stationary) camera may be set to give aperture priority to exposure, automatically adjusting the exposure period (1/10 sec. – 1 min.) as necessary. A booster exposure meter (2E) swings out from camera left side for use in extremely low ambient light conditions (take care not to swing out in bright conditions or inaccurate readings will follow).

Continuous running 12, 18, 24 or 25fps, automatic single shot adjustable 6fps to 1fpm. Reverse running possible at any speed, max. duration 90 frames (5 sec. at 18fps, 3¾ sec. at 24fps). A 150° shutter adjustable to zero in shot to give automatic fade out, fade in, dissolve and to compensate exposure for double exposure shooting, etc.

Pelicle (beam splitter) reflex viewfinding. Light loss one-third stop. Incorporates a light blue tint to make image appear brighter.

Operation

For normal running (shutter full open) set both white dots (2R and S) to green dot. To fade out manually (with camera running) lift and turn knob 2S (max. 5sec. at 18fps, 3¾sec. at 24fps), camera will stop automatically when shutter closed. Press button 2Q briefly to release. For automatic fade out (with camera running) press button 2R until it starts turning and release.

For automatic fade in (after automatic fade out) press camera release followed by knob 2R. To dissolve two scenes automatically, fade out as above, release switch 2Q, slide rewind button 2N until camera stops, fade in as before. Note do not fade in first and last 3ft. (1m) of cartridge loading.

Manual dissolves, double exposures, superimpositions and limited (90 frames) reverse running, etc. are also possible (cap lens when rewinding). A red light shows in viewfinder when shutter is not fully opened.

Camera hand grip twists to forward position for tripod mounting.
Always switch power off (2G) when camera not in use.

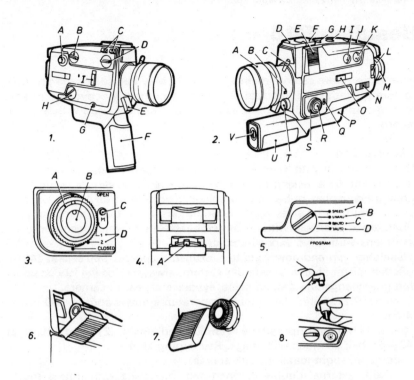

BAUER A508 AND A512

1. A. Intervalometer control; B. Fps control; C. Power zoom controls;
D. Zoom speed control; E. Camera run switch; F. Hand-grip in handhold
position; G. Electric remote release socket; H. Operating mode selector;
I. Filter selector. 2. A. Focus; B. Macro control, C. Manual zoom control;
D. Lamp fixing point; E. Booster exposure cell; F. Manual aperture control
cover; G. Power switch (switch off when camera not in use); H. 54 fps switch;
I. Footage counter; J. Film compartment release; K. Sync socket; L. Ocular
adjustment; M. Eyepiece; N. Rewind control; O. Eyepiece shutter; P. Battery
compartment; Q. Automatic frame counter erase; R. Automatic fade button;
S. Manual fade button; T. Scene length pre-selector for automatic time
exposure; U. Hand-grip in tripod position; V. Battery release.

3. A. Rotate for manual fades; B. Push for automatic fades; C. Push to erase
automatic frame counter; D. Shutter position indications (1 = ½ open, 2 = ¼
open). (All seen in normal run position). 4. A. Manual aperture control.
5. System programme mode selector. A. 'Speed', setting for normal
operation; B. '1/Man' setting for manual single frame operation, (use electric
remote cable into socket 1G); C. 'B/Auto', setting for automatic exposure
single frame, (set scene length pre-selector (2T) to required scene length,
swing out booster cell (2E) before setting to 'B/Auto'; D. '1/Auto' setting for
automatic time lapse operation. Set intervalometer (1A) to required framing
rate, may be used in conjunction with electonic flash. Note after using any of
the above special facilities always set mode selector back to 'speed' for
normal use. 6. Booster exposure meter cell (2E) swung out. 7. A. Camera run
switch (1E); B. Scene length pre-selector (2T). 8. Method of connection flash
synchronisation cable to sync sound socket by means of an adaptor.

A particularly handy, lightweight 16mm camera.

Beaulieu R16

A versatile 16mm camera mainly used wild. May be used as the principal camera for industrial, medical and other documentary coverage or as a second camera to a larger and heavier quiet camera used with a sound recorder.

Description

Three-lens turret with 'C' mounts set closely together, may be secured in one position by a locking screw when a single heavy lens is mounted. A strengthening plate or a single port plate incorporating an Arriflex or other lens mount may be screwed through the turret into the camera body.

Camera is available with a non-removable front which incorporates a zoom lens with servo exposure control.

Guillotine (up and down) shutter. Exposure approx. 1/60 sec. at 24fps.

Reflex mirror shutter viewfinder system, always stops in view position. Non-interchangeable ground glass, eyepiece at rear of camera.

Internal 7.2v motor. At normal temperatures draws approx. 600 mA at 24 fps.

0.5 & 1Ah hand grip batteries run 600 and 1600ft. (210 and 470m), at 24/25fps, half as much with mags. Recharging 15 hrs.

Internal daylight loading 100ft. spools.

A 200ft. external double compartment magazine with torque motor take-up drive which takes daylight loading film may be mounted on top of camera in a position which is adjustable to suit shape of cameraman's head to give additional camera steadiness.

Footage and frame counters on camera, used with internal loading, shows film used in feet and metres. Counter on mag. shows film remaining.

When camera speed set to '24/25fps' left (green) dot at top of tachometer scale indicates 24fps, right (red) 25fps. When switched to 2–64' lower dots indicate 8, 16, 25, 32, 48 and 64fps speeds.

Camera may be run in reverse with internally loaded film only. TTL exposure meter. Single shot capability. Provision for remote release. Camera features include battery charge test meter, master switch, hand grip incorporating small or large capacity batteries.

Serial number engraved either underneath camera (may be hidden by handgrip) or inside behind gate.

Pilotone signal generator may be attached for sep-mag recording.

Dos and don'ts

To check state of battery set master switch to 'control', set filming speed switch to 2–64fps, press power supply switch and release button. Battery is fully charged if indicator needle in red zone after 30 sec.

Don't run camera without film faster than 32fps.

When shooting single frame never put release cable in continuous filming position and don't run camera in reverse.

64

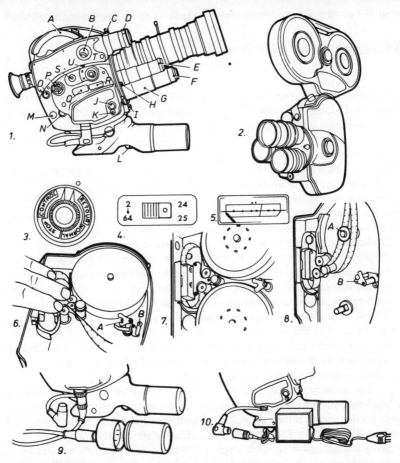

BEAULIEU R16

1. R16 with Agenieux 10 × 12 12–120 mm f 2.2 power-zoom lens: A. Mag. aperture cover; B. Exposure meter setting dial; C. Power zoom control button; D. Power zoom speed control; E. Power zoom 'on/off' switch; F. Exposure auto/semi automatic (manual) switch; G. Reglomatic automatic diaphragm control; H. Fast zoom and full aperture for focus control; I. Camera start/stop button and cable release position; J. Sync pulse generator socket; K. Single shot release; L. Power supply on/off switch; M. Frame counter; N. Frame counter reset; O. Footage counter; P. Master control switch; Q. Speed range switch; R. Fps indicator; S. Remote control socket; T. Fps lock. 2. R16 with fixed focal length lenses and 200ft. (60m) spool-loading magazine. 3. Master switch: set to 'control' to check battery state, to 'stop' when camera not in use, to 'normal' for forward run and 'retour' for reverse. 4. Film speed range switch: set 2–64 for variable speeds and to 24/25 for sync speeds. 5. Tachometer. 6. Method of loading camera by pressing film onto sprocket while starting camera. A. 100ft. (30m) footage counter reset fork in normal position, B. Footage counter reset disconnecting knob in stowed position. 7. Correct film path for 100ft. (30m) loadings. 8. Film path for mag. loaded film. A. Feed roller placed over top spindle; B. 100ft. footage counter reset mechanism disengaged by knob. 9. Method of connecting battery to camera by use of extension cable (spare battery or dummy in position for use as hand-grip). 10. Method of connecting battery for charging. Note correct charger must be used to suit particular battery capacity.

Beaulieu 'News 16'

A compact, double or single system 16mm camera suitable for exterior news and similar coverage. Incorporates semi-automatic loading, exposure, recording and other systems which make it simple to use.

Description

Single 'C' interchangeable lens mount. Camera usually fitted with either an Angenieux 6 x 9.5mm or 10 x 12mm zoom lens fitted with TTL fully automatic or semi-automatic exposure control and finger tip operated electric zoom control. A pre-focus control sets zoom lens to maximum focal length and maximum aperture for focusing before shooting.

Guillotine (up and down) shutter. Exposure approx 1/60sec. at 24fps.

Reflex mirror shutter viewfinder system always stops in view position.

Eyepiece rotates 180°, left eye viewfinder extension and screw-in eyecups are optional extras.

Non-interchangeable ground glass displays normal and TV markings.

Interchangeable motors: standard type (S) is governor controlled at 24 or 25fps or variable 12–40fps. Type 'C' is crystal controlled at 24 or 25fps (a module must be changed to change the speed) or variable 12–40fps. (Not recommended for use when shooting single system sound.)

Interchangeable sound mode modules may be fitted as required: *Single system* (com-mag) recording to be used in conjunction with associated sound recording equipment, *Double system* (sep-mag) which may be used with either type S or C motor with sync marking and Pilotone output (24fps/60Hz, 25fps/50Hz and 25fps/100Hz models available), *Crystal control* for use with type 'C' motor (24 and 25fps models available) sync marking if required, and *Silent* which has no additional facilities.

Daylight loading 200ft. (60m) spools located co-axially in camera body.

Internal 9.6v 1.2Ah battery packs run approx. 6–8 rolls of film at 24fps when fully charged, in good condition and warm. Less time may be expected when running single system sound than when silent and less still with a sync (crystal) motor. An extension cable and adaptor are available to enable the battery to be carried separately from the camera (for keeping it warm). A high speed charger is available which re-charges to 80 per cent in 40 mins. and thereafter at a slower rate. A DC/DC charger is also available for charging off a 12v car or boat battery.

Footage indicator in feet and metres shows film remaining. Camera running indicator on top of camera switches off when film runs out, may be switched off manually by switch below lamp on right side. Warning lamps in viewfinder lights when 25 sec. of film remains. Camera may be fitted with a single system com-mag sound recording module to be used in conjunction with associated recording equipment.

Serial number engraved underneath camera body.

1. Beaulieu News 16. A. Power zoom manual override knob; B. Automatic diaphragm cut-out knob; C. Footage counter; D. Power supply switch (under);

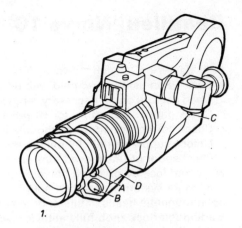

1.

2. A. Interchangeable battery; B. External power and remote control socket; C. Earphone jack; D. Camera to sound connection; E. Control panel cover; F. Sound recording modes switch; G. Camera running light; H. Auto-diaphragm cut-out switch; I. Accessory shoe; J. Indicator light on/off switch; K. Camera run switch; L. Power zoom controls; M. Interchangeable motor.

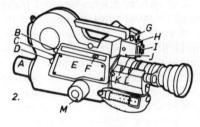

2.

3. Control panel. A. Film speed setting dial; B. Battery check button; C. Bias check button; D. Bias adjustment; E. Two scale tachometer; F. Speed range switch; G. Fps control.

3.

4. Com-mag amplifier. A. Mic-1 volume control; B. Frequency range selector switch; C. Line in-put volume control; D. Direct monitor switch; E. VU meter; F. Battery test button; G. 'On/off' switch; H. VU button; I. Mic-2 volume control; J. Recording level control; K. Manual/auto record mode switch; L. Connection to camera socket; M. Mic-1 input socket; N. Line input socket; O. Mic-2 input socket; P. Headphone jack.

4.

Beaulieu 'News 16' Operation

Pull 'power-on' switch down to 'on' position when loading or using a tripod. When using hand-held web of thumb will push switch up to 'on'.
Open camera and if necessary remove and can-up exposed roll of film.
Check gate and aperture for cleanliness and freedom from hairs.
Check correct sound mode module is fitted for type of filming.
Unlock supply spindle by pulling take-up spindle outwards.
Place spool of unexposed film on spindle (with film coming off clockwise) and lock by pressing down on outside of take-up spindle.
If single system (com-mag) sound system module fitted press arm to open magnetic heads. If silent, or any double system module fitted, turn loading interlock knob fully anti-clockwise.
Cut film end with internal trimmer and offer into upper guide. Press loading lever towards position '1'. Camera will run and film self-thread.
If single system sound module fitted continue to press loading lever until film appears out of upper sprocket or in any other mode until it appears out of guide roller. Keep camera running until there is an 18in. (500mm) loose end of film, release loading lever to stop camera.
Turn upper sprocket clockwise until it clicks once.
If in single system mode open lower sprocket film guide and thread film as diagram. Close lower sprocket film guide. Turn lower sprocket clockwise until damping roller is lined up with curved line engraved on module plate. Close magnetic head pressure arm.
If silent mode or double system thread film under rollers and turn loading interlock knob fully clockwise.
Insert end of film into take-up spool which revolves in a clockwise direction. Fit spool on spindle, run a little film to check all is well. Make sure take-up spindle (red dot) is pushed in, that footage counter automatically re-sets to 200ft. (60m) and replace camera door.
Run through fogged end of film checking camera speed by tachometer and battery condition under load by pressing battery check button (needle of tachometer should be on or beyond red mark).
Check, and if necessary, reset film speed dial to correct ASA rating.
Re-set camera power switch to central 'off' position.

Single system sound
The companion Beaulieu amplifier is used to record com-mag sound. Before use, check single system sound module is in position, that camera is loaded with mag. striped film stock, that amplifier is charged with 9 x 1.5v penlite batteries in a good state of charge (VU meter must display in red area when battery test button is pressed) and that all necessary cables, microphones and headsets are connected.

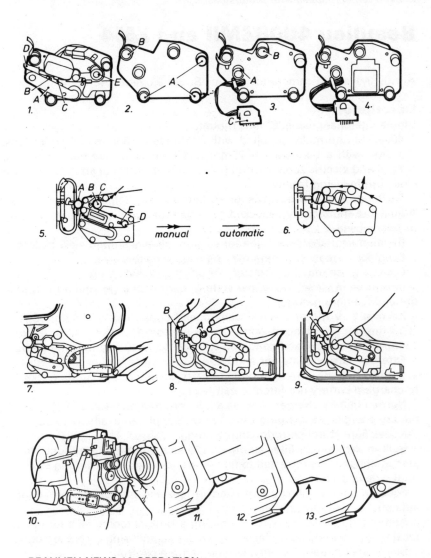

BEAULIEU NEWS 16 OPERATION

1. Com-mag module. A. Magnetic heads pressure arm; B. Recording heads; C. Monitoring head; D. Guide; E. Pressure roller. 2. Silent module. A. Attachment screws (same on all modules); B. Guide roller (same on all modules). 3. Pilotone module. A. Loading interlock knob (same on crystal module); B. Roller (same on crystal module); C. 8 pin connector (same on crystal module). 4. Crystal module. 5. Com-mag loading path. A. Upper sprocket; B. Lower sprocket; C. Lower sprocket film guide; D. Damping roller; E. Damping roller tension mark. 6. Silent loading path. 7. Trim film end. 8. Insert film into upper guide (A), press loading lever (B). 9. Turn upper sprocket 1 click stop (A). 10. Method of hand-holding the camera. 11. Power switch 'off'. 12. Power switch 'on' when hand-holding. 13. Power switch 'on' when on tripod.

Beaulieu 4008ZMII and ZM4

A most advanced camera for serious Super 8 cinematography.

Description
Single interchangeable 'C' lens mount.

4008 ZMII normally supplied with Schneider 6–66mm f1.8 zoom lens, the ZM4 with a Schneider 6–70mm f1.4 both with automatic exposure control and electric zoom control (with manual override) and macro (ultra close-up) focusing facility.

Guillotine (up and down) shutter. Exposure at 24fps approx 1/84 sec. Adjustable shutter may be locked half open for double exposure shooting or fully closed.

Reflex mirror shutter viewfinder system, always stop in view position.

Eyepiece at rear of camera may be used by either eye.

Ground glass may be retracted for brighter viewfinding.

Indicators in viewfinder show state of battery charge, optimum exposure and 'camera running'.

Integral 7.2v motor electronically speed controlled 2–70/80fps. Speed regulator has click stop at 24fps. Draws approx. 400mA at 24fps. Integral 250mAh battery in good condition will run up to 10 cartridges at 24fps.

External battery container and battery to camera lead available for use in cold conditions when desirable to carry battery in operator's pocket or to charge a battery not fitted to camera.

Normal battery charger charges a fully discharged battery in 15 hrs. DC battery charger for charging off a 12v DC supply an available extra.

Kodak 50ft. (15m) cartridge film loading.

Built-in Wratten 85 filter automatically sets when artificial light film is loaded and may be retracted to film in artificial light by inserting key into right side of pistol grip.

Footage counter shows film used in feet and metres. Frame counter indicates 1–100 frames elapsed.

Automatic pre-focus control (pressing a button zooms lens to longest focal length and maximum aperture for critical focusing before shooting.)

Single shot capability, provision for remote control.

Rewind handle for double exposure and dissolve shots and a sync pulse generator (for double system sound recording) may be fitted to camera.

Macro stage slide/title card holder available for close-up filming.

Serial number engraved inside film compartment door.

Dos and don'ts
Never run a camera faster than 24fps without film.

To check battery charge, set master switch to test and press power switch. Needle in viewfinder should be above index notch after 20sec.

When shooting single frame never put release cable in continuous filming position and don't run camera in reverse.

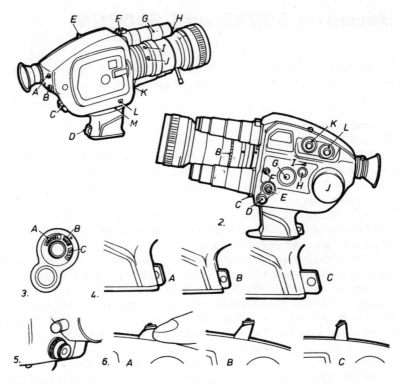

BEAULIEU 4008

1. A. Battery charging socket; B. Remote control socket; C. Tape recorder start/stop socket; D. Power supply switch; E. Variable shutter control; F. Power zoom control switches; G. Zoom motor; H. Zoom speed control; I. Macro zoom control; J. Zoom range limit knob; K. Fast zoom and full aperture for focus control, L. Single frame release; M. Artificial light filter-slot.

2. A. Automatic exposure motor; B. Manual aperture control; C. Start/stop button and cable release socket; D. Sync sound socket; E. Master switch; F. Focusing screen retracting control; G. Frame counter; H. Footage counter; I. Film wind locking button; J. Battery; K. Film speed setting control; L. Fps selector.

3. Master switch set to: A. Manual for manual exposure control; B. Auto for automatic servo control with suitable lens; C. Test to check battery charge.

4. Power supply switch. A. Normal position, press with palm of hand for normal hand-held shooting (note, power switch should not be used as a camera 'on/off' switch); B. Pull out slightly to lock off for travelling; C. Pull fully out for remote control and tripod operations.

5. Release button. Press to run camera, press and turn 90° right to lock on.

6. Variable shutter control. A. Move forwards to close, rearwards to open; B. Half open position; C. Fully closed.

The most professional Super 8 sound-on-film camera.

Beaulieu 5008S and 5008SM

A sophisticated Super 8 camera with facilities for recording com-mag sound. Model SM has multi-speed capability in either sound or silent mode.

Description

Single 'C' interchangeable lens mount.

5008S normally supplied with Schneider 6–66mm *f*1.8 zoom lens, SM with Schneider 6–70mm *f*1.4 both fitted with automatic exposure control (with manual override), electric zoom control and macro (ultra close-up) focusing facility.

Guillotine (up and down) shutter. Exposure approx 1/60 sec. at 24fps.

Reflex mirror shutter viewfinder system with eyepiece at rear of camera which may be used with either eye.

Ground glass may be retracted from viewfinder for brighter viewing (without ground glass focusing facility, focus may be set by scale only).

Integral 7.2v motor. 18/24fps or 8/18/24/45fps depending upon model.

Integral 500mAh battery runs 10–15 cartridges when recording sound and 13–18 when running silent. External battery container and battery to camera lead available for use in cold conditions when desirable to carry battery in operator's pocket or to charge a battery not fitted to camera.

Normal battery charger re-charges batteries in 15hrs., quick charge model charges to 80 per cent capacity in 3hrs. and thereafter at normal rate. DC/DC charger re-charges off 12v DC supply in 10hrs.

Kodak 50ft. (15m) pre-stripe sound or silent cartridge film loading.

Re-wind handle for double exposure shots. (Note this facility may only be used with sound film cartridges and for not more than 100 frames.)

Built-in Wratten 85 filter must be set manually when artificial light film is used for filming by daylight and retracted when shooting by artificial light.

Footage counter in feet or metres shows film remaining.

Automatic or manual-gain control sound recording. DIN standard 5 pin plug for mike and low or high level 'line' inputs. Normal microphone is 50–5000 ohm impedance omnidirectional. A unidirectional microphone is an optional extra. Sound will not operate when film not loaded.

Earphone socket (hears sound as it is recorded, not as playback).

A sound mixer box with two microphone inputs is an optional extra.

Additional extras include sync pulse generator (for sep-mag recording) timer for 0.36–2fps time lapse cinematography and single frame release.

Serial number engraved inside film compartment door.

Dos and don'ts

To run camera press power supply switch (3) followed by the start button (16). Switch off camera before releasing power supply switch. When using camera on a tripod pull power switch fully down to set permanently 'on'.

Check and if necessary, clean aperture plate after each film.

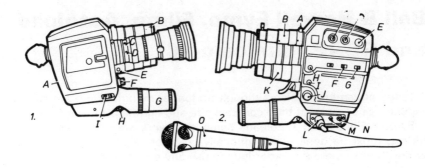

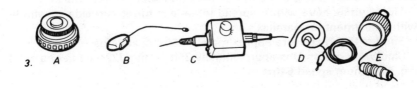

BEAULIEU 5008 MULTISPEED

1. A. Footage counter; B. Zoom speed control; C. Macro knob; D. Zoom range limit switch; E. Fast zoom and full aperture for focus control; F. Start/stop switch; G. Battery; H. Power supply switch (see Beaulieu R16); I. Built-in filter control.

2. A. power zoom control buttons; B. Power zoom servo motor; C. Film speed setting dial; D. Exposure control knob; E. Manual sound volume control; F. Viewfinder needle function switch (exposure/sound level); G. Auto/manual sound lever switch; H. Focusing screen control knob; I. Fps control (multispeed model only); J. Double system sound sync socket; K. Reglomatic automatic exposure control system; L. Sound input socket; M. Remote control socket; N. Earphone socket; O. Unidirectional microphone.

3. Available accessories. A. Rewind knob; B. Remote release; C. Sound mixing box; D. Earphone; E. Sync-pilot generator.

4. Available chargers. A. Standard 50mA, 15hr. recharge time; B. Fast, charges to 80 per cent capacity in 3hrs.; C. DC/DC type.

Bell & Howell Eymo, Filmo, Autoload and GSAP (Minicam-16)

A range of cameras which although no longer manufactured are still in regular use because of their compact size and lightness of weight.

Eymos, Filmos and Autoloads being clockwork are often used when filming must be done in exceptionally cold conditions, or in explosive atmospheres where it is hazardous to use any electrical apparatus.

Bell & Howell Eymo

Takes 100ft. of 35mm film wound on type H daylight loading spools. Certain models take electric motor drive and 400ft. (120m) mags.

Most Eymos have widely spread three-lens turret and side viewfinder with adjustment for parallax.

Shutter 150°. Exposure approximately 1/60sec. at 24fps.

Clockwork motor runs approximately 35ft. of film (22sec.) at one winding. Maximum speed 64fps.

Bell & Howell Filmo

Takes 100ft. daylight loading spools of 16mm film.

Cameras pre No. 154601 had 216° shutter, later 204° (approx 1/40sec.).

Bell & Howell GSAP (Minicam-16)

Cameras made for military purposes and now available known as Minicam-16. Much used for point-of-view filming, attached to crash helmets, missiles, space rockets, skis, racing cars, hang gliders, horses etc.

Shutter; 120°. Exposure 1/72sec. at 24fps.

Operates off 24v DC, draws 900mA, may be run at 24 or 50fps. Uses Kodak 50ft. cartridge loaded film (most types of colour negative and reversal film are available) and being comparatively inexpensive may be considered to be 'disposable' if the shot warrants the cost.

Cameras may be attached to objects by four lugs on the left side, 3in. apart in the horizontal direction, 2¾in. vertically.

Available with 'C' or Arriflex type lens mountings.

Check mag. compartment door latch is effective or film may not pass through camera. If dubious, remove lens, mark film and run to check.

Accurate line-up accomplished by boresight accessory.

Bell & Howell Autoload

Lightweight, simple to use, controls which can be used with gloved hands, a clockwork motor drive which will operate in the coldest climes on and off earth, make the Autoload the automatic choice for use under the most adverse conditions. Uses 50ft. (15m) 16mm cartridge loading film which may be changed without lacing or handling the film.

Some models have a single lens, others a two-lens turret.

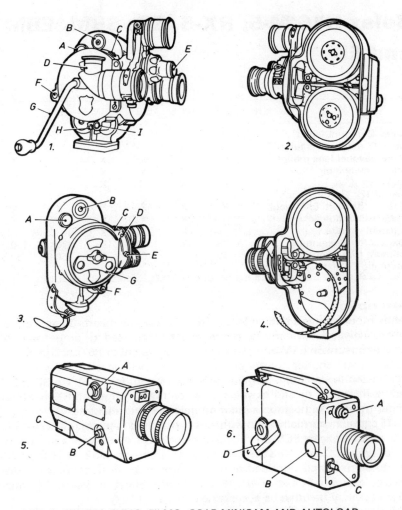

BELL & HOWELL EYMO, FILMO, GSAP MINICAM AND AUTOLOAD

1 & 2. Bell & Howell Eymo. A. Fps setting dial; B. Footage exposed indicator; C. Exposure calculator; D. Focusing eyepiece; E. Turret release lock; F. Motor drive support; G. Winding handle (removed while shooting); H. Start/stop switch; I. Motor drive socket.

3 & 4 Bell & Howell Filmo. A. Fps setting dial; B. Footage shot indicator; C. 'Start/stop' release; D. Turret release; E. Focusing eyepiece; F. Motor drive socket; G. Ratchet winding handle.

5. Bell & Howell GSAP Minicam. A. Fps setting; B. Footage shot indicator and reset; C. 24V DC socket (under).

6. Bell & Howell Auto-load (single-lens version). A. Viewfinder objective; B. Fps control; C. 'Stop/start' switch (here extended for use with thick gloves); D. Clockwork drive winder.

Bolex H16 M-5, RX-5, SB, SBM, EBM and EL

H16	M-5	RX-5	SB	SBM	EBM	EL
Single 'C' mount lens	X					
Triple 'C' mount lens turret		X				
Single bayonet lens mount			X	X	X	X
Reflex viewfinding		X	X	X	X	X
Clockwork drive	X	X	X	X		
Integral 12v electric motor					X	X
Adapted for 400ft. EXT mag.	X	X	X		X	X
Gelatine filter holder		X	X	X	X	X
Adjustable shutter		X	X	X		
Max. shutter opening (°)	133	133	133	133	170	170
Optimum HMI frequency (Hz)	65	65	65	65	50.8	50.8
Automatic TTL exposure control						X

Description

Reflex models have a behind lens prism block which diverts 35 per cent of light to viewfinder system. Exposure must be increased to compensate. At 24fps exposure on EBM and EL models is equivalent to 1/67 sec. on others 1/80sec. (with shutter quarter closed 1/112sec. half closed 1/188 sec.)

Provision for behind lens gelatine filters (except for M–5). On SB, SBM and EL filter may be slid to one side when not required, on RX–5 a filter holder must be in position even if no gelatine filter required.

H16 cameras normally used with lenses matched to prism reflex system.

All models except EBM and EL have a clockwork motor with a maximum run of approx. 28sec. and pre-setting camera speeds of 12, 16, 18, 24, 32, 48 and 64fps, single shot and time exposure. A 12v electric motor (ESM) electronically controlled at 10, 18, 24, 25 and 50fps or a wild 12–15fps EN motor may be fitted as accessories.

Models EBM and EL have integral 12v electric motor with the same pre-setting speeds as above. Electric motors may be fitted with crystal speed control and sync pulse generators.

All models may be rewound in the 100ft. loading mode.

All cameras take 100ft. spool loadings internally some are also adapted to take external mags. which may be loaded with 400ft. rolls or 100ft. or 200ft. spools. All models have an accessory shoe to hold an exposure meter.

Footage and frames (not on EBM,) elapsed counters on side of camera.

Optional accessories include bellows sunshade, hand-grip, clip-on exposure meter, automatic fader, side viewfinder, sound barney, under-water housing, intervalometer, electric motors for clockwork models etc.

Serial numbers engraved on underside of camera alongside tripod bush.

BOLEX

Bolex H16 M5 with Sopelem pan cinor 85 17–85 mm f2: Reflex zoom lens.
1. A. Attachment point for 400 ft mag.; B. Clockwork motor disengage; C. Footage counter; D. Spring motor wind handle; E. Accessory attachment point; F. Frame counter; G. Film rewind shaft; H. Electric motor drive shaft; I. Variable shutter control; J. Instantaneous/time exposure control; K. Frames per second selection; L. Manual start/stop control; M. Continuous run/single frame side release.
2. RX5 with Kern 10 mm f1.6, 26 mm f1.1 and 75 mm f1.9 fixed focal length lenses (10 mm may be converted to 5.5 mm with attachment lens). A. Reflex finder; B. Light control lever; C. Three lens turret.
3. SB with Kern Vario-Switar 17–85 mm f3.5 zoom lens.
A. Bayonet type lens mounting; B. Gelatine filter holder control; C. Gelatine filter holder slide; D. Clapstick lamp housing; E. Exposure meter shoe.
4. SBM with Kern Vario-Switar 100 POE 16–100 mm f 1.9 zoom lens. A. Film speed; B. fps settings for auto-exposure metering; C. Aperture control; D. Meter battery housing and check; E. Camera on/off with auto-exposure selection; F. Power zoom control; G. Cable release.
5. EBM with Angenieux 10 × 12 mm 12–120 mm f2.2 zoom lens, 400 ft. external mag., power grip. A. 400 ft mag.; B. Detachable take-up motor; C. Footage counter; D. Magazine power connection; E. Speed selector and sync position lock; F. On/off switch.
6. EL with Kern Vario-Switar 12.5–100 mm f2. A. Footage counter; B. Film speed selector; C. Frame counter; D. Frame counter setting knobs; E. 1 : 1 spindle; F. Fps selection; G. Clapper lamp switch; H. Sync pulse or crystal control socket; I. Power socket; J. Remote control socket; K. Shoe for exposure meter.

Bolex H16 M-5, RX-5, SB, SBM, EBM and EL Operation

Check shutter is set as required. A triangular warning sign appears in corner of viewfinder when not fully open.

Model RX–5 must have gelatine filter holder in position, even if no filter required, (slides in from left side between lens and reflex prism). If gelatine filter used, check it is correct and clean. SB, SBM and EBM have a two-position gelatine filter holder which may be set 'in' or 'out' without being removed from camera. EL has provision for circular gelatine filter behind lens mount.

Check camera speed is set correctly. As no tachometer is fitted to any H16 camera it is a wise precaution to occasionally test camera speed by checking footage counter against a watch. At 24fps exactly 12ft. or 480 frames of film should pass through the camera in 20sec.

A fuse protects electronics of EL (for access remove camera base).

Loading the camera

Fully wind clockwork model cameras and set release button to 'stop'.

If reloading a daylight spool, place unexposed film away from light (in cameraman's pocket will do) in order to have an empty film can ready and open to receive exposed roll. In dim light open camera door and if reloading quickly remove exposed roll from bottom compartment of camera by pressing ejector lever, transfer to empty can and seal.

Remove film pressure pad and check gate aperture for hairs and emulsion build-up. Replace pressure pad and check gate is locked closed.

Remove empty spool by pressing eject lever.

If it is desirable for camera (not EBM or EL) to make a clicking sound every second (at 24fps) as an aid to shot timing, set audible signal lever, centre right inside the camera, downwards. If not set it to 'O'.

Set loop formers by moving small lever located between sprockets to downwards position. Place roll of unexposed film on top spindle, trim film with cutter at bottom of camera and remove off-cut. Offer film end to top sprocket and run camera. Film will emerge from lower sprocket. Continue to run until there is sufficient film to attach to take-up spool. Insert end into slot in centre of empty spool, place in camera, wind-on several turns and finally run camera for a second or two to check all is well.

Close door, run through beginning of roll until footage counter reaches zero. After 100ft. run off remaining 10ft. to protect used film.

To use mag. loaded with 400ft. rolls of film, check core centres and footage counter lever roller are in position in mags. and attach take-up motor. Check film rollers are positioned on camera spindles, open sprocket guides, attach mag., plug-in power supply, form film loops, close sprocket guides, take up slack film and securely close camera door.

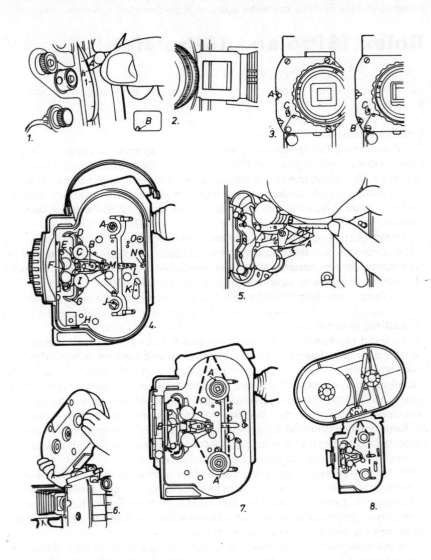

BOLEX H16 TYPE OPERATION

1. Adjustable shutter control. A. Actuating lever; B. Triangular warning signal which shows in viewfinder if shutter not fully open. 2. RX5 behind-the-lens gelatine filter holder. 3. SB, SBM, EBM, 'slide-over' filter holder. A. Filter positioned; B. Filter stored; C. Release to extract. 4. Typical H16 interior. A. Upper spindle, B. Loop former control; C. Upper sprocket; D. Upper loop former; E. Pressure pad securing screw; F. Gate pressure pad; G. Lower loop former; H. Film knife; I. Lower sprocket; J. Lower spindle; K. Retaining arm; L. Spool ejector; M. Loop former opening knob (RX5, SBM and EL); N. Footage counter knob; O. Audible counter control (not EL). 5. Loading film. A. Loop former control in closed position; B. Loop formers release button. 6. Attach mag. from front. 7. Camera set for mag. loaded film. A. Rollers on spindles; B. Sprocket guides held open for loading. 8. Film paths.

Bolex 16Pro and 16Pro-100

Sophisticated 16mm cameras for sep-mag or com-mag sync sound filming.

Description

Positive clamped type bayonet lens mounting system of unique design. Specially mounted Angenieux 10 x 12mm (12–120mm) *f*2.2 and Schneider Variogon 10–100mm *f*2 zoom lenses are available incorporating in-built sound proofing and linkage for servo-operated zoom, focus and aperture controls. Also available is a Zeiss-Distagon 8mm *f*2 fixed focal length wide-angle lens with connection for automatic diaphragm control.

Shutter; 132°. Exposure 1/65sec. at 24fps.

Spinning mirror reflex system. Three position eyepiece may be set normal, upwards or forwards. Viewfinder may be instantly changed from a ground glass focusing screen showing full 16mm frame to a clear glass bright image showing TV area markings. In either position the *f* stop is displayed with *f*8 in the centre and dots representing other *f* openings in an ascending order. Eyepiece opened by pressure of operator's eye, may be locked open. Eye must always be close to it or automatic exposure control may be effected by stray light. Extension available for left eye viewing.

Integral 12v motor. 16Pro has variable speeds 16–50fps, 16Pro-100 model 16–100 fps (requires 24v supply). Automatic exposure compensation as camera speed is changed in shot. Camera may be run in reverse. 24 or 25fps crystal sync modules may be plugged into control unit and are activated by plugging a sync plug into an external socket. Sync pulse output generated electronically by crystal sync module.

Electronics protected by a 5 x 20mm fuse engraved *f*.6.3 in the power pack or a trip switch in the battery belt. Special charger recharges fully discharged battery to 80–90 per cent charge in 12hrs. and to full charge in 18hrs. Red light on charger shows when battery discharged, extinguishes when battery 80–90 per cent capacity.

Yellow indicator lamp on camera is lit when no film is loaded, off when camera is loaded, flickers when less than 400ft. of battery charge remains.

400ft. mags. Unique automatic loading system. Mags. cannot be removed from camera without cutting film or re-laced without unloading previously shot film. Metre and footage indicators on camera show up to 99.9ft. and metres elapsed. Frame indicator reads single frames up to 40. Footage indicator on mags. show film remaining and film shot. Com-mag sound module may be plugged into camera, is used with companion fully automatic or manual amplifiers.

Other facilities include automatic servo-exposure control, servo-control of zoom lens focal length and focusing by switches and levers on hand-grips with fast zoom-in for focus preview.

Camera serial number on underside of camera body.

BOLEX 16PRO AND 16PRO-100

1. Bolex 16Pro. A. Rubber sunshade; B. Angenieux 12–120 mm f2.2 or Schneider Variogon 10–100 mm f2 zoom lens; C. Film speed setting control; D. Mag. lock.

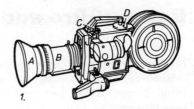

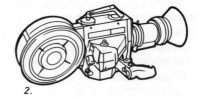

2. Bolex 16Pro.

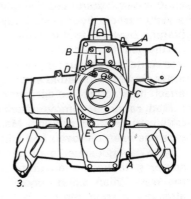

3. A. Umbrella holder; B. Accessory mounting shoe; C. Slating lamp replacement position; D. Servo drive gear; E. Servo couplings;

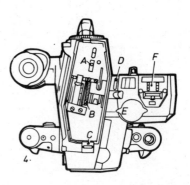

4. A. Servicing start switch; B. Film cutting knife; C. Mag. holding point; D. Knife for partly exposed film loading; E. Loading knob; F. Frame and footage counter.

Bolex 16Pro and 16Pro-100 Loading

Mag. is upright when lettering on footage indicator reads correctly.

Remove left lid of mag. by releasing three cornered safety catch and rotating mag. lid 90° anti-clockwise. (Note three-cornered safety catch on take-up side has a small felt insert for identification in the dark.)

Place film in mag., thread end through light trap, re-set footage indicator lever against film and replace lid.

If film is in take-up side of mag. remove and can-up in the dark.

In the light pull out beginning of film, locate under sprung holder with perfs. located on ends. Tear off loose end of film while holding down holder.

Place an empty core on spindle on take-up side of mag. and check footage indicator lever is resting against it. Replace lid without threading film further.

Threading the camera

Connect camera to electronic control unit, check module is in place and knob is set to com-mag if single system sound recording required.

With camera door closed attach mag. to rear by engaging at bottom, hinging upwards and locking it.

Turn loading knob fully clockwise and hold until yellow light goes off and camera stops running. Return loading knob to original position. Camera is now fully threaded and ready for shooting. The loose end of film will attach itself to take-up core automatically during first take.

Mag. cannot be removed from camera until film is completely run-out or until camera stops running. Mag. cannot be re-used until film in take-up side has been removed and an empty core fitted.

Note daylight spool loading film may be used for take-up after removing spinning flange/core adaptors and locking footage indicator arms out of the way. When using spools for take-up, film end must be manually attached to spool after threading through camera. In replacing spinning flanges note one for take-up side has a white dot for identification purposes (similar to white dot on safety catch).

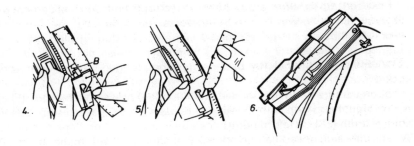

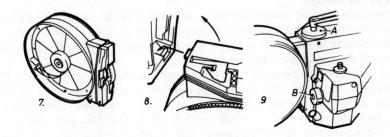

BOLEX 16PRO LOADING

1. Mag. is upright when footage indicator reads correctly. 2. Release supply side lid by rotating triangular catch (without felt insert) anti-clockwise and unscrewing cover. 3. Load film with end pushed through aperture, replace mag. lid. 4. Lift spring holder A, and locate film on pins B. 5. Press down spring holder and tear off waste end of film. 6. Film ready for camera. 7. Place film core in take-up compartment and replace lid. 8. To attach mag. to camera hook bottom lug over holding point and swing upwards. 9. Lock A will engage automatically, to complete loading (with power on etc.) turn knob B clockwise and hold until yellow light goes off.

Bolex 16Pro and 16Pro-100 Operation

For com-mag sound recording head module must be in camera (1).

For sep-mag operation with automatic sync marking correct (16Pro or 16Pro-100) sync pulse plug must be plugged into accessory socket (2E) of electronic unit, speed control (3C) on hand-grip set to 24 or 25fps and sound recorder connected to electronic unit.

For crystal controlled speed, crystal module must be plugged into electronic unit and correct (16Pro or 16Pro-100) sync plug plugged into accessory socket (2E).

For speeds up to 50fps, attach battery electronic unit, connect camera by cable, switch to 'forward' or 'retro' (reverse) as required.

For 16–50fps on model 16Pro-100 cameras, a bridging plug must be plugged into accessory socket (2E) when sync pulse not required. For 50–100fps an additional 12v battery must be plugged into an accessory socket.

To run camera (with film loaded and iris open) press start button (4F) at rear of right hand-grip with thumb and release. Press again to stop. Speed control knob (3C) on left hand-grip can be locked in 24 or 25fps positions. When unlocked, speed can be adjusted in shot, with automatic exposure control, by rotating knob with left thumb. Set between 16 and 20fps and pull-out for single frame operation. To run camera with or without film or with iris fully closed press override switch (4E) on right hand-grip to rear.

Servo-systems

For normal manual control of focus and zoom (with iris permanently at one setting) set 'servo' switch (4C) to 'off', to control iris manually or automatically without servo focus and zoom control set to 'iris' and for servo-control of all systems set to 'full'.

To zoom lens by servo to long focal length press front of lever on right hand-grip (3B) with little finger, for wide angle press rear with middle finger. Select zoom speed by rotating servo knob (4D) with index finger. Use same finger to press override switch (4E) forward for fast zoom.

To focus lens to infinity by servo press front of lever on the left hand-grip (4B) with little finger. For close focus, press rear with middle finger.

For automatic exposure control set 'servo' switch (4C) to 'full' or 'iris' and set ASA/DIN knob as required. The iris knob (3E) is spring-loaded to 'A' (automatic). It is important to prevent stray light entering the eyepiece. For manual control of iris (by servo) or to hold it on a setting turn iris knob (3E) to 'M' with left index finger. Press light coloured iris manual button (3D) with left thumb to open iris, press black coloured one to close, *f* setting can be seen in viewfinder. If black knob is held until iris closes, camera will stop automatically.

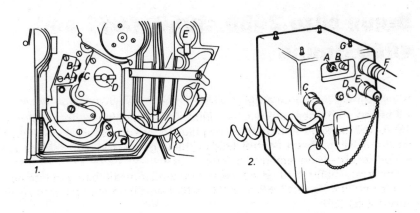

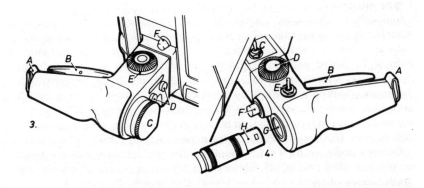

BOLEX 16PRO AND 16PRO-100 OPERATION

1. Magnetic heads in position for com-mag recording. A. Recording head;
B. Playback head; C. Sound drum connected to two fly-wheels;
D. Com-mag/sep-mag control (must be set to sep-mag if camera is to be run
in reverse); E. Playback ear-piece.

2. Electronic control unit and battery module for 16Pro. A. Main power and
reverse run switch, B. Control lamp; C. Connection to sep-mag tape recorder;
D. Fuse; E. Accessory socket with appropriate bridging plug in position;
F. Connecting cable to camera; G. Auto-recorder attachment points.

3. Right control handle. A. Socket for remote control; B. Power focus control;
C. Fps control; D. Diaphragm controls; E. Auto/manual exposure control
switch; F. Yellow indicator light.

4. Right control handle. A. Remote control socket; B. Power zoom control;
C. Servo control selector switch; D. Power zoom and focus speed control;
E. Fast zoom to long focal length/double exposure switch; F. Camera start
and stop switch; G. Power to camera socket; H. Electronic unit to camera
cable.

Versatile sound-on-film cameras.

Braun Nizo 2056, 3056, 4056 and 4080 Sound

Fitted with non-interchangeable *f*1.4 7–56mm (7–80mm model 4080) Schneider Macro-Variogon zoom lens, beam-splitter reflex viewfinder (light loss ⅓ stop) rangefinder focusing, manual or automatic exposure control, 9, 16⅔, 18, 24, 25, and 36fps, (54fps models 4056 and 4080) single shot or time lapse running, automatic or manual sound recording with facilities for monitoring, shooting to playback, delaying sound start and muting recording. Ultra wide angle lens attachment 4–32mm (4–45mm model 4080). Zoom operation by power control only (model 4080 also manual). Capability for shooting close-ups by macro zoom or diopters.

Operation

Loading film automatically sets automatic film exposure speed. Internal 85 filter (IC) must be set manually for daylight operation. Automatic exposure may be varied ±1 stop by control ID, set +1 stop for individual shots by control 2B (used with principal foreground subject against light background), set at fixed aperture (zoom into principal subject, set control 2B to 'fix') or set manually, (operate by moving control 2B to + or −), models 2056 and 3056 have automatic fade-in and fade-out, models 4056 and 4080 automatic dissolve operated by button in centre of aperture control (2B). 225° shutter, (200° model 2056). 24fps exposure time 1/38 (1/43 model 2056).

 Camera powered by 6 x 1.5v penlite batteries, (nicad optional, standard on models 4056 and 4080). Battery test button in centre of speed control (both halves of rectangle below viewfinder should illuminate).

 Hand-held camera started by pressing main power switch (IG), then shutter release (1F). On tripod, lock switch 1G by slide 1H, press button in centre of run control (2C) for intermittent operation or set run control to 'O' for continuous. For single frame operation set run control to square, and either press release 2C, or plug cable release into 1M or remote switch into 1K. With speed control set to red dot (18fps) time lapse cinematography possible by setting run control (2C) to '−' for 4fpm, to '..' for 12fpm, or '...' for 30fpm. Sync flash possible with single frame or time lapse.

 Sound recording by microphone (omnidirectional type supplied with models 2056 and 3056, cardioid type with 4056 and 4080) or direct feed from tape or disc etc. (Set switch 2G accordingly). Sound level control (2H) may be automatic with choice of sensitivity ('mic = max, [mic] = min.) or manual (recording level shown by indicator light system in viewfinder two green lights are good, red is over-modulating). Socket 1J is output for 1500 ohm earphone. Sound recording may be muted by pressing centre of sound control (2H). Commencement of recording may be delayed by 1 sec. of each shot (set switch 2F to '1 sec.'), for editing purposes and/or faded in and out with picture at start and finish of shots (press centre of camera speed control 2B).

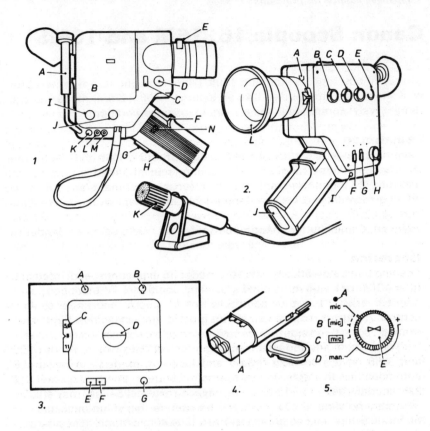

BRAUN NIZO 2056, 3056, 4056 AND 4080

1. A. Fold down shoulder support; B. Film compartment release and ejector;
C. Daylight filter control; D. Automatic exposure level adjustment; E. Manual
zoom control; F. Hand-hold start/stop; G. Main power switch; H. Power
switch lock; I. sound input; J. Earphone socket; K. Remote release socket;
L. Flash synchronisation socket; M. Cable release socket, N. Charger socket
for NC rechargeable batteries.

2. A. Macrofocus setting; B. Aperture switch, press for automatic fade in or
out; C. Camera-run control, press to run camera; D. Fps switch, press for
battery check; E. Film counter; F. Sound start delay switch; G. Mic/phon
switch; H. Recorder gain switch/control, press to mute sound; I. Hand-grip
release for tripod operation; J. Battery compartment; K. Omnidirectional
microphone (may be attached to other models 4056 and 4080); L. Lenshood
accessory; M. Motorised zoom control/macro focus rocker switch.

3. Viewfinder. A. Film running indicator (flashes when condition
satisfactory); B. Daylight filter signal; C. Exposure indicator; D. Rangefinder;
E. Battery voltage low/sound minimum level indicator; F. Battery
voltage/sound level too high when lit; G. Battery voltage/sound level too high
when lit. 4. A. Battery container. 5. Sound level control. A. Exterior
recommended setting; B. Interior setting; C. Interview setting; D. Manual
control; E. Press to mute.

Canon Scoopic 16, 16M and 16MS

Unpretentious, highly automatic, 100ft. (30m) capacity, 16mm cameras for wild shooting. Later models take an external 400ft. (120m) magazine and run at crystal controlled 24fps for sep-mag sync operation.

Description

Non-interchangeable zoom lenses, Model 16: 13–76mm *f*1.6, 16M and MS: 12.5 – 75mm *f*1.8 (T2.5) with macro-focusing. Wide angle 9.5mm adaptor, 112.5mm tele-converter long focus attachment and close-up lenses are available accessories. Model MS has provision for behind-lens filtering.

Fixed opening shutters. Model 16 : 135°, 16M : 170°. Calculate Model 16 exposure at 1/100 sec. to compensate for shutter and reflex-light loss. 16M 1/50 sec. (use T stop).

Prism reflex viewfinding system. Model 16 has centre spot focusing screen, 16M has all over ground glass and additional TV markings.

Built-in exposure meter, parallel with taking lens, has angle of light acceptance approximating to a 38mm focal length lens with a light value indicator in the viewfinder. Automatic servo or manual exposure control.

Integral 12v motor and small rechargeable batteries which will run 16 x 100ft. rolls in favourable conditions. Two batteries may be recharged simultaneously in 14hrs. in an accessory battery charger (model S12 charger recharges in 3½ hrs.). Large capacity external battery may also be used. Battery 'state of charge' meter on camera rear (blue indicates OK, red NG). Camera may be pre-set to 16/24/32 or 40fps. Model 16M may also be set to 64fps and single shot. Later models are fitted with a 24fps crystal control system and earlier models may be retro modified.

Later models are fitted with an external magazine adaptor which takes a 400ft. CP or Mitchell type magazine.

Master switch on right side of camera switches all systems 'off' and selects 'auto' or 'manual' exposure control. Camera started by fully pressing button by right thumb (and turning to 'RL' for continuous running). Partial pressing activates exposure control system only. Model 16M has an additional button to set aperture to full aperture while focusing.

Later models have portable lamp shoe on top of camera.

A barney is available to quieten camera when shooting sync sound or keep it warm when shooting in the cold.

Film threading is semi-automatic. Gate pressure plate may be removed for checking and cleaning. To load, open camera door and place roll of film on rear spindle, trim film end with cutter and insert tip of film into guide. With speed set at 16 or 24fps, run camera while pressing film. Film will automatically thread. Check loops are properly formed, secure loose end of film to take-up spool, put take-up spool on front spindle, close camera door and run camera until footage counter reads '0'.

On model 16M make sure film feed knob turns while camera is running.

Camera serial number engraved on right side.

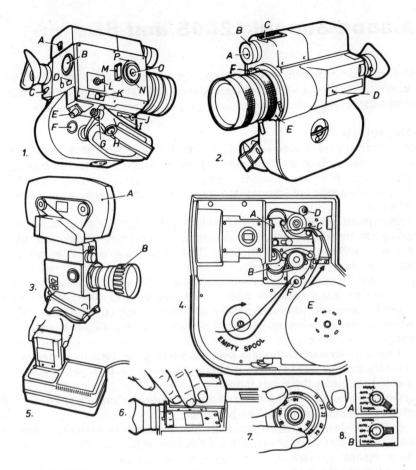

CANON 16MS

1. Canon 16MS. A. Battery compartment lock; B. Frame and footage counter; C. Finder shutter; D. Battery check switch and meter; E. External power supply socket; F. Film feed indicator; G. Cable release socket; H. Camera start button; I. Shutter lock release; J. Aperture open button; K. Single frame selector knob; L. Power supply switch (EE selection switch); M. Gelatine filter holder; N. Fps selector; O. Film speed dial; P. Fps selector lock release button (with EE attachment part).

2. A. Exposure meter window; B. Manual aperture scale (T stops); C. Accessory shoe; D. Focal plane position mark; E. Macro ring.

3. 16MS with 400ft. (120 m) mag. (A) and 1½ × tele-converter attachment (B).

4. Film path (loop forming guides open and close automatically as door is attached and removed). A. Pressure plate; B. Film guide; C. Film holder; D. Film guide release pin; E. Film supply spool; F. Guide roller.

5. Placing battery in charger. 6. Placing battery in camera. 7. Setting filming speed (release button on 16MS only). 8. Power supply switch A. Model MS; B. Model M.

Canon Scoopic 200S and SE

An enlarged and somewhat more sophisticated version of the Scoopic 16 with com-mag sound recording capability specifically designed for TV news gathering.

Description

Camera may be loaded with 200 or 100ft. (60 or 30m) daylight loading spool wound film with magnetic stripe if sound on film recording is required.

The 200ft. (60m) of 16mm film runs for 5½ mins. long enough for most purposes.

Non-interchangeable 12.5 – 75mm *f*1.8 (T2.5) zoom lens. A 9.5 wide angle attachment may be used to extend the focal range. Minimum focus distance without diopters 3ft.7in. (1.1m). Diopters available for close-up shooting down to 2ft. (0.6m).

Shutter 170°. 24 or 25fps models available. No variable speed facility.

Reflex shutter viewfinder system. Full area ground glass also displays letter M when on manual exposure aperture setting (T stops) and under- or overexposure warning. Model SE ground glass has TV additional markings.

Provision for behind-the-lens gelatine filtering. It is recommended that a clear UV filter be used even if no filtering is called for, to maintain accurate focus throughout the zoom range.

Servo operated TTL automatic exposure control. (Compensates for filter in use). Manual operation also possible.

Batteries 24v, located in the amplifier unit powers camera, exposure control and amplifier for up to 15 x 200ft. rolls at 68°F (20°C). Recharges in 5 hrs. Neither camera nor amplifier operate separately.

Amplifier CRA-2 (Scoopic 200 SE) has 2 mic. inputs with individual automatic gain or manual volume controls, a manual line control, and a VU meter. Headphones hear playback off recorded sound only. Model CRA1 (Scoopic 200S) has single microphone input only.

Threading may be modified to bypass sound sprocket and recording drum when shooting mute but amplifier must be connected and switched on nevertheless.

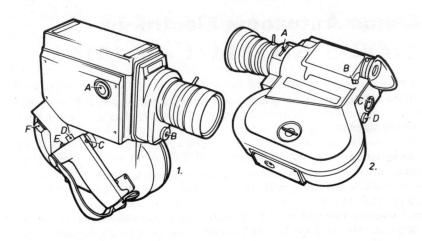

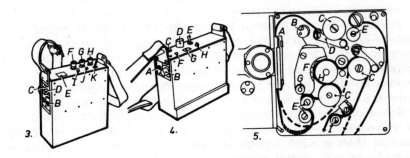

CANON 200SE

1. Canon 200SE. A. Film speed dial; B. Manual exposure control (EE switch); C. Aperture opening button; D. Camera start/stop switch; E. Mirror inching switch; F. Amplifier connection socket.

2. A. Gelatine filter holder; B. Eyepiece shutter; C. Footage counter; D. Manual inching knob.

3. Type CRA-2 Recording Amplifier. A. Mic-1 socket; B. Mic-2 socket; C. Headphone socket; D. Camera cable socket; E. Recording level meter; F. Mic-1 level control; G. Mic-2 level control; H. Line input control; I. Battery check button; J. Pilot lamp; K. 'On/off' switch.

4. Type CRA-1 Recording Amplifier. A. Mic socket; B. Camera cable socket; C. Battery check button; D. Recording level control; E. 'On/off' switch; F. Headphone socket; G. Recording level meter; H. Pilot lamp.

5. Film path (com-mag shown solid, silent shown dotted). A. Pressure plate; B. Head plug; C. Sprocket; D. Retaining shoe; E. Guide roller; F. Recording head unit; G. Recording head retaining screw; H. Sound drum; I. Tension roller.

Super sophisticated Super 8 cameras.

Canon Autozoom Electronic
514XL-S, 814, 814XL and 1014

These cameras have many automatic facilities not to be found on even the most sophisticated 35mm camera. The 514XL-S has com-mag sound recording capability.

Description
All models have non-interchangeable zoom lenses. Model 514XL-S has a 9–45mm *f*1.4, the 814 and 814XL have 7.5–60mm *f*1.4, the model 1014 a 7–70mm *f*1.4. Minimum focusing distance approximately 4ft. (1.2m). Diopters available for close-up shots with zoom capability down to 1ft. 2in. (373mm). Macro zoom facility for ultra close-up shooting but without the possibility to hold focus while zooming. Manual or power zoom operation. An optional wide angle attachment lens for model 514XL-S converts minimum focal length to 5.9mm.

Adjustable shutters. Maximum opening 150° (setting O). XL models may also be set to 220° for existing light cinematography. Other shutter openings are set 2 = 75°, setting 4 = 37.5° and 'C' – fully closed. Model 1014 may be rewound and a 50 frame lap dissolve made between scenes. Always check that shutter is set as required before shooting. Automatic exposure control automatically compensates for shutter angle.

Reflex viewfinder. Split image rangefinder focusing viewfinder also displays aperture, over- or underexposure and end of film warnings. Lights up after 47.5ft. of a 50ft. roll. Model 1014 also has shutter angle indication and an automatic closing eyepiece.

TTL automatic exposure control with manual option.

An internal 85 filter automatically positions in light path when artificial light type film cartridge is inserted. May be cancelled by inserting a special screw, normally stored on the underside of the camera, into a hole at the top or attaching a special filming lamp.

Speed capability 18 and 24fps, single shot and slow motion (40 or 54fps). 4 or 6 × 1.5v AA batteries (depending on model) run camera for 10 cartridges (1 cartridge at single shot).

Single shot may be synchronised to electronic flash. Remote control and time control switches and an intervalometer are available accessories (set camera switch to RL).

The amplifier of 514XL-S is built into the camera.

There is also a Double Super 8 version of the Scoopic 16M.

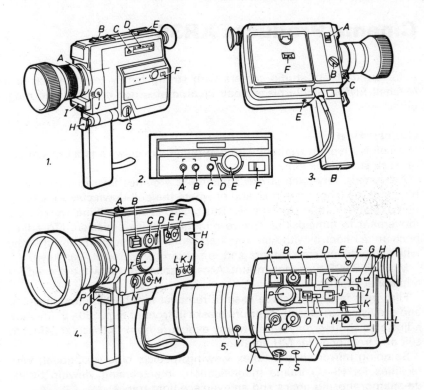

CANON SUPER 8 CAMERAS

1. Canon 514 XL-S Canonsound. A. Macro indication scale; B. Power zoom switch; C. Battery check button; D. Footage counter; E. Accessory shoe, F. Sound control panel; G. Main switch; H. 'Start/stop' lever; I. Cue light; J. Automatic exposure lock knob.

2. A. Remote control and single frame (silent running) jack; B. Mic input; C. Earphone jack; D. Auto/manual sound lever switch; E. Sound lever control; F. Tone select switch.

3. A. Colour correction filter to use type A film in daylight, B. Fps selector; C. 9v external power supply; D. Battery compartment; E. tripod bush; F. film type indicator.

4. Canon 814 XL Electronic. A. Daylight colour correction filter cancellation socket; B. Instant slow-motion switch; C. Fps control; D. Automatic exposure control; E. Frame counter; F. Footage counter; G. Battery check window; H. Battery check button; I. Variable shutter control; J. 8-pin sound sync jack; K. Remote control socket; L. Flash synchronising socket; M. Main switch; N. Manual aperture control dial; O. 'Start/stop' switch; P. Macro setting knob.

5. Canon Auto Zoom 1014 Electronic. A. Slow motion switch; B. Fps control; C. Automatic exposure setting; D. Frame counter; E. Eyepiece shutter; F. Footage counter; G. Battery check window; H. Battery check button; I. Film transport indicator; J. Rewind switch and indicator; K. Rewind mechanism cancel control; L. Remote control/single frame socket; M. Electronic flash synchronising socket; N. Fading setting indicator; O. Fading setting knob; P. Variable shutter control; Q. Main switch; R. Auto/manual exposure control switch; S. Tripod bush; T. Filter cancellation adaptor storage; U. 'Start/stop' switch; V. Macro zoom setting knob.

Basically a Mitchell NC in a sleek housing.

Cinema Products XR35

A full-sized 35mm studio camera with strong family resemblance to a Mitchell BNCR. Single piece body incorporates non-demountable mag. blimp.

Description
Mitchell NC type movement with two pull-down claws and a register pin on each side of the film.

A two-axis vary-pitch stroke adjustment provides for separate adjustments of the length of stroke and of where the pull-down claws enter the perfs. relative to the register pins. This facility is used to 'tune' the camera movement to filmstock to ensure minimum noise emission. (To adjust pitch unlock control with Alan key, start camera, adjust pitch control screw with screwdriver, stop camera and re-tighten control with Alan key.)

Mitchell BNCR type lens mount. Accepts zoom lenses without need for additional support.

Film gate facilities include ease of removal for checking and cleaning and provision for placing aperture masks in front of film. 180°–5° 'in-shot' adjustable shutter, may be set to any exposure from 1/48sec. (at 24fps) to suit any frequency for MH lighting.

Spinning mirror shutter reflex viewing (pellicle type is optional) with facilities for HI–LO image magnification, interspersing viewing filters, de-anamorphosing optics and an eyepiece light-trap.

A filter holder in front of the shutter holds up to six gelatine filters. (Access to gelatine filter disc on right front of camera. Frequently check gelatine filters for dust, oil or scratches caused by camera shutter.)

Crystal control 28–36v DC motor with 24/25fps sync and 4–32fps continuous variable speed capability. A buzzer and a flashing light warn if camera is out of sync. Normal power consumption 7amp. An automatic power circuit breaker trips at 15amp.

Unique 1000ft. displacement type magazines incorporate footage remaining indicators. Mags. are placed into the camera from the rear.

Re-settable footage shot counter on camera rear panel on cameras no. 1–7. Cameras No. 8 onwards have an electronic footage counter set on front left side of mag. An adjoining button is used to illuminate counter when camera's power is switched off.

Camera inched for loading from inside camera body.

Serial number engraved on mechanism plate.

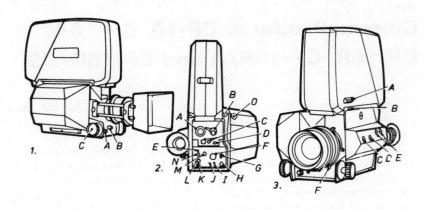

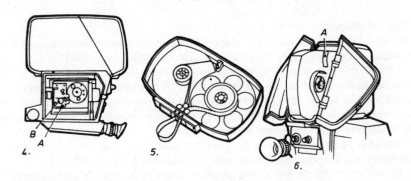

CINEMA PRODUCTS XR35

1. CP XR35 fitted with mattebox. A. Follow focus tension control; B. Follow focus clutch; C. Magnetic focus discs.

2. A. Filter disc selection control. B. Adjustable shutter control and indicator; C. Footage indicator and reset button (cameras 1–7); D. Illuminated level; E. Green 'camera running' light; F. 'Out of sync' sound warning; G. Power to camera switch; H. Power connection; I. Red 'out of sync' warning light; J. 'Out of sync' tone level control; K. Battery charge condition; L. Camera stop button; M. Power overload circuit breaker; N. Camera start button; O. Inching knob.

3. CP XR35 with Canon K35 25–120 mm f2.8 zoom lens with macro lens capability A. Electronic footage counter (cameras No. 8 onwards); B. Tape hook; C. De-anamorphose/spherical control; D. Hi/lo image magnification and viewfinder closed control; E. Viewing filter control; F. Follow focus linkage take-off point.

4. CP XR35 fitted with Canon 55 mm f1.2 aspheric lens. A. Mitchell NC mechanism; B. Adjustable two-axis stroke control. 5. Displacement type magazine. 6. 'Clamshell' type magazine access door open. A. Mag. footage remaining indicator.

The preferred newsreel camera of many TV networks.

Cinema Products CP-16, CP-16A, CP-16R, CP-16R/A and CP-16R/DS

A range of cameras of Auricon ancestry. Primarily used for TV news, documentary and drama production.

CP–16: non-reflex 180° shutter, 'C' lens mount, sep-mag or com-mag.

CP–16/A: as above but with integral automatic com-mag amplifier.

CP–16R: 156° shutter reflex, CP (miniature BNCR) lens mount, sep-mag or com-mag with amplifier separate from camera. Later type has 170° focal plane shutter plus mirror reflex.

CP–16R/A: As CP–16R but with integral com-mag amplifier.

CP–16R/ADS: as CP–16R but for sep-mag (double system) sound only.

Description

Auricon type movement (see page 60). Dummy sound head must be in position when magnetic recording heads not fitted (not 16R/DS).

CP–16 models use Angenieux reflex zoom lenses fitted with short eyepieces for viewfinding purposes. CP–16R models being reflex, may be used with a wider range of lenses including non-zoom, wide aperture, wide angle and telephoto. Many Arri- and Nikon-mounted lenses may be fitted by the use of suitable adaptors.

Standard CP eyepiece may be interchanged with CP or Angenieux orientatable type. A viewfinder extension is available for tripod filming.

Provision for behind-the-lens gelatine filters, with storage places for two filter slides inside camera.

Integral motors operate off small 20v 0.55Ah interchangeable batteries which slide into right side of camera. This battery also powers the integral recording amplifier when fitted. Under good circumstances will run approx. 2000ft. (600m) at one charge. Charging time 14hrs. In emergency camera may be run off AC supply via type NC-4 charger.

A charger which recharges 6 batteries simultaneously (type MBC-6) is an optional accessory. Cameras may be supplied to run 24 or 25fps crystal controlled. (A plate inside the camera indicates which.) A red light flashes when off speed. All 24fps CP-16R models may be run at pre-set 12, 16, 20, 28, 32 and 36 fps variable speeds, 25fps models at 5 per cent more.

All models take lightweight CP400ft. (120m) separate compartment film magazines or slightly modified Mitchell 400 and 1200ft. types (lock mount stud, CP part number 70–55 must be screwed into threaded hole in magazine base). 'B' wound roll film or daylight spools may be used. 3in. (75mm) take-up cores should be used with 1200ft. loadings.

Accessories include sound recording amplifiers and mixing units, an improved magnetic head module (type 3XL), fully or semi-automatic exposure control, power zoom control, VU meter visible to the camera man, shoulder rest, adaptors for fitting filming light and microphone etc.

Serial number on label inside camera on topside of film compartment.

96

CINEMA PRODUCTS CP-16 RANGE

1. CP-16. A. NC-4 20v 550 mAh battery; B. 24 (25)/36 (37.5) fps switch; C. Angenieux reflex zoom lens short viewfinder eyepiece.

2. CP-16A com-mag sound recording version. A. Battery (as above). B. VU meter; C. Headphone jack and volume control; D. Bias switch; E. Auto record ('on/off') switch; F. Mic-1 volume control; G. Amplifier 'on/off' switch; H. Mic-2 volume control; I. Int/ext mixer mode unit switch; J. Line volume control; K. Auxiliary mixer and accessory socket; L. Bias adjustment access hole; M. 'On/off' switch; N. Battery test meter; O. Battery test switch; P. Variable speed setting knob; Q. Footage counter reset.

3. CP-16R mirror shutter reflex model. A. CP-standard reflex viewfinder; B. CP-16 lens mount; C. Auxiliary 'on/off' switch.

4. CP-16R A newsreel mode. A. Battery or mains operated portable filming lamp; B. Microphone; C. Mic-1 input socket; D. Mic-2 input socket.

5. CP-16R/DS with studio rig. A. CP orientable viewfinder; B. Viewfinder extension; C. Balancing slide and support bar fixture; D. Remote control plug and socket; E. Zoom control over drive; F. Studio mattebox and filter holders; G. Studio focus knob; H. Zoom motor support bracket.

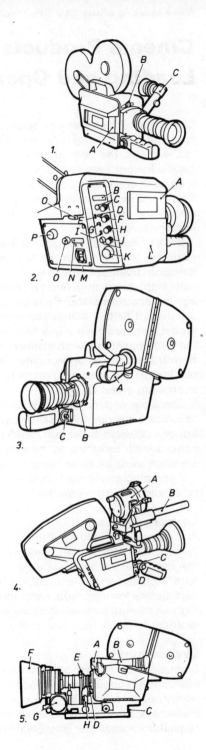

Cinema Products CP-16 Type Loading and Operation

Check mag. for cleanliness before loading, check or remove as necessary core adaptors if using core wound or daylight loading filmstock. On the CP PLC-4 mags. the core adaptors may be stored inside the film compartments. In complete darkness place unexposed film in left compartment of mag. with end coming off in a clockwise direction, pass through light trap, form loop with emulsion out and thread back into rear compartment. Attach end securely to take-up core, or daylight spool, with emulsion out, anti-clockwise.

Before loading, the spring-loaded gate pressure plate should be removed to check aperture for cleanliness and freedom from hairs and emulsion build-up. (To remove, hold plate down with left thumb, lift lever with right hand and remove plate. Do not allow lever to spring back against aperture plate.) Remove emulsion dust.

If using 1200ft. loadings check long mag. take-up belt is in position. Late model cameras have a low film warning light in the viewfinder. If fitted, the three position switch inside camera should be set for 200, 400 or 1200 ft. (off) loadings as appropriate. Check battery state by pressing battery-test button and observing meter pointer. (Red is NG, yellow sufficient for a short take, green OK).

Check out-of-sync lamp flashes each time camera is started and stopped to indicate it is operating satisfactorily. Note cameras fitted with stop/start buttons on front hand-grip handles are usually wired in parallel so that either switch switches on but may be wired in series, in which case both switches must be on to make the camera run.

If shooting com-mag (single system) sound, check magnetic heads are clean and free from emulsion build-up.

Camera loading

Pull approx. 2ft. (600m) of film out of front magazine chamber, pass into camera and attach mag. securely to camera. Thread film according to diagram; pull pressure plate open by knob at rear and pass film through gate. Inch camera by knurled knob on sprocket wheel to engage claw in perf. before forming loop. Form loops correctly and close sprocket rollers. Tighten take-up by turning pulley wheel on back of mag. Run camera for a moment to check film runs well.

Crystasound

Crystasound amplifier on right side of camera has 2 x low impedance, 1 x 600 ohm line inputs with individual volume controls, switchable variable compression automatic gain control, switchable bias, VU meter, headphone jack, auxiliary mixer input. A pre-amplifier suitable for an additional capacitor microphone (say Sennheiser 804/805) is an available extra.

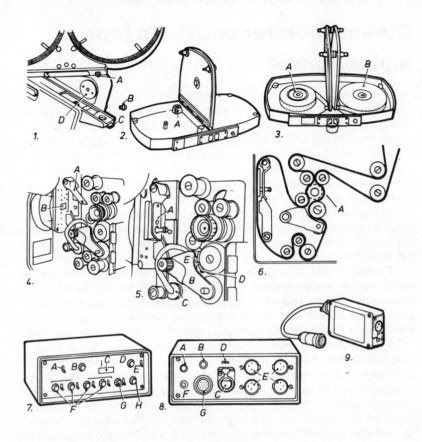

CP-16 TYPE LOADING AND OPERATION

1. Necessary lock mount and modification to Mitchell mag. for use with CP-16 cameras. A. Position of stud; B. CP part P/N 70-055; C. Latch; D. Take-up pulley. 2. CP PLC/4 two-compartment mag. A. Storage place of core adaptor when using daylight loading spools. 3. Loaded PLC/4 mag. A. Supply roll; B. Take-up (film emulsion out).

4. Pressure plate removed for gate checking and cleaning. A. Spring lever in held back position; B. Aperture plate. 5. Gate ready for loading. A. Pressure plate in position; B. Crystasound magnetic head unit; C. Electronic connecting plug; D. Recording head, E. playback head. 6. Film loading path. A. Inching knob.

7. Crystasound auxilliary mixer (model 6C). A. Monitor auto (playback) source (input) switch; B. Monitor volume; C. VU meter; D. Master volume control; E. AGC switch; F. 4 × dynamic microphone volume controls and switches; G. Capacitor mic. volume control and switch; H. Line input volume control. 8. A. 50 ohm headphone jack; B. 600 ohm line input jack; C. Capacitor mic. input; D. Sennheiser mic. type 805/804 selection switch; E. 4 × 150 ohm dynamic mic. inputs; F. 600 ohm line input; G. Camera connecting cable socket. 9. Pre-amplifier CMI for Sennheiser 804 and 805 capacitor mics. for use with on-board Crystasound amplifier.

A remarkable record of reliability in adverse circumstances.

Cinema Products CP-16 Type Maintenance

A 20amp fuse of 30 gauge fuse wire is located either in the Crystasound amplifier or inside the auxiliary side cover at the back of the battery slide. A fuse fitted to each NC-4 battery pack can only be changed at the factory.

To remove fibre optic viewing screen on early 16R models press right end of retaining spring clip in and down and on late models loosen retaining screws, and raise plate clear and remove retainer if fitted. Attach a small piece of camera tape to viewing screen surface to assist removal. Clean only with alcohol and cotton swab. The fibre optic viewing screen may be replaced with the frame line markings either up or down (this does not apply to ground glass screens) entering side with markings closest to the edge first.

To remove right side cover or Crystasound amplifier from camera for maintenance, remove battery, hold spring-loaded battery latch in position, remove five screws and lift clear (it may be a tight fit due to lightproof seal) unplugging power and sound connecting cables as they are revealed. When replacing check sound plug is correctly lined up to prevent damage.

To replace drive motor belt, remove two small screws securing tachometer board (4K) and gently remove board to clear timing wheel. Unhook belt from front pulley first, do not force over timing wheel. Tension correct when two sides of belt can barely be made to touch in centre.

Clutch drive belt tension may be adjusted by loosening and sliding idler pulley (4A) until belt is just straight between pulley wheels. Too much or too little tension will adversely affect wow and flutter. To replace clutch drive belt, unhook motor drive belt from front pulley (but do not remove) remove four binder head screws retaining diagonal bearing cross brace and remove carefully, keeping it parallel to the camera at all times. Note position of underside shims and replace similarly when re-assembling.

Sync camera speed may be changed to and from 24/25fps by changing the main shaft pulley; 24fps pulley is black, 25fps red. Reversible speed indicator plates inside the camera and on the speed selection dial on the back of the camera are marked 24fps on one side and 25fps on the other.

To replace entire drive motor system, including control electronics, as a unit, turn mirror shutter to fully open position, unhook belt (4H) (but do not remove), remove choke (4N) unscrew ground (earth) strap (4M) remove cross brace (see above), remove screw securing circuit board (4F) remove nut securing low film warning switch inside film chamber, remove three screw retaining shock mounted camera assembly and remove all including wiring harness. When replacing, ensure shock mounts and flanged spacers correctly assembled and low film switch is correctly orientated.

Incorrect take-up tension is usually rectified by replacing take-up belt. Clutch can be tightened and if necessary spring replaced. Beware of excessive take-up tension which causes com-mag wow and flutter.

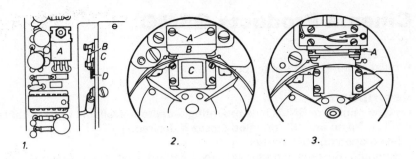

1. 2. 3.

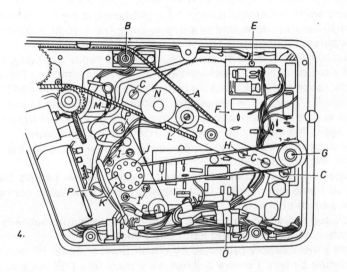

4.

CP-16 TYPE MAINTENANCE

1. Position of fuse is relative to electronics and rear of battery compartment
A. Electronic board; B. 30amp fuse; C. Rear of battery compartment; D. Spare
fuse wire. 2. Procedure for replacing fibre optic viewing glass. A. Screws to
be loosened; B. Retainer; C. Reflection of viewing screen in reflex mirror.
3. Alternative type of fibre optic security. A. Spring clip in latched positon.

4. Internal mechanism compartment. A. Clutch drive belt; B. Clutch drive belt
tension adjustment idler; C. 4 × screws which retain crossbrace;
D. Crossbrace; E. Screw retaining circuit board; F. Circuit board; G. Main
shaft pulley; H. Drive motor belt; I. 4 × motor mounting plate screws;
J. Timing wheel; K. Tachometer board; L. Parked alternative 24/25 fps pulley
wheel (G); M. Earth (ground) strap, N. Choke; O. Connecting harness;
P. 3 × motor mounting assembly screws.

A value-for-money camera.

Cinema Products GSMO

A quiet running, general purpose, inexpensive camera.

Description

CP type miniature BNCR lens mounting, adaptors available to fit suitable Arriflex, Nikon and 'C' mounted lenses if desired.

Fixed opening 180° shutter.

Spinning mirror viewfinder system, standard rotatable or Angenieux or CP orientatable type eyepieces may be fitted.

Compact 20v Samarium Cobalt type motor draws 350mA. 12, 16, 24, 25, 32, 48 and 64fps selectable speeds, all crystal controlled. CP 16 type 20v 550mAh battery on right side of camera, runs 4–6 x 400ft. rolls of film. Button operated battery test light shows red when voltage low.

Mags.: 100, 200 and 400ft. (60, 160 and 120m) types available, larger sizes take roll or daylight spool-loaded film. Mags. incorporate film drive sprockets, loops and back pressure plate. Footage indicator on 400ft. mag. shows full, ¾, ½ or ¼ roll remaining. (Correct for roll wound film).

Gate pressure plate and loop former may easily be removed from mags. for cleansing. No other routine camera maintenance necessary.

Interchangeable fibre optic type viewing screen. Various markings available. (Not interchangeable with CP-16).

Pilotone output switchable 50/60Hz (selector switch behind battery pack). Full frame sync marker light operates when sync cable connected by 6–pin Lemco connector.

Camera run switch on camera rear, additional switch automatically connected when shoulder rest and hand-grip attached.

Camera power supply protected by circuit breaker, reset by removing and replacing battery. Camera will not run if mag. lock (3B) not set. Internal 20 A (30gauge) fuse inside camera, additional fuse inside each battery pack.

Serial number engraved on right side of camera. May be seen when battery pack removed.

CINEMA PRODUCTS GSMO

1. A. 400 ft. mag.; B. Mag. footage remaining indicator; C. Mag. clutch disengage knob; D. Detachable carrying handle; E. Variable speed control; F. Battery pack (camera serial number and pulse Hz switch behind); G. Battery release.

1.

2. A. Footage counter reset button; B. Footage meter digital display; C. Footage counter display button; D. Footage-meterage selector switch; E. Battery test button and lamp; F. Power socket; G. 'On/off' switch.

2.

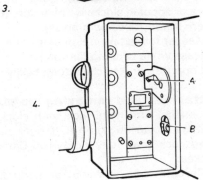

3. A. Standard viewfinder; B. Mag. lock.

3.

4.

4. A. Mag. drive clutch; B. Pull-down claw.

103

Cinema Products GSMO Operation

Each mag. incorporates the film transport sprockets, film guides, film gate rear pressure pad.

Magazine loading

To remove exposed film, turn mag. upside-down against flat of hand, press centre button with middle finger. Reel of film on flange, or spool, will fall away easily. Replace flange after canning film. Small button on centre of square spindles on either side of mag. must be pressed both to fit and to remove daylight loading spools or roll film flanges which are otherwise locked in position by spring-loaded balls.

Open supply right side of mag. place film in position with end coming off counter-clockwise, trim film end with cutter on mag. door. Push end through light trap above roller and engage onto supply sprocket by turning clutch knob counter-clockwise. Close and lock mag. door. Remainder of operation may be continued in light.

Open film transport compartment by pushing release button forward. Close top loop former by pressing downwards. Turn clutch knob counter-clockwise until sufficient film has passed into take-up compartment. Press finger on film end as it passes through gate aperture to assist passage if necessary.

Close film transport compartment door, turn mag. over and remove take-up door.

Turn sprocket to wind on more film until end reaches take-up belt. Engage end on sprocket, continue turning, feed film through light trap and into take-up compartment. Pass film under take-up roller and attach to core or spool in clockwise direction. (Conicle roller below take-up roller is there to reduce camera noise).

Keeper round take-up roller may be retracted to adjust loop size. (Do not release while winding film on.)

Loop former retracts automatically when mag. is attached to camera.

Attaching and removing magazine from camera

To attach, turn mag. lock knob clockwise, retract mag. clutch drive on camera by pushing knob 1C to right, push mag. fully into position and turn mag. lock knob fully clockwise. Camera will not run unless mag. fully locked.

Reset footage display by pressing display and reset buttons simultaneously (meter may be set before start of roll to read feet or metres).

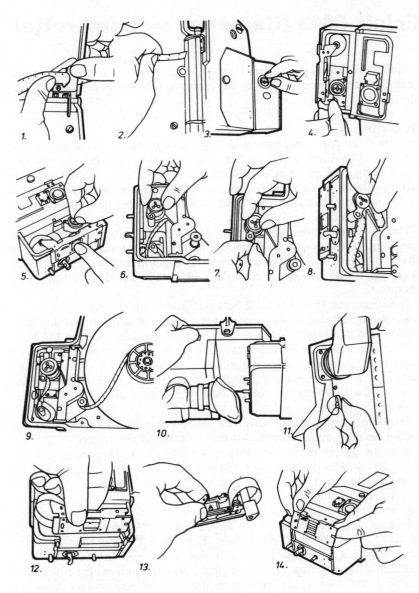

CINEMA PRODUCTS GSMO OPERATION

1. Trim end of film before loading. 2. End of film pushed through light trap.
3. Wind film on by turning clutch knob. 4. Press loop former down to close.
5. Wind film on, guiding it past gate aperture with finger. 6. Film wound on
until it reaches drive belt. 7. Film guided on to sprocket. 8. Film guided
through light trap. 9. Film path on take-up side. 10. When fitting mag. to
camera slide knob on top of camera to retract mag. clutch drive. 11. Locking
mag. 12. Remove gate assembly from mag. to clean. 13. Remove gate
pressure plate to clean. 14. Lay assembly back to ease re-assembly.

Very versatile hand-held wild camera.

Eclair CM3 (Cameflex or Camerette)

Portable wild, basically 35mm camera, especially suited to steady hand-holding. Certain models may be converted to run 16mm as well as 35mm film.

Description

Ratchet claw-type movement which engages perfs. on either side of the film, pulls film down as it is held in position by pressure pads on the mag. and sprung side guide rails. Having pulled the film down the required distance the spring-loaded ratchet claws travel upwards sliding over the perfs. in readiness for the next pull-down. The movement is somewhat noisy but effective.

The 35/16mm model may be converted from 35 to 16mm operation by inserting a 16mm mask, inserting a forked plate in place of the gelatine filter, re-setting the pull-down stroke and using special 16mm mags. Recessed 16mm pull-down claw does not cause damage during 35mm operation.

Conversion to Techniscope 2-hole pull-down is possible.

Shutter adjustable while camera is stationary. Maximum opening 200°, minimum 40° (model C – 16mm only – adjustable from 230° to 110°).

Divergent 3-lens turret with Eclair type CA lens mounts onto which wide angle and zoom lenses may be mounted simultaneously. Some models have one lens port, marked 'Scope', offset to line up with centre of full aperture frame. Provision for gelatine filters or mattes immediately in front of film plane.

Spinning mirror reflex viewfinder. Eyepiece may be rotated through 360°, does not have automatic horizon orientation correction.

Interchangeable motor. Variable speed 6/8v DC is standard and draws up to 9A. Crystal governor controlled 12 & 24v are optional as are AC mains synchronous, single shot and a hand crank attachment. Maximum camera speed: 40fps.

A tachometer on left side indicates fps rate. Individual mags. have footage remaining indicators. 100, 200, 400 & 1000 ft. and 400ft. low profile (30, 60, 120 and 300m) clip-on mags. The mags. incorporate pre-formed loops. Possible to change mags. with the camera running.

Optional accessories include a sophisticated underwater housing a sound proof blimp, an intervalometer for single-shot operation, a dovetail-type quick release plate, a lens support and mattebox system that slides on rails which fit to front of camera, and a companion lightweight tripod.

Serial number engraved behind top right lens position, visible when turret is partially rotated or top right lens removed.

Note centre screw in dovetail base plate normally supplied with camera may be removed to reveal a normal ⅜in. 16 thread tripod screw socket.

ECLAIR CM3

1. Eclair CM3. A. Off-set triple-lens turret; B. Lens turret release knob; C. Camera serial number is engraved behind this position; D. Adjustable eyepiece; E. 400 ft. (120 m) mag.; F. Adjustable bellows sunshade/filter holder; G. Lever to ease camera off dovetail slide.

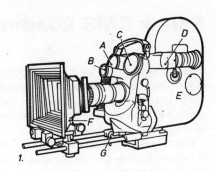

2. A. 6/8v DC motor, B. Variable speed adjustment control; C. Control run switch (pass through boost position quickly when switching on or off); D. Dovetail/tripod screw adaptor base and support bar attachment.

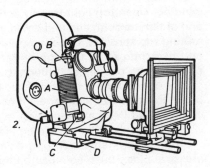

3. A. Screw covering cleaning access to ground glass upper surface/gelatine filter holder safety retainer screw; B. Gelatine filter holder/16 mm aperture plate slot (one or the other must always be in position to avoid risk of light fogging; C. Variable shutter adjustment control, D. Footage remaining indicator. E. Tachometer; F. Inching knob.

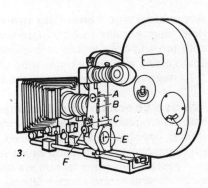

4. A. Accessory attachment point and drive; B. Mag. supply tightening knob; C. Take-up tightening knob; D. Camera body release from base; E. Power supply socket, F. Mag. release.

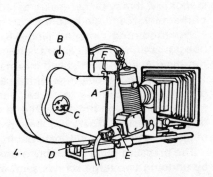

Eclair CM3 Loading and Operation

Eclair magazines may be loaded with film wound either emulsion in or out. 16mm film may be core wound or on 100 or 200ft. daylight spools.

To load, open mag. making sure it does not contain film already exposed. Check interior for cleanliness and for free movement of front spring-loaded pressure plates.

Open sprocket guide rollers and, if preferred for easier loading, film side pressure guides by raising and turning outwards.

Lay roll of film on top of mag. with end coming off according to film winding. Open top light trap by pressing opposite end to entry and poke end of film through and pull down approx. 2.5ft. (750cm) of film. Lace film around top sprocket, close top roller and side pressure guide. Push loose end back into mag. through bottom light trap, leaving a loop just long enough, with one finger through it, to be pulled up level with top of mag.

Lace over bottom of sprocket, close roller and side pressure guide, double check loop size and correct if necessary. Attach end of film to take-up core to wind in an anti-clockwise direction and take-up slack.

Close mag. lid, film remaining indicator will set automatically.

Check loop is emulsion out, divide in two by pressing centre against pressure plate, push equal amounts back into each half of mag.

Attaching and removing magazine from camera

Hold mag. parallel to gate plate and push smartly together. Make sure both top and bottom locks are engaged. Inch film a little to engage pull-down claws and check there is no slack film in the take-up roll.

To remove, press button at right front of mag. and pull away.

Pre-use checks and maintenance

Before using the CM3, as with any variable shutter camera, check that the shutter opening is set as required. To observe shutter opening angle engraved on movable blade where it joins the mirror shutter, loosen and partly rotate lens turret or remove taking lens. To adjust the variable shutter press and rotate shutter adjusting knob while holding inching knob stationary. It may be necessary to loosen a safety locking screw at the root of the movable blade before it can be shifted.

When starting camera using 6/8v motor pause only momentarily in boost position so that camera comes up to speed powerfully but does not run overspeed. Adjust speed by rotating top of motor.

To lubricate, oil bearings which can be seen through two holes in gate plate, inching camera to reveal bushes successively. Other lubricating points are through holes marked in red (two have dust seals which must be pushed aside.) There are three red marked screws in each mag. which must be removed to lubricate behind.

The pressure plate assembly of the mag. may be removed for cleaning by undoing two large screws seen on right side of mag.

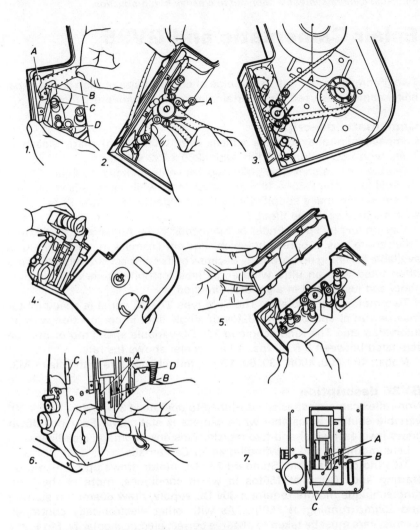

ECLAIR CM3 LOADING AND OPERATION

1. Introducing film through top light trap. A. Film side-pressure guide;
B. Upper light trap; C. Upper guide roller, to be pulled out and upwards to
open sprocket guide rollers (D). 2. Measuring loop length. A. Guide roller.
Film wound 'emulsion-in' should be laid above this roller, film wound
'emulsion-out' should be laid below. 3. Mag. loaded and loops formed.
A. Mag. lubrication points (remove screws for access).

4. Offering mag. to camera body. 5. Mag. pressure plate assembly remove for
cleaning. 6. Using special tool to reset 35/16 mm pull-down claw mechanism.
A. 35 mm pull-down claws; B. 16 mm pull-down claw; C. 35 mm gelatin filter
holder/16 mm aperture plate access position; D. 16 mm aperture plate
storage slot. 7. Camera body lubrication points. A. Movement bearings. Inch
camera to reveal both ends of linkage; B. Sealed oil holes, push in lubricating
can to open; C. Open lubrication holes.

Industrial camera sometimes applied to creative film production.

Eclair Camematic and GV35

Two 35mm instrumentation cameras of compact size or high speed capability, sometimes used for entertainment and documentary filming.

Camematic description

Compact, non-reflex camera which, with 100ft. (30m) mag. measures 7.9in. high x 9.2in. long x 5.5in. wide (200 x 233 x 140mm).

Double claw ratchet type pull-down movement similar to Eclair CM3.

Variable shutter (160° – 10°), adjustable only while camera is stationary.

Cameras normally supplied with Eclair type CA lens mount, but other systems may easily be fitted.

Viewfinding by sportsfinder or monocular or by Angenieux 10 x 24mm reflex zoom lens. A boresight which clips onto camera in place of mag. is available for lining up purposes. Because of its compact size this camera is often fitted with an ultra wide angle lens for point-of-view (subjective) shots and just aimed in a general direction.

Two motors are available. The SFM type 27v DC variable speed motor may be run at speeds up to 32fps or single shot in conjunction with an intervalometer. The Kinotechnique 27v DC variable speed motor may be regulated between 8 & 40 fps. A tachometer shows fps rate.

Mags.: 100, 200, 400ft. (30, 60, 120m), interchangeable with Eclair CM3.

GV35 description

Non-reflex camera especially designed to operate at 30–150fps. 160° – 10° variable shutter, adjustable while camera is stationary. Four pull-down claws (two each side) and two register pins ensure image steadiness.

Lens mounting and viewfinding as for Camematic.

Two motors available. Standard 27v DC motor draws up to 40amp on starting and 16amp at 150fps in warm conditions, more in the cold. Kinotechnique motors require a 30v DC supply, draw 60amp on starting and 20amp running at 150fps. As with other electronically controlled motors, care must be taken to observe correct electrical polarity. Pin 1, 30v DC positive, pin 2, 30v DC negative.

The 400ft. (120m) mags. are standard but 200 and 1000ft. (60 and 300m) are available to special order. Mags. look similar to Eclair CM3 but incorporate an electro-mechanical circuit breaker and a magnetic brake to cope with frame rates up to 150fps, and are therefore not interchangeable. Fps indicated by tachometer. Mags. incorporate footage remaining indicators.

For instrumentation purposes both cameras may incorporate frame marking systems.

110

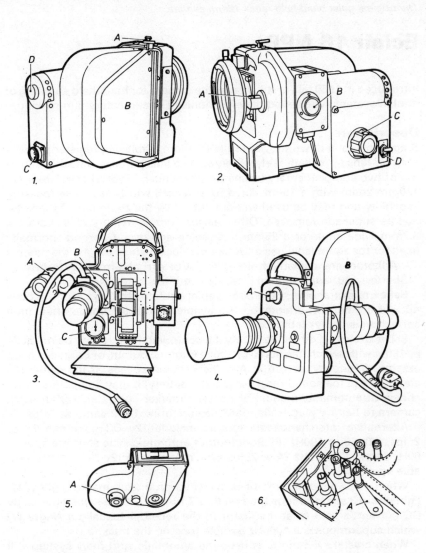

ECLAIR CAMEMATIC AND GV35

1. Eclair Camematic with 100 ft. (30 m) mag. A. Mag. release; B. Mag.;
C. Power socket; D. Inching knob. 2. A. Shutter adjusting knob;
B. Tachometer; C. Fps control; D. 'On/off' switch.

3. Eclair GV35. A. Monocular viewfinder; B. Motor; C. Tachometer; D. Marker
slits; E. Numbering light; F. Double pull-down claws; G. Twin registering
pins. 4. A. Shutter adjusting knob; B. 400 ft. (120 m) mag. (1200 ft. 360 m
mag. also available).

5. Special GV35 mag. incorporating an electro-mechanical circuit breaker and
a magnetic brake. A. Electrical connection to mag.; 6. Mag. lacing path.
A. Film tension arm.

The original quiet hand-held reflex 16mm camera.

Eclair 16 NPR

Introduced in 1960 this is still a favourite camera for hand-held shooting of double system sync sound. It revolutionised documentary film making.

Description

Single claw pull-down movement with a film stabilising register pin.

A two-lens turret with fairly widely spaced lens ports permits the mounting of two complementary lenses simultaneously. Typical pairs are a 12–120mm zoom with a 15mm fixed focal length which has close focusing capability and may be used without cut-off by the zoom lens if the latter has its sunshade removed. Other lenses complementary to a zoom are 5.7mm wide angle or a 25mm f0.95 wide aperture. One port (normally used for the zoom lens) has a CA bayonet locking lens mount, the other is 'C'. Adaptors are available from 'C' to CA or Arri and from CA to Arri.

Shutter: 180° adjustable to 5° while camera is stationary.

Reflex mirror shutter. Standard eyepiece rotates through 360° but does not correct horizon orientation. An eyepiece with automatic orientation correction is an available extra.

Eclair Beala and other 12v DC crystal controlled motors may be run at 24 or 25fps with switchable 50, 60 or 100Hz Pilotone output, or be slaved to an external frequency, or run at 4–40fps variable speeds. If the camera is connected to the sound recorder (via the battery) it may be operated with choice of automatic, manual or no sync marker light. Canon XLR 4 pin camera-to-battery plug is standard. Motors draw 1.6–2.6amp at 24fps.

Alternative interchangeable motors include 12v DC governed 24 or 25fps, (50, 60 or 100Hz) Pilotone output automatic sync start mark, 100v 60Hz 24fps, 220v 50Hz 24 or 25fps sync motors and 12v DC 4–40fps variable speeds.

When a DC governed motor is switched on a sync marker light (E48) lights for 0.3 sec. and fogs the first 6 or 7 frames. At the same time an 8v DC current is sent to an oscillator in the recorder (usually a Nagra IV) which superimposes a 1000Hz audible tone on the track.

When crystal sync motor is used the automatic start mark system will not function unless the recorder is plugged into the battery as for non-crystal sync. Eclair crystal motors have a three position switch which may be set: (a) that the sync marker light does not function, (b) where the recorder is plugged into the battery, to fog the first 6 or 7 frames as with a governed motor but at the same time interrupts the Pilotone frequency to indicate the start of sync position or (c) a manual mark as b) but which the cameraman may operate himself at any time, usually at the end of a shot. This facility is useful when the camera is switched on before the recorder. Lamps on motors light up when camera is running at rated speed.

Clip on co-axial 400ft. (120m) mags. Footage and meterage remaining counters on top of each mag. indicate for film wound on cores or on daylight spools. Serial no. engraved on camera body behind top lens port.

ECLAIR NPR

1. A. 'CA' lens mount; B. Turret lock; C. 'C' lens mount; D. Sync marker lamp; E. Camera running light; F. Base affixation lug; G. Power and Pilotone socket; H. 'On/off' switch; I. Shutter control knob on run position; J. Inching knob; K. Lens mattebox support bar socket; L. Mag. take-up side.

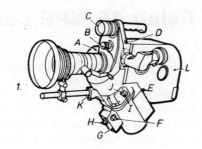

2. A. Mag. feed side; B. Footage/meterage counter; C. Motor.

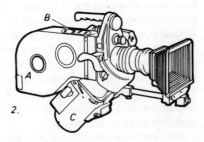

3. A. Mag. lock; B. Mag. release; C. Mag. catch; D. Spring-loaded side pressure plate; E. Pull-down claw; F. Register pin; G. Mag. drive; H. Rubber motor drive coupling; I. Motor locking catch; J. Shutter opening setting knob.

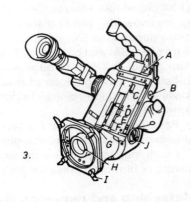

4. A. Flat base adaptor.

113

Not all co-axial magazines have the unexposed film on the same side of the camera.

Eclair 16 NPR Loading

Mags. are co-axial and incorporate the drive and take-up sprockets.

Loading the magazine

Remove right mag. lid, check interior and film guides are free of film chips and the pressure plate at front of mag. is clean and free to spring up and down. Move footage counter arm (1B) to locked position.

For core wound film check flange and core adaptors (1A) are in place.

In total darkness place roll of film on flange with film paying off with emulsion towards top of mag. Open sprocket guide rollers, pass end of film between roller and sprocket checking that perfs. are engaged on sprocket teeth. Close guide rollers, replace lid and lock securely.

If daylight loading spools are used first remove (if necessary) flange and core adaptor. After putting spool in position check catch does not rub against mag. lid. Proceed as for core wound film.

Remove lid from take-up side of mag. and can-up any exposed film. The remainder of the operation may be done in the light. Check mag. interior and film guides are clean.

Turn take-up spindle counter clockwise as marked by an arrow until 4in. (100mm) of film emerges into chamber. Open upper and lower sprocket guide shoes (2C and F) place film on sprocket forming a loop as marked, close upper shoe (2C) continue to turn spindle while pressing front pressure plate (3A) and push end of film through lower opening and into lower film guide. Pull film through between lower side of sprocket and guide rollers (2F) leaving a loop of exactly 12 frames (about two finger widths), close lower guide rollers checking that perfs. are engaged correctly on sprocket teeth.

Pass film over roller and attach to take-up core or spool which rotates counter-clockwise, (emulsion-out), Replace mag. lid on take-up side.

Count loop length to ensure exact 12 frames length (not 11 or 13) press centre of film onto pressure plate and push both ends back into mag.

Attaching and removing the magazine

Check camera aperture plate is clean and free of emulsion build-up, that aperture is free of hairs etc. and that spring-loaded side pressure guide works freely. Remove any emulsion build-up with an orange stick, or similar material. Double check film loop is exactly 12 frames long and evenly divided with 6 frames pushed into either side on mag.

Hold mag. square to camera, engage two lower guides (1G) into slots and pivot upwards until it is securely locked. Lock safety catch (6A).

To detach mag. push safety catch (6A) to right, hold camera and mag. firmly in both hands and press release button (5B). If filming is complete, protect aperture plate and mag. front with covers.

114

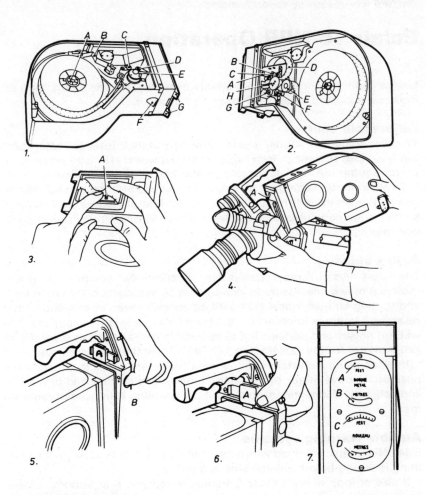

ECLAIR NPR LOADING

1. NPR mag. supply side. A. Core centre (may be removed when daylight loading spools are used); B. Film remaining counter arm; C. Guide shoe release; D. Guide shoe; E. Feed sprocket; F. Drive shaft; G. Mag. locating tongue. 2. NPR mag. take-up side. A. Film guide opening pin; B. Upper guide shoe release; C. Upper guide shoe; D. Film loop from supply side; E. Guide roller; F. Lower guide shoe; G. Lower guide release; H. Feed and take-up sprocket.

3. Forming equal hole loops on either side of mag. throat. A. pressure pad. 4. Offering mag. to camera. A. Mag. locking stud.

5. Removing mag. from camera by opening mag. lock. (A) and pressing mag. release button (B). 6. Securing mag. to camera by moving safety lock (A) to left. 7. Mag. film remaining counter. A. Daylight loading spool wound film indication in feet; B. Daylight loading spool wound film indication in meters; C. Core wound film indication in feet; D. Core wound film indication in meters.

115

Eclair 16 NPR Operation

Unless certain requirements are strictly observed, trouble, in the form of incorrect exposure, noise and jamming will occur.

Adjustable shutter

To check adjustable shutter is set as required, unlock turret and rotate 90°. Set lever (1A) to 'reflex'. Inch camera knurled wheel (1B) until junction of mirror shutter (5A) and adjustable shutter blade (5B) are visible.

To alter shutter setting set lever (1A) to 'reglage obturateur' and hold in position, push in and rotate button (4F) on right of camera until desired shutter opening is obtained. The lever automatically returns to run position 'moteur'.

Reflex viewing

The latest crystal motors always stop in the 'view' position. On other motors it may be necessary to inch camera by setting lever (1A) to 'reflex' and turning knurled wheel (1B) until an image is seen in viewfinder and resetting camera to 'moteur'. Unless lever (1A) is reset to 'moteur' camera will run noisily and perhaps not to speed. No damage will result and it is just a matter for the cameraman to quickly reset the lever correctly.

If, when using a crystal motor, camera consistently fails to stop in view position, remove motor by loosening four locking catches and turn drive knob slightly. If it continues to slip rubber coupling is in need of replacement.

Audible warning systems

Eclair NPR mags. are fitted with noise-making devices which warn if something is wrong before any damage is done.

If size of loop is not exactly 6 frames at top and 6 at bottom, a loop warning noise will sound. Stop camera, remove magazine, pull out loop, count frames and if correct reset 6 and 6. If fault persists and correct size loops are lost, check loading of both sides of mag. (in a dark environment) in case a jam has occurred. Also check cleanliness of aperture plate, free operation of spring-loaded side pressure guide and springiness of mag. pressure plate.

Mags. are also fitted with a torque-warning noise-making clutch which operates if film jams. When this occurs stop camera, remove the mag. and check loading in the dark.

Most problems with Eclair NPR cameras can be put down to incorrect mag. loading and failure to keep film path absolutely clean.

Lubrication

The moving parts of the Eclair 16 NPR are fitted with permanently lubricated bearings and should not be additionally lubricated.

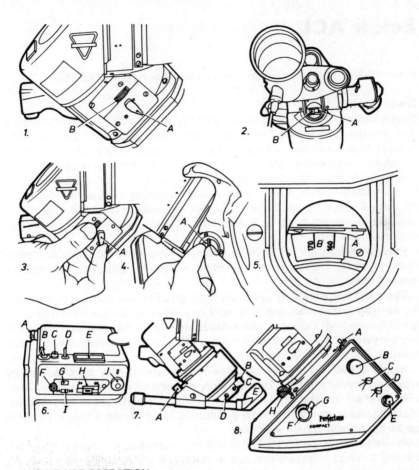

ECLAIR NPR OPERATION

1. Shutter control lever in inching position. A. Shutter control lever; B. Camera inching knob. 2. Turret turned 90° to observe shutter opening. A. Mirror shutter; B. Adjustable shutter blade.

3. Shutter control lever (A) set to 'reglage obturateur'. 4. Shutter control knob (A). 5. Shutter adjusted to desired setting. A. Mirror shutter; B. Adjustable shutter blade.

6. Eclair Beala crystal motor. A. Fuse; B. Camera run switch; C. Off-sync warning light; D. Switch to automatic start mark/no start mark/manual start mark; E. Tachometer; F. External sync socket; G. Int/ext sync switch; H. 50/60/100 Hz Pilotone output switch; I. 24/25 fps switch; J. Crystal sync/variable speed switch and control. 7. Aaton Alcan 54 Motor. A. Camera run switch; B. Variable speed control; C. Crystal speed warning light; D. Mode switch 1. crystal 2. crystal 3. variable E. Adjustable shoulder rest. 8. Perfectone Compact motor. A. Off-sync speed warning light; B. Variable speed control (12–40 fps); C. Sync speed/pulse selector switch; D. Int/ext sync selector switch; E. Fuse; F. Camera running button; G. Camera run lock; H. Auxiliary switch socket.

117

Although from the same stable as the NPR, nothing is interchangeable.

Eclair ACL

A particularly compact, simple, quiet 16mm camera without frills.

Description
Single interchangeable lens mounting; a broad ring or flange with internal and external threading. The inside thread is a 'C' mount and onto the outside may be screwed Eclair TS mount adaptors to take CA, Arriflex, Nikon or any other lens mounting system provided the lenses used have a mechanical back clearance distance greater than 0.690in. (17.52mm).

Provision for gelatine filter in a metal slide immediately behind lens (can be seen through reflex finder). Even if filter not used, slide must be in position to prevent fogging. Spare filter or empty slide may be stored in optional hand grip.

Focal plane shutter (175°) independent of the reflex system. Oscillating (side to side) mirror reflex viewfinder system. Non-interchangeable ground glass.

Standard eyepiece fully rotatable through 360°, has manual adjustment for horizon orientation, left and right eye viewing compensation and iris type closure ring. Optional orientatable viewfinder has automatic horizon compensation. A TTL exposure meter with indication which may be seen through the viewfinder is available.

Single speed 12v DC 24 or 25fps motor (speed may be changed by replacing crystal unit) or 12v multi-duty motor with crystal control at 24 or 25fps and set variable speeds 8, 12, 50, and 75fps. Motors draw 0.8amps. Motors always stop in the view position, a lamp on the motor (3F) lights up as 'off crystal speed' warning.

Available 50, 60 or 100Hz Pilotone and automatic sync start mark module has three position switch, left or right is is 'automatic sync mark on', centre is 'off'. Switching to left or right during a take gives a manual start mark. Pilotone module may operate off internal 12v battery or be plugged into camera supply. (Internal/external power supply switch requires that Pilotone frequency be set correctly.)

A normal small battery runs 2400ft. (700m) in good conditions. Standard charger recharges in 15hrs.; optional high speed charger in 2hrs.

The 12v power supply may be supplied with either 4–pin Canon or Jeager plugs (check correct cables are supplied with camera). Jeager plugs automatically lock in position when plugged in. To remove pull on ridged ring, do not twist.

Co-axial mags., 200 and 400ft. (60 and 120m). Footage remaining counter on mags. marked for both spool and core wound film.

Other accessories include magazines modified for com-mag (single system) sound recording and EBU time-code marking system.

Serial number of French manufactured models on left side of camera body, of English models on left inside magazine recess.

ECLAIR ACL

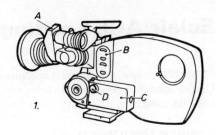

1. Eclair ACL with 400 ft. (120 m) mag. A. Orientable viewfinder; B. Footage/meterage remaining indicator; C. Eclair multi-duty crystal controlled/variable speed motor. D. Fps contro'

1.

2. Eclair ACL with 200 ft. (60 m) mag. A. Start/stop switch; B. Mag. take-up side; C. Intermediate lens-mount adaptor; D. Standard type (non-orientable) viewfinder.

2.

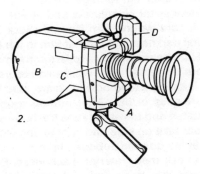

3. ACL camera body, mag. removed. A. Gelatine filter slide; B. Mag. lock; C. Mag. lock; D. Aperture plate; E. Mag. drive; F. Motor 'off speed' warning light; G. Exposure meter sensitivity control; H. Power supply socket; I. Clapper switch; J. Spare gelatine filter slide storage.

3.

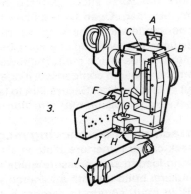

4. ACL com-mag (single system) sound model. A. Sound recording amplifier; B. 2 × mic. inputs; C. Sound selection switch; D. Sound recording connection to magnetic recording and play-back heads in mag.

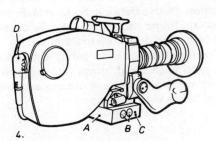

4.

119

Eclair ACL Loading

Eclair ACL mags. are co-axial and incorporate drive and take-up sprockets. Unexposed film is housed in left compartment. Single or double perf. film may be used, emulsion in or out, 'A' or 'B' wound.

Loading the magazine

Remove left mag. lid by turning catch counter-clockwise and pulling lid backwards. Lift footage counter arm which locks up automatically. Check chamber for cleanliness and absence of film chips.

If core wound film is used check flange and adaptor is in position. In total darkness hold roll of film in left hand and push approx. 6in. (150mm) of film between guide rollers with emulsion towards exterior of mag. Place core on flange and replace lid securely.

If daylight loading spools are used first remove (if necessary) flange and core adaptor (IC). After putting spool in position check catch is properly located and the spool runs freely without touching mag. or lid. Remove lid from take-up side and can-up any exposed film. The rest of the operation may be done in subdued light.

Check mag. interior cleanliness. Pull end of film over roller, through upper film guide and back through lower film guide. Pull 20in. (50cm) of film into mag. Open both guide shoes place film between sprocket and upper guide shoe, checking that perfs. are correctly located. Adjust loop size until level with top of mag., close lower guide rollers and form top and bottom loops inside mag. The lower loop may be made one frame larger than the upper to compensate if one frame is lost when the pull-down claw first enters the film. Secure film to take-up core or spool which rotates in a clockwise (emulsion out) direction. Replace mag. lid on take-up side.

Attaching and removing magazine from camera

Check camera aperture plate is clean, that aperture is free of hairs and spring-loaded side pressure guide is free to work correctly. Remove any emulsion build-up with an orange stick or similar non-metallic aid.

Hold mag. square to camera but tilted backwards with lower part of front resting on aperture plate and with mag. drive shaft (ID) correctly aligned. Pivot mag. upwards until sharp click indicates it is locked firmly in position. Push safety catch inwards. Ensure mag. really is locked tightly in position. Slight misalignment may cause film to pass through mag. but not be pulled down intermittently.

To detach mag. slide safety catch outwards, hold camera and mag. firmly in each hand, press release lever with index finger pulling mag. downwards and away. If filming is complete, protect aperture plate and mag. fronts with covers.

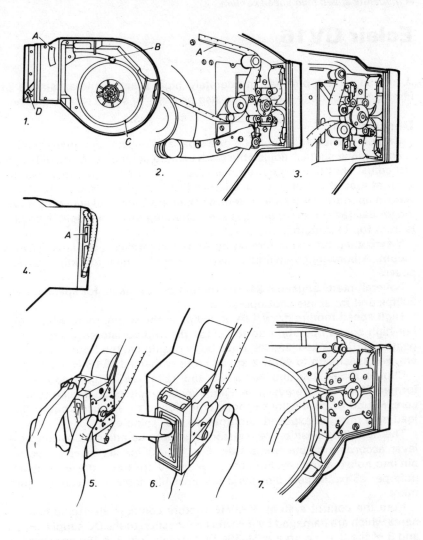

ECLAIR ACL LOADING

1. ACL mag. (200 ft., 60 m) supply side. A. Footage remaining indicator; B. Footage indicator arm; C. Supply flange and core centre, to be removed when using film wound on daylight loading spool; D. Take-up drive. 2. Film path (400 ft., 120 m mag). A. Film channel from supply side. 3. Film path (200 ft., 60 m mag.).

4. Setting loop length, A. Gate pressure plate. 5. Judging loop length of com-mag (single system sound) mag. 6. When loading com-mag mag. entire 21 perf. loop is pushed back into mag. towards the take-up spool and then reversed 6 perfs. toward feed side leaving a small loop on top and a large one below. 7. Loading path of com-mag (single system sound) mag.

121

Eclair GV16

A compact multi-purpose, moderately high speed camera capable of filming rates of up to 200fps. May also be used for single shot operation.

Description

Twin pull-down claws, (both on one side) and register pin movement.

Focal plane shutter, adjustable (with camera stationary) from 180 – 10°. (To adjust shutter opening remove mag. or aperture cover, inch camera knob at rear of motor until junction of fixed adjustable shutter blades is seen in aperture. Turn knob in centre of camera front until engraved marking for desired shutter opening is seen, checking that movement of shutter is from top to bottom.)

Viewfinding for action filming by Angenieux reflex zoom lens. 'C' lens mount. A boresight viewfinder may replace film mag. for lining-up purposes.

Several interchangeable 24–30v motors are available for speeds up to 200fps and for single shot operation.

High speed motors draw 12A at 200fps in the warm, more when cold. For high speed operation up to 200fps the appropriate speed reduction gearbox (1D) marked '200 I/S' must be in position in the front of the camera. For speeds up to 40fps a speed reducer marked 40 I/S is used.

Clip-on mags. 100 and 400ft. (30 and 120m) which incorporate preformed film loops are available. Film may be single or double perforated, core wound or on daylight spools, emulsion in or emulsion out. (When loading a mag., unexposed film goes on rear spindle.)

The operating position of register pins must be adjusted by a special lever according to the frame rate. For 100–200fps set lever of locking pin into hole marked red. For speeds below 100fps lower the lever by one hole per 25fps. Inspect film perfs. for possible damage to check adjustment.

Note the control system of GV16 motors contains electronic components which are damaged by incorrect connection to the DC supply. Pins 1 and 3 of the 8–pin plug are 24–30v DC positive, pin 2 is 28v negative.

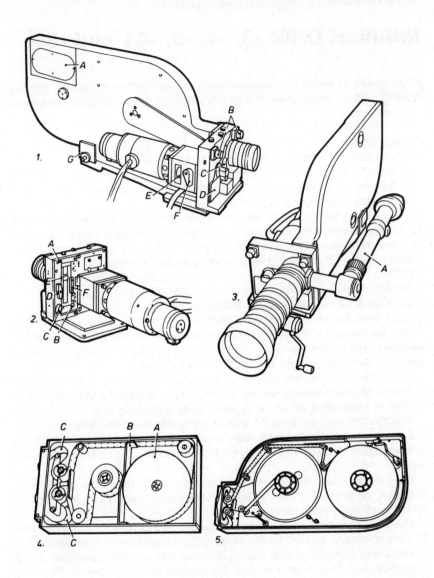

ECLAIR GV 16

1. A. Footage/meterage remaining counter; B. Neon marker lamp; C. Shutter adjusting knob; D. Speed reducer; E. Inching knob; F. 10–50/50–200 fps speed range switch; G. 400 ft. (120 m) mag. support. 2. A. Mag. latch; B. Mag. drive; C. Claw tension adjustor; D. Safety catch; E. Marker light and numbering apertures; F. Double pull-down claw. 3. A. Reflex zoom lens finder.

4. 100 ft. mag. A. Film supply; B. Sliding separator; C. Preformed loops.
5. 400 ft. (120 m) mag.

Milliken DBM -3, -4, -5, -44 and -55

High speed cameras for instrumentation, scientific and sports filming DBM -3, -4 & -5 models take 100, 200 & 400ft. (30, 60 & 120m) film loadings respectively.

Description
Double pull-down, double register pin movement.

Fixed opening focal plane shutter; 7½, 10, 18, 36, 60, 72, 120, 140 and 160° settings are optional. To check which blade is fitted remove lens mount plate from front of camera.

Viewfinding for action filming by reflex zoom lens. Cameras intended for instrumentation filming may have a reflex boresight which may only be used while the camera is stationary.

Various 28v DC and 115v AC motors may be fitted viz:

DBM-3, -4 & -5; governor controlled 64, 128, 200, 400 fps.

DBM-5D: governor controlled 64, 128, 250, 500fps.

DBM 44 & 54: variable speed 2–400fps.

DBM 45 & 55. variable speed 2–500fps.

On the governor controlled motors two speeds may be selected by switching (while the camera is running) and two by removing the motor and adjusting the gearing i.e: 64/200 or 128/400fps.

Some DBM-5 cameras have a 'G–19' three ratio transmission, the control knob of which may be set (while the camera is stationary) to give 24/40 64/100 or 250/400fps. Must be in neutral while loading film.

The 28v DC motors draw 7.5amp at 400fps & 9amp at 500fps.

Cameras take 100, 200 and 400ft. daylight loading spools according to model. 1200ft. (360m) mags. may be fitted to DBM-4M and DBM-5M models.

Film must have double perfs. Cameras may take film perforated 0.3000in. or normal 0.2994 pitch. A label inside each camera indicates which perf. pitch is necessary.

The 28v DC motor power supply is connected to pins 10 (positive) and 11 (negative) and the DC heater to pins 7 (positive) and 11 (negative).

The 115v DC motor power supply is connected to pins 1 (positive) and 2 (negative) and 115v heater to pins 6 (positive) and 2 (negative). Pin 19 is earth (ground).

Footage remaining indicator on camera rear and on mags.

Camera serial number on label on side of camera.

Lubrication
Certain bearings of cameras run at 400 and 500fps should be lubricated with a recommended oil and gaps between ends of pilot pin lever and slide block must be greased (work a little grease in at each end with a tooth pick) after every 1200ft. (360m) of film (see illustration).

MILLIKEN CAMERAS

1. DBM 3 (100 ft., 30 m).

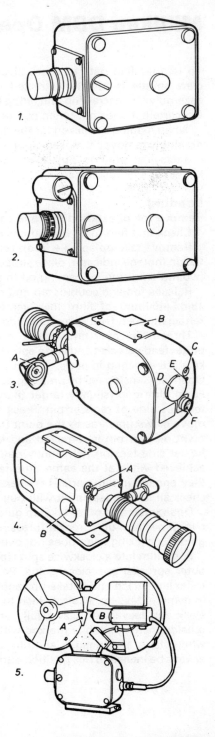

2. DBM 4 (200 ft., 60 m).

3. DBM 5M with Angenieux 10 ×
12 mm f2.2 reflex zoom lens.
A. Short eyepiece for hand-held
operation; B. Attachment position
for 1200 ft. mag. C. Speed control;
D. Footage remaining counter;
E. Footage counter tab; F. Power
and control systems socket.

4. DBM 5M with 'G-19' three-ratio
transmission. A. G-19 transmission
control (change only when camera
is stationary and set to neutral
when loading); B. Outside inching
knob and indication of film locked
position to be set during
transportation.

5. DBM 5 with 1200 ft. mag.
A. Footage indicator; B. Take-up
motor.

Milliken DBM Operation

To remove film gate to check cleanliness, inch camera until pull-down claw shuttle is in fully retracted position, carefully remove film gate assembly by unscrewing and lifting knurled knobs at top and bottom making certain it does not touch pull down claws en route.

When loading a Milliken for the first time, inch camera slowly with gate assembly removed to observe point in intermittent cycle when register pin retracts just prior to pull-down claws entering perfs. This moment is known as the 'loading zone'.

Loading

Remove roll of exposed film and can up if necessary.

Check that film to be loaded has correct perf. pitch.

Remove take-up spindle (red), retract footage counter arm by rotating tab on footage indicator, place supply roll of film on inner spindle with film (wound emulsion in) coming off in a clockwise direction.

Release footage counter tab and replace take-up spindle. Pull off about 18in. (450mm) of film. Inch camera until pull down claws are fully retracted, open feed sprocket guide.

Thread film over timing-lamp housing and guide roller, around and under feed sprocket and close sprocket guide. Inch camera to check sprockets are engaged in perfs. correctly, returning to fully retracted position. Open film tension rail by pressing down and sliding upwards to lock open. Form film loop (slightly larger than marked) slide film into gate until it touches side of register pin. Press on rear of pull-down claw shuttle to move claws upwards to the point they are just touching the film. At this point register pin is retracted and film can be correctly located in gate. Re-set side tension rail. Gently pull film down until correct size loop is achieved while at the same time feeling pull-down claws forward until they engage in film perfs. Take care not to damage film. Inch camera to check all is well, leaving it with pull-down claws engaged.

Open inner and outer take-up guides. Form lower loop and thread film over inner take-up sprocket (pressing in automatic cut-off switch). Close guides, checking lever does not over-travel and touch film.

Form film into a clockwise spiral loop according to markings, engage on outer sprocket and close guide. Pass film counter-clockwise round last roller and attach end to take-up spool emulsion-in (clockwise). Place spool in camera, take-up all slack, inch to check and to remove any remaining slack and leave with claws fully engaged. Replace camera door. Note outside inching knob is marked with an arrow which points downwards when claws are engaged and film is locked in position. Camera should always be inched to this position during transportation and between takes.

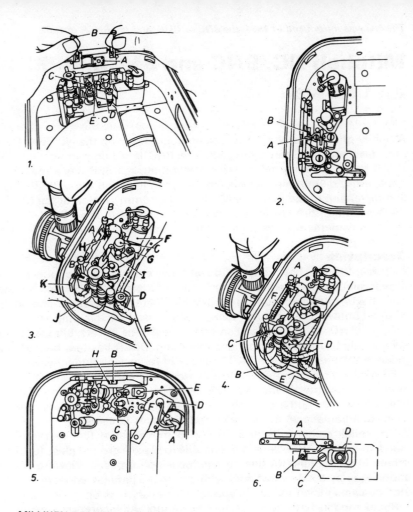

MILLIKEN DBM OPERATION

1. Removing aperture plate for cleaning. A. Aperture plate; B. Knurled knobs; C. Shuttle in fully retracted position; D. Inside inching knob and feed sprocket; E. Register pin. 2. Movement in loading zone position for lacing. A. Shuttle just about to enter film; B. Register pin just retracted.
3. Lacing, first stage. A. Aperture plate; B. Knurled securing knobs; C. Inside inching knob and feed sprocket; D. Brake roller; E. Supply spool; F. Timing light, assembly; G. Timing light, guide roller; H. Film tension rails locked open (pressed down and slid upwards); I. Feed guide release; J. Inner take-up sprocket; K. Inner take-up guide toggle arm (push rearwards to open). 4. Lacing, second stage. A. Film tension rails closed (raised); B. Spiral climbing loop; C. Outer take-up sprocket; D. Clutch arm; E. Cut-off switch arm; F. Outer take-up guide toggle arm (lift to open).
5. Means of access from film compartment to lubrication points. A. Timing light assembly removed; B. Register pin; C. Inside inching knob removed; D. Cover plate removed; E. Slide block; F. Pilot pin lever; G. Lever pivot; H. Register pin pivots. 6. Points to be oiled. A. Register pin pivots; B. Register pin linkage pivot; C. Register pin lever pivot; D. Both edges of slide block where it makes contact with pilot pin lever. Note late camera models, and cameras retro-modified do not require lubricating.

The NC was introduced in 1934, the BNC in 1938, and the BNCR in 1967.

Mitchell NC, BNC and BNCR, SPR, 16 and Newall

A family of cameras sharing a common ancestry with the NC 'New Camera' designed by George Mitchell. The BNC is a blimped version. The BNCR has a spinning mirror reflex viewfinder, the SPR has a thin semi-transparent membrane (pellicle) set between lens and film. The BFC is a 65mm version of the BNC, the Mitchell 16 a 16mm version of the NC and the Newall a British made camera almost identical to the NC.

35mm cameras may be modified for Techniscope two-hole pull-down.

Description

All (except 16mm) have four pull-down claws and two register pins to give exceptional image steadiness. Unblimped models are much used for special effects multi-exposure photography. (Blimped versions should be wedged between camera and blimp body if used for this purpose.)

Original NC, 16 and Newall cameras have 4–lens turrets, blimped models a single bayonet/lock ring lens mounting. BNCR has less behind-lens mechanical clearance than BNC because of reflex viewfinder system.

Focal plane type shutter, adjustable from 175° – 0° while camera is running. (16mm cameras after No. 227 have a max. shutter opening of 235°.) BNC adjustable shutter controls may be interlocked with camera running to make automatic 96 frame fades and dissolves in camera.

Non-reflex cameras have a facility to move entire film bearing and viewfinding portion of camera to one side to place a ground glass focusing screen in focal plane for line up and focusing purposes. Viewing during shooting is by a side viewfinder with automatic parallax correction operated by cams which are made specially for every lens on every camera.

Reflex models have normal reflex viewfinder. All incorporate two stage image magnification and viewing filter facilities. Non-reflex models may be made 'reflex' by the use of a reflex zoom lens.

Motors available include crystal and mains sync, battery/mains multi-duty variable speed etc. NC and BNC motors are interchangeable (except DC variable speed). Max. speed of the 35mm cameras is usually 32fps, the 16mm model is capable of 128fps. High speed 35mm Mitchell cameras have a 'Standard' type movement which is totally different from the NC.

Buckle trip switches fitted to NC type cameras are located in the camera box and on BNC cameras on the outer camera door.

Separate compartment 1,000ft. mags. are standard; 400ft. or bipack may also be used; 16mm model takes 400 and 1,200ft. mags.

Other Mitchell facilities may include built-in four way mattes for horizontal or split-screen cinematography, a filter disc holding 6 behind-lens gelatine filters or a gelatine filter holder slot, rise and fall front (NC with 4–lens turret) internal heaters, buckle-trip switch, spirit level.

Camera serial number on mechanism plate and (inner) camera door.

MITCHELL CAMERAS

1. Mitchell NC. A. 1000 ft. (300 m) mag.; B. Take-up pulley for reverse running; C. Four-lens turret; D. Non-reflex viewfinder; E. Rise and fall lens adjustment; F. Interchangeable motor.

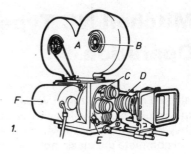

2. Mitchell BNC/BNCR Rear Panel. A. Mag. blimp release; B. Adjustable shutter control and scale; C. Automatic 'in-camera' fade and dissolve control; D. Shutter position and camera running indicator (miniature shutter); E. Motor inching knob; F. Total footage shot counter; G. Viewing filter select button; H. Magnification control; I. Focusing viewfinder (reflex viewfinder on BNCR); J. Non-reflex auto parallax side viewfinder (optional on BNCR); K. Side viewfinder field of view control; L. Scene footage-shot counter; M. Frame counter; N. Operator's focus control; O. Level; P. Camera carrying handles; Q. Rack-over control (not on BNCR).

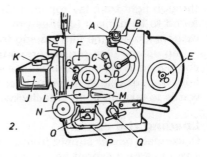

3. Mitchell BNCR. A. Focus control lock; B. Focus controls; C. Focus control fine adjustment; D. Focus control engagement lock.

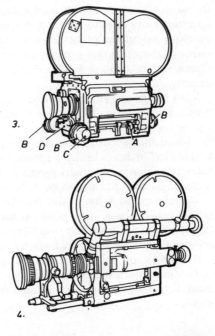

4. Mitchell 16 converted to reflex by the use of an Angenieux 10 × 12 mm f2.2 reflex zoom lens.

Mitchell NC Type Loading and Operation

Mitchell mags. lined with velvet or corduroy are particularly prone to pick up particles of dirt which may cause scratches or black sparkle on the film. They should be thoroughly cleaned with an air-line as often as possible.

In complete darkness, hold unexposed stock (must be wound 'emulsion in') with loose end coming off in a clockwise direction. Push end down between the centre wall of mag. and the idler roller until it emerges through light trap, lay roll in compartment and close lid securely. If it is found to be difficult to thread the film through the light trap make a 6in diagonal fold in the film sloping from the centre outwards.

Can up any film in rear compartment. Remainder of operation may be completed in the light. Push loose end of film back into mag. through rear light trap, over idler roller and secure to take-up core with emulsion outwards to take up in an anti-clockwise direction.

Loading the camera

Disconnect power supply from camera or disengage buckle switches to ensure camera cannot be run by accident during loading operation.

Clean inside of camera with brush or air-line. To remove aperture plate for checking and cleaning, inch camera until pull-down claws are fully disengaged from perfs. and withdraw register pins by pulling register pin throw out knob outwards and sideways to right. Turn top and bottom aperture plate release levers anti-clockwise until pins point upwards and carefully withdraw plate directly outwards. Check aperture mask is as required. Remove rear pressure plate to clean by swinging retaining lever. Check rollers revolve freely. Replace aperture and pressure plates and secure.

Turn sprocket guides to release guide rollers from sprocket.

Pull a short loop of film from front compartment of mag. and pass into camera. Attach and secure mag.

Thread film according to diagram, inch camera until pull-down claws engage in film sprockets. Re-set register pin. Form upper loop so that at its fullest position it just clears radius of aperture plate and lower loop so that it clears bottom of camera by ⅛ – ¼in. (4 – 8mm).

Tighten guide rollers, slip take-up belt over rear mag. pulley wheel (check it is properly over pulley wheel inside camera), take-up film slack. Reset buckle trip switches, run film to check all is well and to adjust pitch control (if fitted) to point where noise is minimised. Close camera door.

Reset footage counter, check shutter opening is set as required.

To run camera in reverse place take-up belt over front pulley wheel of mag. If take-up belt makes a noise during shooting rub in a little french chalk.

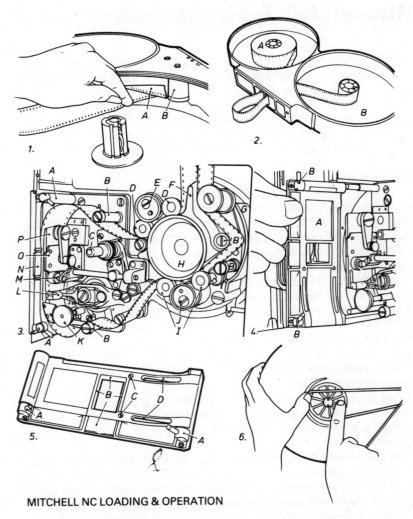

MITCHELL NC LOADING & OPERATION

1. Threading Mitchell type mag. End of film may be folded over A, to ease passage past idler roller B. 2. Film path of loaded mag. A. Supply side; B. Take-up.

3. Film lacing path. A. Aperture plate release; B. Film rollers; C. Register pin throw-out; D. Upper guide sprocket rollers; E. Upper sprocket film guide; F. Stripper, G. Buckle-trip switch; H. Drive sprocket; I. Lower sprocket guide rollers; J. Lower sprocket guide; K. Pitch adjustment; L. Pull-down claws; M. Register pins, N. Aperture mask or matte slot; O. Pressure plate; P. Register plate. 4. Removing aperture plate (A) from camera. B. Aperture plate releases.

5. Aperture plate. A. Aperture plate release; B. Aperture mask; C. Register pin clearance holes; D. Pull-down claw clearance slots. 6. Take-up belt should be wound onto pulley wheel, not stretched.

Mitchell NC Type Lubrication

The lubrication of an item of precision engineering such as the Mitchell movement at the correct intervals is absolutely essential if reliability of operation and longevity of equipment is to be ensured.

The following information applies to all Mitchell NC based cameras including the CP XR35 and the Panavision PSR. Only a recommended camera oil should be used and then very sparingly, with any surplus oil wiped away so it does not splash onto film surface.

Movement
Every 2000ft. (600m): eccentric arm bearing (1), timing block unit (2), register pin bearings (3), register pin bearings (4), eccentric arm bearing (5), eccentric shaft sliding block bearing (6), top and lower sides of sliding block (7), rear bearing of register pin arm (8), rear bearing of register pin arm (10), rear pivot arm bearing (11), front bearing of toggle arm (12), rear bearing of toggle arm (13).

Every 5000ft. (1500m): swivel block on register pin arm (9).

Every 10000ft.: pressure plate rollers (14, a drop on each end).

Every 50000ft.: pressure plate retainer arm (15).

Film rollers
Every 3000ft.: 19, 20.

Every 10000ft.: 16, 17, 18, 21, 23, 24, 25, 26, 27, 28, 30.

Every 50000ft.: 22, 29.

In addition the film runners of the aperture plate and pressure plate should be wiped clean with a slighly oiled lint-free cotton swab and polished with the thumb or heel of the hand to ensure that all oil is removed.

The gibs on which rack-over cameras slide must also be oiled occasionally and there are two grease points (31 and 32) behind screw heads on the motor side of the camera box, one for the sprocket shaft bearing, the other for the shutter shaft which should be greased every 50,000ft.

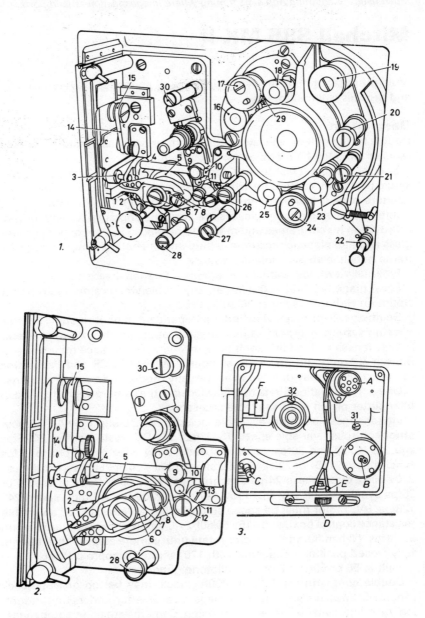

MITCHELL NC TYPE LUBRICATION

1. BNCR lubrication points.

2. NC movement lubrication points.

3. Reverse side of NC type camera. A. Motor power socket; B. Drive shaft; C. Buckle-trip switch plunger; D. Motor securing latch; E. Heater element; F. Adjustable shutter control knob spring tensioner.

Mitchell S35 MK II

Multi-purpose camera for sync, high-speed, animation, reverse running and process cinematography.

Description

Double forked pull-down claws engage in four perfs. simultaneously. Dual register pin. May be modified for Techniscope.

Special 3 prong 'twist-to-lock' lens mounting system, 3-lens turret or a single port front, centred for either academy or full-frame apertures. 'Full' aperture plate is standard, masks available for all other formats.

Interchangeable ground glasses are available engraved for any format.

Provision for cut-frames and mattes to be placed in front of both ground glass and film plane for accurate line-up and in-shot masking. An accurate frame punch is an available accesssory.

External viewfinder with auto-parallax an optional accessory.

Focal plane type 170 – 0° shutter, adjustable while camera is running. Optimum HMI frequency at 24fps 50.8Hz.

Spinning mirror reflex viewfinder independent of photographic shutter. Viewing system incorporates hi-lo magnification, and two viewing filters.

Only lenses with a fairly long back mechanical clearance may be used. Bausch & Lomb and Kowa are standard. Mitchell BNCR and Panavision mounted lenses may be used with specially modified mounting systems.

One or two gelatine filters may be placed in the camera aperture plate. A filter cutter punch is an available accessory.

Interchangeable motors available include: 24v DC and 115v AC/DC governor controlled variable speed 16–32fps, 36v DC crystal control 24/25fps and 12, 16, 20 and 30fps variable speeds; 115v 60Hz single phase 24fps synchronous; 115v or 220/24v 50Hz single phase 24 or 25fps synchronous; 220v 60Hz three phase 24fps synchronous; 220v 50Hz three phase 24 or 25fps synchronous; 24v DC, 115v AC/DC or 220/240v AC high speed 24–128fps. (AC motor must be speed controlled by a Variac, DC by a variable resistance control box), and 115v 50/60Hz AC single shot or continuous run at 1.1fps. (When fitting this motor rotate until camera stops with shutter in fully closed position.) Exposure with 170° shutter is approx. ½sec.

Built-in 50 or 60Hz 1.2 or 1.8v Pilotone generator.

Double compartment 1000 or 400ft. mags. may be top or slope-back mounted. Special 400ft. inverted mags. available for underslung mounting. All mags. suitable for reverse running. Camera with underslung mags. may be hand-held with special hand-grip or tripod mounted with special hi-hat adaptor, latter facility is useful when shooting with limited headroom.

Footage counter and tachometer are mounted on rear of camera. A sound-proof blimp an optional accessory. Camera serial number engraved on mechanism plate and top of camera.

MITCHELL S35 Mk II

1. Camera with single lens front and top mounted 1000 ft. mag.
A. Lens release; B. Mounting for non-reflex side viewfinder;
C. Reflex image magnification control; D. Door lock; E. Viewing filter controls; F. Short run switch;
G. Eyepiece focusing release;
H. Light trap control.

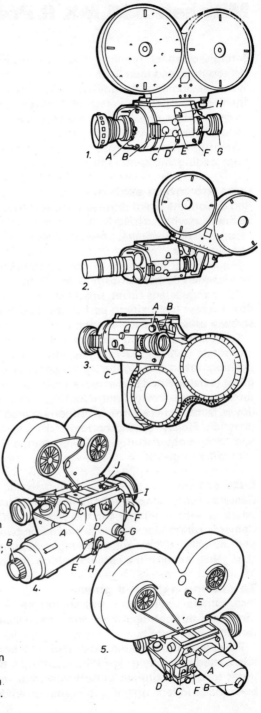

2. Camera with 3-lens turret, 1000 ft. mag. mounted in slope-back position.

3. Camera with 400 ft. (hand-held) underslung mag. in position.
A. Footage counter re-set;
B. Footage counter; C. Special adaptor to use camera on tripod with underslung mag.

4. Camera with 400 ft. mag. mounted in top position. Note a method of absorbing surplus length of long take-up belt. A. 24v variable speed motor; B. Speed control; C. Tachometer; D. Motor attachment screws; E. Reverse run switch; F. Remote-run socket; G. Inching knob; H. Power socket; I. 'On/off' switch; J. Adjustable shutter control. 5. A. High speed motor (sync motor is similar); B. Inching knob; C. Reverse-run switch; D. Sync pulse outlet; E. Additional roller used when putting take-up belt onto front pulley wheel for reverse running; F. Power supply socket. Note when running camera at high speed it is important to take up any slack film in the magazine before each take.

135

Mitchell S35 MK II Preparation

Before use, attach required motor, connect power supply and test run.

If top-mounted mag. is to be used check that light tight cover is in place over rear opening. If slant-back mag. position to be used check that top opening is properly covered and that rear mag. adaptor is in position. For inverted mags. check top opening is covered and re-align gear train to avoid damaging take-up mechanism.

Aperture plate and pressure pad removal for checking and cleaning, and mag. loading and camera threading are similar to Mitchell NC (page 130).

Lens mounting system
Red dot on one leg of three prong 'twist-to-lock' bayonet lens mount must be lined up with a similarly marked slot on the camera. Rotate clockwise to secure. To remove lens, press spring-loaded locking catch and rotate lens anti-clockwise.

Super Baltar lens mounts incorporate a focus locking ring, which must be loosened by quarter turn to permit focusing.

To change a lens turret, unscrew centre locking screw and central hold-down screw (with single port turret loosen also top and bottom locking screws) press release lever and remove turret from camera.

To fit a turret offer it up to camera, press release lever, push in firmly and rotate until it locks into position and release lever returns to original position. Insert and tighten turret central hold-down screw. If a rotating turret is being fitted this screw should be loosened very slightly to permit turret to rotate freely. Centre locking screw is then inserted and screwed down. Double check turret is properly seated by trying to rotate it in either direction. Finally top and bottom locking screws of single lens type turret should be tightened down. Finally, flange focal depth must be checked with a depth gauge.

Lubrication
Cameras run at a normal 24fps should be lubricated as indicated and at intervals recommended for the Mitchell NC type cameras (page 132). Cameras run at higher speeds should be oiled with increasing frequency until at 100 – 128fps operation *movement to be lubricated before every take*. (Note never run a camera at high speed without film being laced.)

To change a ground glass
inch camera until mirror and shutter are in fully open position. Insert forefinger through lens port and gently slide out ground glass to pass through. If a matte is in position this should be removed at same time.

To replace, slide ground glass in with etched side toward lens and check it is seated correctly (page 18). Note it may be necessary to remove lens turret to change ground glass unless two small clearance notches have been made in lens opening to permit ground glass to pass through.

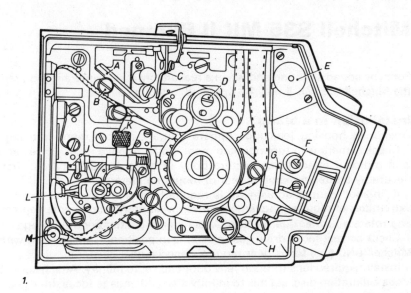

1.

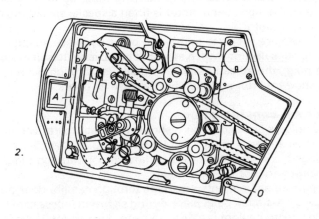

2.

MITCHELL S35R Mk II LACING

1. Threading path for a top-mounted mag. A. Upper buckle trip-switch;
B. Buckle reset knob; C. Camera door stay and release; D. Upper film guide
eccentric; E. Footage counter reset; F. Take-up clutch adjustment screw;
G. Buckle trip-switch; H. Buckle switch reset; I. Lower film guide eccentric;
J. Register pins; K. Register pin throw-out knob; L. Pull-down claws;
M. Aperture plate release lock.

2. Camera threading for rear or underslung mag. A. Aperture mask/gelatine
filter holder.

A register pin camera which can be used in many modes.

Mitchell S35 MK II Blimped

For sync sound shooting and when a reasonably quiet camera is required, the Mitchell S35 MK II may be operated in a blimp.

Installation in a blimp

Open mag. housing, lens door, camera door and remove motor housing.

Check camera is in top mounted mag. mode, remove mag., lenses and wild motor if fitted. Place camera body in blimp locating it front first. Secure by tightening knob at rear of mounting plate.

If 'in-shot' shutter adjustment is required set shutter control stops to extremities of required movement, unscrew shutter control knob, depress and rotate a further quarter turn. Attach blimp shutter control linkage.

Check correct focus drive gear cluster is in position. (Lenses fitted with Mitchell BNC type focus gear require a special gear cluster.)

Install required lens through lens door and set to infinity. Attach correct focus calibration disc, set this to infinity also and engage focus drive gear. If a zoom lens is to be used, attach the zoom extension blimp, couple focus linkage and plug in zoom motor.

Attach camera motor and motor blimp housing. If a CPD crystal motor is to be used, modified motor blimp housing must be fitted upside down from normal. If a high speed motor is fitted a special spacer must be used to clear longer motor.

Remove camera eyepiece and install blimp eyepiece adaptor.

Check power selection switch at rear of blimp is set to suit motor in use.

Attach mag., thread camera, inch a little film through before switching on for a short trial run and then finally close all doors.

Operational considerations

If camera noise is not as quiet as it should be, check there is no mechanical contact between the camera and blimp housing, that rubber seals round all openings are seating fully (this is most important) and that focus and zoom linkages are not too tightly set.

Lens aperture adjustments are made through camera door opening.

Window covers must be in place during shooting unless care is taken to ensure that no bright light is able to shine through and reflect back into the lens via front blimp glass.

Filtering

In its standard form, S35 blimp will accommodate a single 5in. square filter in addition to 'in-camera' behind the lens filter. A number of users however, have made modifications to accommodate 6.6in. sq. rotating and sliding filters in front of blimp front glass.

138

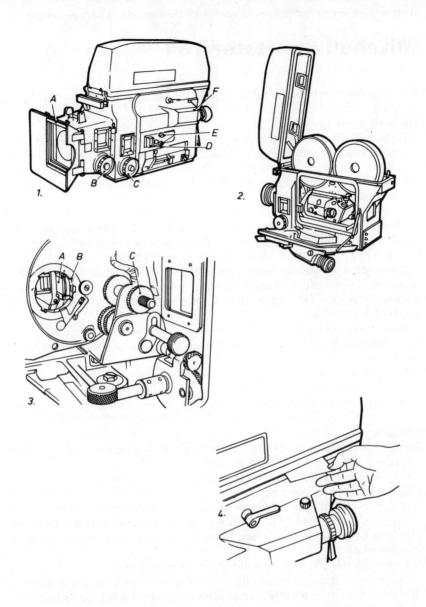

MITCHELL S35 Mk II BLIMPED

1. S35 Mk. II camera in studio blimp. A. Addition zoom housing; B. Zoom control knob; C. Focus control; D. Image magnification control; E. Viewing glass controls; F. Viewfinder light-trap. 2. Blimp fully open.

3. Lens port and focus linkage gears. A. Interchangeable ground glass; B. Nicks out of the lens mounting to permit ground glass to be extracted; C. Cluster of gears which engage in focus ring of lens. 4. Testing blimp for sound-proof seal by trying to pass a visting card between faces.

139

Mitchell Sportster 164

A two-speed 16mm high speed camera for action cinematography.

Description
Double pull-down claw, double register pin movement. Suitable for double perf. stock of either .2992 or .3000 pitch. Focal plane shutter. 140° is standard, 7½, 10, 15, 20, 30, 45, 60, 72, 90, 105 or 120° available to order. To check which shutter is fitted, remove lens and inch camera until shutter angle engraved on shutter blade is seen.

Single 'C' type lens mount.

Viewfinding for action filming by 10 x 12mm f2.2 reflex zoom lens with short eyepiece. Other focal length reflex lenses available include 6 x 12.5mm f2.2, 10 x 9.5mm f2.2 and 20 x 12mm f3.5/4.8.

Boresight and internal reflex system (cannot be used while the camera is running) available for optical lining-up purposes.

Integral 28–30v DC motor, draws 10amp at 500fps. A 15amp fuse is situated on rear panel.

Two-speed control by switch on hand-grip. Camera may be set at 16, 24, 32 or 48fps switchable to five fixed speeds up to 240 or 500fps (depending upon model).

Daylight loading 400ft. spool film capacity. Footage counter on front of camera, re-set button inside camera. All bearings are self-lubricating requiring no maintenance. Serial number on plate on camera rear.

Loading
Remove take-up spool adaptor, replace empty daylight loading spool with full spool with film coming off clockwise.

Position pull-down claw in retracted position by lining up claw teeth with lower dot engraved on plate.

Unscrew register pin retention screw and retract register pins.

Unroll 4in. (100mm) of film and thread into register plate until 4 perfs. protrude below upper dot. Place nearest perf. over locating pin at top of register plate.

Insert register pin in perf. and tighten retraction screw.

Thread film through threading shoe at lower end of aperture plate. If film does not automatically feed around co-axial sprocket, guide film onto sprocket teeth with finger tips. Advance film 6in. (150mm).

Unlock sprocket keeper pin, form a spiral loop, position film on upper sprocket teeth and turn keeper pin handle to locked position. Loop should just clear boss on bottom camera housing. Guide film around top of run-out switch, install take-up spool adaptor, attach film to take-up spool and install in camera. Inch camera to check film moves easily before doing test run.

MITCHELL SPORTSTER 164

1. A. Automatic exposure control geared to lens aperture ring; B. Footage shot counter; C. Reflex zoom lens viewfinder; D. Boresight reflex control and aperture; E. Hi/lo speed switch; F. Start/stop switch.

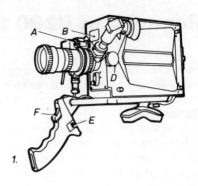

1.

2. A. High speed setting control; B. Low speed setting control; C. Connection to trigger switch; D. Power connection; E. Fuse.

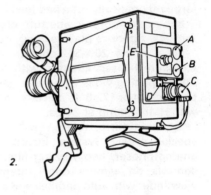

2.

3. A. Supply spool below; B. Upper sprocket inching knob; C. Upper loop; D. Side guide; E. Upper dot; F. Lower dot; G. Boresight reflex assembly; H. Register pin retention screw; I. Sprocket keeper lock pin (locked); J. Lower loop; K. Co-axial take-up sprocket; L. Spiral loop; M. Film run-out switch alarm; N. Film run-out roller; O. Take-up spool (top).

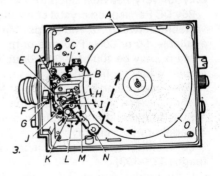

3.

A camera much used for shooting feature films & TV commercials.

Panavision R200 Silent Reflex

Very quiet 35mm lightweight camera for studio or location use developed from Mitchell NC family of cameras.

Description

Double fork pull-down movement claws engage in four perfs. Dual registration pins locate film throughout exposure period. Adjustable pitch control to modify position of register pin relative to pull-down claw entry position may be set to suit individual rolls of film to minimise camera noise.

Focusing by large knobs on each side and at rear of camera or remotely by flexible drive shaft from all positions. Focus points may be marked on large magnetically attached lens calibration discs.

Full or anamorphic aperture plates, hard masks available for all other formats. Aperture plate is easily removable for checking and cleaning.

Focal plane 200–50° shutter independent of mirror reflex system. Exposure 1/43sec. at 24fps. with 200° shutter opening, may be set to any other opening while camera is running. Some cameras have special settings at 144 or 172.8° to suit 60 and 50Hz mains frequencies when shooting with HMI lighting at 24fps.

Spinning mirror reflex viewfinder. Partial mirror (pellicle) available to special order. System incorporates zoom variable magnifier, de-anamorphoser, two viewing filters and light cut-off, all with individual controls on camera door. Interchangeable ground glasses. External viewfinder with auto parallax and anti-reflection lenses available to special order.

Gelatine filter holder between shutter and film plane. Matteboxes with provision for two or more sliding and rotating filters, circular pola screen holders and front masks available for all lenses.

Panavision clamp ring lens mount with positive axial location. Takes all Panavision anamorphic and spherical lenses. Additional support required only for very heaviest telephoto and zoom lenses.

36v DC Panaspeed crystal controlled motor may be run at 24 or 25fps or variable between 12 and 32fps. Mains sync and multi-duty motors also available. 50 or 60Hz Pilotone output for cable sync.

Mags. may be 400 or 1000ft. double compartment, the former used with a special low profile housing.

Footage counter and tachometer (on Panaspeed crystal motor only) on rear of camera, visible to operator.

Sync marker light available to order.

Serial number engraved on panel at rear of camera.

For loading, operating and lubrication information see Mitchell NC, etc. (pages 128–133).

Later model, Super R200, has 24v integrated motor and digital type footage and speed readouts.

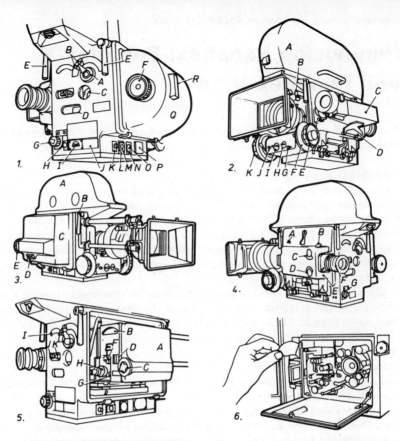

PANAVISION R200 SILENT REFLEX

1. Panavision PSR. A. Adjustable shutter control; B. Pre-settable shutter stops; C. Shutter position indicator; D. Footage counter; E. Carrying handles; F. Inching knob; G. Rear focus control; H. Footage counter illumination switch; I. Level; J. Camera serial number plate; K. Sync pulse/bloop light socket; L. Heater 'on' indicator; M. Heater power socket; N. Heater 'power' indicator; O. Camera motor power socket; P. Footage counter lamp battery compartment; Q. Mains sync motor cover; R. Attachment point for in-line power switch. 2. A. 1000ft. (300 m) mag. blimp; B. Lens calibrations illuminating lamp; C. Optional auto-parallax side viewfinder; D. Auto-parallax cam; E. Two speed focus control; F. Magnetic focus marking discs; G. Auto-parallax linkage disengagement control; H. Focus disengagement control; I. Focus engagement lock; J. Power for zoom control motor; K. Right-hand focus control.
3. A. 400ft. (120m) mag. blimp; B. Right-hand tape hook; C. Panaspeed motor cover; D. In-line power switch attachment point; E. Panaspeed inching knob.
4. A. Left-hand tape hook; B. Light trap; C. De-anamorphose control; D. Int/ext viewing filter control; E. Zoom image magnification control; F. Eyepiece focus and marker bezel; G. Panaspeed battery condition indicator lights.
5. A. Panaspeed crystal-sync motor; B. Tachometer; C. Inching knob; D. 24–25 fps switch; E. Sync/variable speed switch; F. Variable speed control; G. Sync-pulse outlet; H. Connection for motor control systems to blimp; I. Tachometer; J. as E, K. as F. 6. Method of inserting gelatine filter holder.

A unique camera, designed by Robert Gottschalk.

Panavision Panaflex, Panaflex-X and Panaflex-X 16

A quiet and highly sophisticated 35mm motion picture camera available only on a rental basis. Individual cameras are regularly updated.

Description

Two claw pull-down and double register pin of original design. To minimise noise generation movement incorporates fine pitch and stroke adjustments to tune pull-down stroke to actual film perf. pitch. Also fitted are lubrication pads which smear a miniscule amount of silicone grease onto undersides of pull-down claws before each stroke to ease passage of claws into perfs. Gate plate, pressure pad and intermittent movement may be removed for cleaning.

Adjustable 200–40° focal plane shutter. May be adjusted to pre-set stops while running, for inshot exposure control. Cameras located in 50Hz areas may have special 172.8° shutter position for filming with HMI lights at 24fps. Remote shutter control may be operated from position behind camera operator.

Spinning mirror reflex viewfinder. 'Panaglow' accessory, makes image and safe area markings on ground glass glow red for easier visibility against dark backgrounds.

Camera viewfinder system incorporates two contrast filters, a zoom magnifier used as an aid to lighting, focusing or operating, a de-anamorphoser and a light cut-off. An optional extension eyepiece used when camera is mounted on a head incorporates an additional magnifier. Eyepiece diopter adjustment has an index facility for quick resetting to personal eyesight. Eyepiece may be tilted with auto-horizon correction to suit height of the camera operator.

Interchangeable ground glasses. Side viewfinder with auto-parallax correction may be used with a studio base optional accessory.

Panavision type positive clamp and locking ring lens mounting with a locating pin to ensure exact axial location, (essential for anamorphic lenses). Heavier lenses are additionally supported by support bars. Provision for gelatine filters in front of film plane.

No lens blimp required with any lenses, even in studio. Lenses are focused, zoomed and set for aperture directly by engraved markings. Large and small side accessories focus knobs with remote control are provided. Focus controls have interchangeable magnetically attached discs which may be marked with focus positions.

A wide range of matteboxes available to suit all lenses, with provision for several filters, some of which may rotate and/or be slid across screen. Matteboxes incorporate front masks to suit various focal length lenses and 'donuts' to stop stray light entering from the sides.

Small lamp fitted to illuminate focus scales in dark conditions.

Power for electric zoom lens control taken from outlet on camera.

144

PANAVISION PANAFLEX

1. Panaflex with top mounted 1000 ft. (300 m) magazine.
A. Viewfinder eyepiece;
B. Extended eyepiece tube;
C. Viewfinder/Panahead linkage;
D. Follow-focus control;
E. Panaglow; F. Panahead balancing slide release; G. Super Panazoom 50–500 mm f5.6 anamorphic zoom lens incorporating a piggy-back silent zoom control-motor; H. Small detachable lamp to illuminate lens scale in dark conditions; I. Footage shot indicator recall button (on top) and re-set button (at front). To re-set footage counter to zero both buttons must be pressed simultaneously.

2. A. Zoom lens support bracket;
B. Mattebox type sunshade hinge release; C. Attachment point for top sunshade flap; D. Mattebox and heavy lens support bars;
E. Tripod head adapter; F. Right hand-hold attachment point;
G. Zoom control power outlet;
H. Battery condition warning light;
I. Heater power socket; J. Heater 'on' warning light; K. Power socket; L. Bloop/sync/remote socket; M. Hand-grip (may only be fitted when top mag. is used);
N. Mag. footage remaining indicator; O. Footage indicator actuator knob; P. Mag. 'taking-up' indicator.

3. Panaflex with rear mounted 250 ft. (75 m) magazine and 20 mm f1.2 spherical Panavision Ultra Speed lens. A. Eyepiece in short mode as used for hand-holding; B. Carrying handle attached to top mag. aperture cover; C. Top mag. release lever; D. Rear mag. release; E. Shoulder support; F. Left hand handle used when hand-holding; G. Attachment point for mechanical remote focus control; H. Focus control release knob; I. Camera door lock; J. Soft pad to make camera comfortable when hand-holding.

4. Panaflex with rear mounted 500 ft. (150 m) mag.
A. Ultra-lightweight mattebox/sunshade; B. Right-hand hand-grip; C. Camera 'on/off' switch (short run switch is set

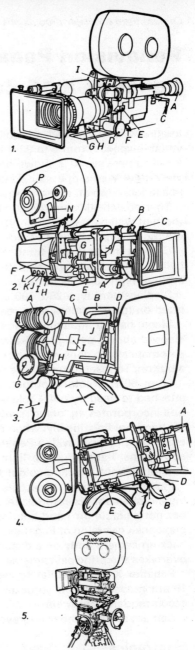

behind); D. Tape hook; E. Earlier design of socket and indicator panel which includes the 24–25 fps switch.

5. Panaflex-X. Similar to the regular Panaflex but with a straight through viewfinder for tripod mounting only.

Panavision Panaflex, Panaflex-X and Panaflex-X 16 continued

Integral 24v DC crystal controlled motor may be run at 24/25fps or at variable speeds from 6 to 32. Always stops in viewfinder 'view' position. Exact camera speed is shown on a digital display above eyepiece. Light in viewfinder warns operator if running off crystal speed. Camera may be phase locked to an external source for playback, TV filming, etc.

Thermostatically controlled internal heaters in camera body and mags. (both of which may be plugged into a power source independent of camera motor supply) ensure efficient running in cold conditions.

Camera motor draws 4amp. Heaters, when operating draw 2amp. (If a belt or other small capacity battery is used for actual shooting, plug camera into high capacity battery to operate between set-ups.)

Displacement type 250, 500 or 1000ft. (75, 150 & 300m) mags. may be fitted on top of camera or at rear for low profile or hand holding.

Mags. have a manually operated footage remaining indicator. Footage elapsed shown by digital display above viewfinder. Display switches off automatically to conserve battery supply but may be recalled by pressing a button. To reset to zero press reset and display buttons simultaneously.

50 or 60 Hz Pilotone output. Provision for sync marker light. Camera attached to head by quick release base/balance slide. Two handles (right one incorporates an 'on/off' switch) and a shoulder support are provided for hand-holding. Ideally, when mounted on a tripod, dolly or crane, camera should be used with a Panahead. Provision for mounting companion above-lens 'Panalite' (obie light) the intensity of which may be varied in-shot without affecting colour temperature.

Panaflex-X in most respects, similar to standard Panaflex in body castings, movement accessories, lenses and mags. Straight-through viewfinder not suitable for hand-holding. Tripod or dolly mounted, it serves as inexpensive version of Panaflex, as a second camera to a Panaflex or as a back-up camera body on a distant location to be used only if an accident overtakes the principal camera.

Panaflex-X 16 is similar to regular Panaflex cameras except it has a 16mm movement end sprocket wheel and magazines have spacers to accommodate 16mm film.

Camera serial number engraved on plate affixed to rear of camera.

Electronics

Like any other state-of-the-art equipment, Panaflex cameras are controlled by advanced electronics almost all of the components for which are contained on four plug-in circuit boards. In the event of a malfunction, Panavision Inc. and its associates will provide information as to which board to change in an emergency (see pages 153–154 for phone and telex numbers).

146

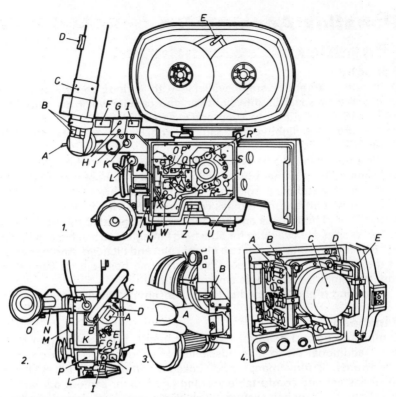

PANAFLEX LOADING AND OPERATION

1. Panaflex camera with film threaded for top mounted mag. A. Viewfinder tilting lock; B. Viewfinder eyepiece/extension lock and safety catch; C. Viewfinder extension; D. Extension image magnification control; E. Mag. footage remaining roller; F. Footage shot digital read-out; G. Footage shot recall (on top); H. Camera battery charge condition indicator lamps; I. Camera speed digital read-out; J. Viewfinder image magnification control; K. Int/ext viewing filter control; L. Normal–de-anamorphose–close viewfinder control; M. Aperture mask; N. Aperture plate release; O. Bloop light socket; P^1 and P^2 movement securing screws; Q. Register pin retraction knob; R^1 and R^2 Sprocket guide rollers; S. Guide between top and rear film paths; T. Buckle switch; U. Safety switch (inhibits motor when door is open); W. Adjustable pitch control; X. Adjustable stroke control; Y. Filter slot cover; Z. 24–25 fps sync speed switch.

2. A. Adjustable shutter control and attachment point for remote control; B. 50–200° shutter scale; C. Pre-settable shutter stops; D. Lock to set shutter at 172.8° exactly (European based cameras); E. Inching knob; F. Inching safety catch; G. Sync/variable speed switch; H. Safety catch for G; I. Variable speed control; J. Camera 'run' switch; K. Rear mag. aperture cover; L. Level; M. Camera door removal safety lock; N. Extended eyepiece support; O. Viewfinder to Panahead attachment point; P. Camera serial number plate. 3. A. Gelatine filter holder; B. Panaglow switch. 4. Interior of motor compartment. A. Power and light board; B. Camera drive board; C. Motor; D. Catch-all board; E. Crystal control board.

Panaflex Accessories

Panaglide
A 'floating camera' system available with various camera types. One incorporates a special lightweight Panaflex camera which is quiet in operation and most suited to sync and dialogue shooting, another uses a highly modified lightweight 35mm Arriflex and yet another 16mm Aäton.

Systems consist of a body harness and support arms which isolate body movements from camera head and a dispersed camera whereby camera power supply and electronic control components are separated from the film-bearing part to form a mass counterweight. Viewfinding is by closed circuit TV and both focus and aperture may be operated by radio control.

Accessories are available for attaching Panaglide to a vehicle, helicopter or other moving platform or to a normal pan and tilt head. Another version of the Panaglide makes it possible to reverse positions of camera and counterweight for low-angle cinematography.

A docking tripod is provided to hold ensemble between takes.

Panahead
Companion geared head for Panaflex camera. Three speed pan and tilt drive, additional tilt to give possibility of shooting directly upwards or downwards, tilt movement may be linked to camera extended eyepiece to give constant and comfortable viewing position for camera operator. Tilt drive is by a rubber belt system which eliminates usual geared head problem of wear in centre of quadrant. Camera is mounted on a longitudinal slide for balancing purposes, may be slid further back to align front entrance pupil of lens with centre of the pan and tilt axes of head for nodal panning and tilting. Head may also be used in gyro, free or friction modes by addition of pan handles.

A heavier version Panahead is available for use with Panavision PSR cameras.

Panalite
A 800–1000W variable intensity camera mounted 'Obie' type lamp. Normally used as a 'fill light' close-to and above camera lens. Incorporates a white/black adjustable reflector, segments of which may be rotated to reflect a variable amount of light. Reflector may be adjusted between all white and all black during take.

Panavision accessory case
Contains a variety of connecting cables in duplicate, for all purposes, matteboxes/sunshades with filter holder systems of greater or lesser sophistication for all principal lenses, various small accessories such as remote focus and shutter adjustment drive, hand-holding parts, etc.

148

PANAVISION ACCESSORIES

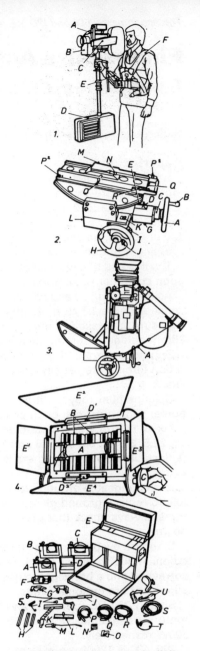

1. Panavision Panaflex Panaglide.
A. Special lightweight Panaflex camera; B. Radio controlled lens control; C. TV viewfinder; D. Counterweight unit containing camera electronics and battery; E. Sprung/shock absorbing camera support arm; F. Body harness.
2. Panavision Panahead. A. Tilt control with (B) reversible knob; centre may be pressed to release and knob fitted to other side of wheel when using head in gyro mode; C. Tilt lock; D. Three speed plus neutral gearbox control; E. Pan friction control; F. Tilt friction control (on right side of head); G. Pan tension control (to right of tilt gearbox); H. Pan control; I. Pan three speed plus neutral gearbox control; J. Pan lock; K. Level; L. Tilt tension control (at front); M. Quick release dovetail camera attachment point and balancing/nodal slide; N. Two camera release controls; O. Balancing slide/lock; P^1 and P^2 Pan handle attachment points; Q. Additional tilt release; R. Release to turn top section about for choice of additional tilt up or down.
3. Panaflex Panahead with Panaflex camera in max. tilt-up position. A. Link arm between head and viewfinder for constant viewing position.
4. Panavision adjustable intensity 'Obie' light. A. Lamp holder and reflector; B. Adjustable reflectors; C. Control knob; D^1 and D^2 filter and diffuser frame fitting positions; $E^1 - E^4$ barn doors.
5. Panaflex accessories.
A. Spherical mattebox; B. Anamorphic mattebox; C. Wide-angle anamorphic mattebox; D. Gelatine filter holders; E. Accessory case; F. Follow focus unit; G. Short and long support bar adapters; H. Support bars of various lengths; I. Additional focus control knobs and adapter to use for remote control of shutter angle; J. Carrying handle to use with top fitted mag.; K. Lamp support; L. Lamp adapter spiggot; M. Probe light to illuminate focus scales etc.;

N. Spare batteries for probe light; O. Special lubricant for pull-down claws; P. Two battery-belt to camera cables; Q. Two pulse cables; R. Remote switch; S. Two battery to camera cables; T. Two camera to power zoom cables; U. Hand-hold grips and shoulder rest.

149

Photosonics Actionmaster/500, Sportsmaster/500, IPD, IPDL and IP

High speed 16mm cameras for sports, documentary and scientific filming.

Description

Double claw pull-down intermittent movement with two register pins. Movements are incorporated in each magazine.

Actionmaster/500 and Sportsmaster/500 models have a two-speed capability, may be set for 24 or 48fps on one control and for 100, 200, 300, 400 or 500fps, on another. Change from one speed range to another is by pressing a button on hand-grip.

The IPD and IP have a single speed capability of 16–200, 400 depending upon customer requirement.

Actionmaster/500 and IPD cameras have prism reflex viewfinder system which absorbs 1/3 stop of light, which must be allowed for when setting exposure, and take Arri mounted lenses which must not extend more than 28mm behind mounting flange. IPDL has crystal controlled 24fps.

Sportsmaster and IP models are non-reflex, have 'C' lens mounts. For action filming are usually fitted with Angenieux 10 or 20 : 1 reflex zoom lenses.

Gelatine filter may be fitted behind lens. If this facility is not used filter holder slide must still be in position to prevent fogging.

Fixed 160° opening focal plane shutter standard. Interchangeable 7.5, 15, 22.5, 30, 45, 60, 90, 120 and 160° shutter blades and a variable shutter (adjustable only while camera is stationary) from 7.5 to 160° are optional extras.

Interchangeable ground glasses are available extras. Note as it is possible to replace ground glasses upside down resulting in out of focus pictures, always check that ground glass has been put in with etched side down.

Standard eyepiece rotates through 260°, does not correct horizon orientation. A 360° rotating eyepiece with fully automatic horizon orientation correction and a boresight to use in place of the magazine to check optical alignment are optional extras.

Built-in 28v DC motors draws 12amp at 500fps. 115v, 50, 60 or 400Hz motors are optional. Optional 28v DC or 115v AC/DC heaters draw 200 and 300W respectively.

200, 400 & 1200ft. co-axial mags. are available. Film must be wound on daylight loading spools. Film must have double perfs. but may be perforated with standard 0.2994in. pitch or 0.3000in. long stroke without adjustment to camera.

Manual footage remaining indicator on each magazine. Other optional extras include automatic exposure control, time lapse control, instrumentation and timing light systems. Serial number on plate on top of camera.

PHOTOSONICS

1. Photosonics 1PD single speed reflex model. A. 400 ft. mag. incorporating film transport mechanism; B. Orientable eyepiece; C. Single speed control; D. Variable shutter adjustment knob (far side of lens).

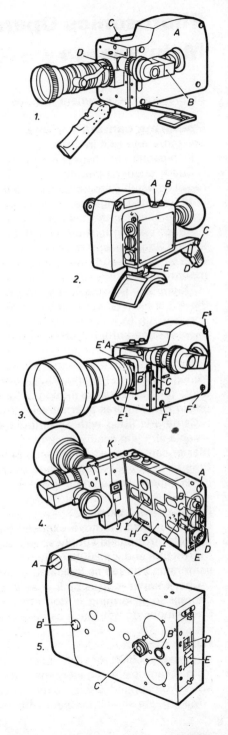

2. Photosonics Actionmaster/500 two speed reflex model.
A. 100–500 fps speed setting knob;
B. 24–48 fps speed setting knob;
C. Dual speed operation switch;
D. Swivellable pistol grip;
E. Adjustment to set shoulder pad in comfortable position or to remove for tripod operation.

3. Photosonics Actionmaster/500 with telephoto lens fitted. A. Light trap control; B. Interchangeable ground glass; C. Filter slot; D. Film inspection port; E^1 and E^2 Arri mounted lens releases; F^1–F^2 mag. door releases. 4. Photosonics Actionmaster/500 with mag. removed. A. Press-to-test switch and re-set switch; B. Motor inching knob; C. Mag. lock release button; D. Mag. lock; E. Power connection; F. Mag. latching pin; G. Heater blankets; H. Run-out switch; I. Mag. drive; J. Clearance for pull-down claws in mag.; K. Aperture and front pressure plate. 5. 400 ft. mag. A. Footage remaining indicator; B^1 And B^2 attachment studs; C. Mag. drive; D. Aperture and rear pressure plate; E. Pull-down claw cover.

151

Photosonics Operation and Maintenance

Before use, check camera has been lubricated after high speed usage.

Preparing camera for use

Set camera to required fps.

Inch camera to check it is running freely before turning on power.

Check shutter opening by observing engraved figure in window. To re-set adjustable shutter pull out knob at front of camera and rotate shutter until required angle is seen in window. Remove front cover plate to change fixed shutter blades.

Attach pistol grip/shoulder pad by 3 screws to underside of Actionmaster and Sportsmaster models. This assembly incorporates the dual speed control switch and must remain fitted even if the camera is tripod mounted.

Plug in 28v DC supply, the following pins are used for normal filming. Pin A 28v main power supply to camera. Pin B 28v camera remote control and overrun (will keep camera running for set periods after camera has been switched off). In normal filming Pins A and B are connected in parallel. Pin C 28v DC negative (−). Pins R and S 28v DC thermostatically controlled DC internal heater. Pins D and F 115v AC thermostatically controlled AC internal heater. Pin L earth (ground). Pins J, K, U and T timing lights (instrumentation filming). Pins E and M shutter pulse and return (to phase two cameras alternatively).

Camera is fitted with an automatic electric cut-out switch which trips when a film jam occurs or camera is similarly stalled. Red re-set button at rear of camera must be pressed before camera may be run again. From time to time check cut-out and overload switch works by setting fps to lowest speed and using a towel to apply a load to camera inching knob.

Magazine loading

Clean out mag., remove exposed film spool and spindle. Clear footage indicator from used supply spool, hold and remove spool.

Trim film end, on 200ft. mag. rotate film supply indicator, place spool in camera and thread as indicated, rotating camera drive to assist passage.

Check upper loop is as low as possible without becoming tight. Fully depress loop forming button at base of mag. to set line of lower loop. Check loops do not touch camera walls before replacing mag. lid.

Lubrication

After every 1200ft. of high speed filming old lubricants should be wiped from eccentric pin, register pins and bushings and a thin film of MX–80 or MX–90 oil applied. Do not overlubricate.

Mag. gears should be oiled with same lubricant at monthly intervals.

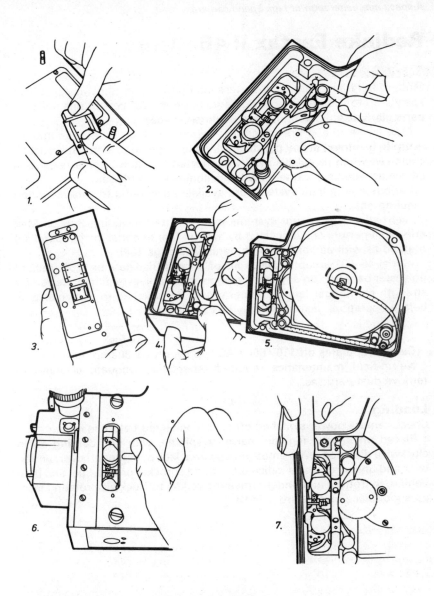

PHOTOSONICS LOADING AND OPERATION

1. Before loading trim end of film; 2. Push film end over roller and on to upper sprocket, rotate drive gear to pull film through.
3. Check film passes aperture opening and does not exit through. 4. Engage film pull-down pins and form bottom loop by pressing loop forming button on inside of mag. and hold until film tracks onto lower sprocket. 5. Rotate mechanism until sufficient film is available to attach to take-up spool in clockwise direction. 6. After attaching mag. open mag. inspection part, press test switch to new film to check lacing integrity. 7. Lubricate eccentric pin, register pins and bushings after every 1200 ft. at 200 fps or faster.

Redlake Fastax II 46

Modern full frame 16mm shutterless instrumentation cameras capable of speeds up to 6000fps in environments of up to 50g. Low profile makes it particularly useful for fitting into confined spaces.

Max frame rate is pre-selectable. Camera may be used to trigger an event to be filmed at any pre-determined footage up to 99ft. Care must be exercised when using this facility connected to a gun or other explosive device as when set, camera switch becomes firing trigger.

Various timing light systems are available according to data recording requirement.

Alternative lens mount systems may be fitted including Pentax. Max effective aperture $f2.7$. Focusing by ground film or aerial image (parallax) method as with earlier Fastax cameras (see page 160).

Model 46–001 accepts 100ft. rolls of normal triacetate or 125ft. rolls of polyester base film on daylight loading spools. Polyester film preferred for strength and longer length. Camera must be switched to particular type before operation. Exposure may be calculated: $\dfrac{1}{3\text{x fps}}$

Camera operates off 115v 60Hz AC supply, draws 30amp max.

No in-field maintenance required other than frequent cleaning to remove dust particles.

Loading

Check camera power switched off or disconnected before loading.

Placed unexposed film on rearmost spindle, with film coming off in clockwise direction. With emulsion upwards lace over, under, over, under, over and under rollers as indicated, around sprocket drive wheel and then behind, in front of and under remaining rollers to clockwise rotating take-up spool place on forward spindle.

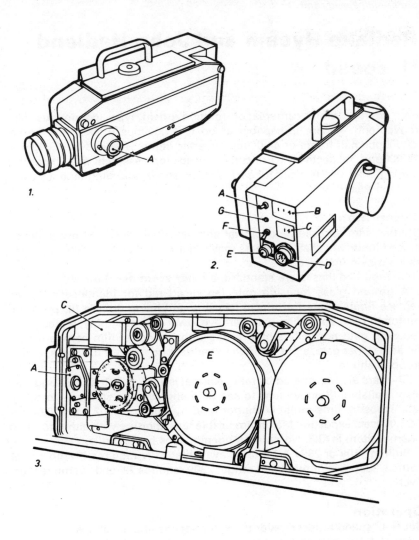

REDLAKE FASTAX II 46

1. Fastax II camera model 46. A. Boresight eyepiece attachment point.

2. A. 'On/off' switch; B. Speed control selector; C. Event trigger selector;
D. Power input, pulse and event trigger output; E. Timing signal and remote
'on/off' connector; F. Polyester/acetate film type selector; G. Camera ready
indicator.

3. A. Prism assembly; B. Drive sprocket with viewing prism in view position;
C. LED timing light; D. Supply film spool; E. Take-up film spool.

Redlake Hycam and John Hadland Hyspeed

High speed 16mm cameras of rotating prism type (continuous film movement). Hycam is capable of up to 11,000pps (fps) at full frame, 22,000pps half frame or 44,000pps quarter frame, Hyspeed is 10,000 and 20,000pps respectively. Principally used for research and industrial filming. May also be used for oscillograph, streak, and simultaneous oscillograph recording.

Description

Shutter, film sprocket and optical compensation prism all mounted on same film driven shaft. Cameras may require up to 200ft. of film supply to reach maximum speed.

'C' mounted lenses are standard, a reflex zoom may be used.

A ground glass focusing gate (anodised red for identification) may replace filming gate for critical focusing and lining up. (To fit, push red button to raise upper film gate, remove lower gate assembly, replace with focusing gate normally stored in top right corner of film compartment. Relatch upper gate, sight through lower gate prism after turning sprocket to open shutter.

Shutters are designated by ratio. Normal is 1/2.5; 1/5, 1/10, 1/20 and 1/50 also available. (Remove lens to see ratio engraved on shutter.) To calculate exposure time multiply shutter ratio by 1/pps, e.g. 1/2.5 x 1/10,000 = 1/25,000sec. exposure. Maximum usable lens aperture with either rotating prism system is f3.3. No point in opening lens beyond this.

Built-in 110v or 230v AC motors available; 110v requires 20amp power source, 30amp in unregulated range; 230v requires 7.5 and 20amp respectively.

Operation

Set H–L 'speed reducer' lever to 'H' for speeds above 100pps.

Set H–L 'servo brake' lever to 'H' for speeds above 1,000pps.

Set 'drag brake' control to 'O' for speeds above 1,000pps, to '30' for speeds below.

Set pps dial in conjunction with multiplier switch.

'Start/stop' switch must not be operated until camera has been plugged into power source for at least 10 secs.

Spooled film loading 400ft. (120m) is normally used; 100 and 200ft. loadings also suitable. If using 400ft. split spools frequently, replace plastic cores on take-up side to prevent fatigue breakage. Use 3in. (75mm) cores above 6,000pps. Always close camera door when running at high speeds. Before loading, check camera is switched off by pressing end-of-film cut off switch.

156

REDLAKE HYCAM AND HADLAND HYSPEED

Redlake Hycam camera.
1. A. Taking lens; B. 'Start/stop' switch; C. Multiplier switch; D. Fps dial; E. Drag brake control; F. Servo brake control; G. Timing light connection; H. Frame rate sensing connection.

1.

2. A. footage indicator; B. Remote connection; C. Fuse; D. Event connection; E. Shutter pulse connection; F. Power connection; G. Motor connection.

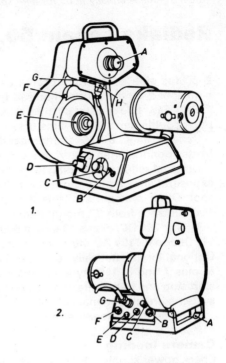

2.

3. A. Upper film gate; B. Latch block mounting screw; C. Red focusing gate storage; D. First idler roller; E. Supply ejector button; F. Servo brake arm; G. Event footage follower; H. Event sync, scale and setting knob; I. 200 ft. spool adapter mounting hole; J. Supply damping roller; K. Take-up shaft; L. 100ft. spool adapter mounting screw; M. Take-up damping roller; N. Take-up ejector button; O. Film roller; P. Lower film gate; Q. Film sprocket; R. 'U' prism housing; S. Take-up.

3.

4. Hadland 'Hyspeed' camera. A. Taking lens; B. Motor; C. Frame rate selection controls.

4.

Model 51–006 is equally good for high speed or stop frame.

Redlake Locam 50, 51

2–500fps high speed 16mm cameras. Model 51–006 equally suitable for high speed, single shot and pulsed time lapse operation.

Two claw, two register pin intermittent movement, accepts long or short pitch double perf. 16mm filmstock.

Variable angle 0–160° shutter standard, 30, 20, 15, 16, 7½ and 5° fixed blades optional. Remove front panel to re-set or change shutter.

Optional reflex viewfinding by beam splitter prism (allow one third stop exposure) shows full aperture with TV safe action plus a central focusing spot. Other systems available if camera used only for instrumentation. Max distance from 'C' mount flange to prism 4mm, 5/32in.

Motor: 28v DC, draws 10amp at 500 fps, + connected to pin 10, – to pin 11. Optional 115v AC motor connected to pins 1 and 2. Pin 19 is ground. Optional thermostatically controlled heating systems, 28v type connected to pins 7 and 8, 115v type to pins 8 and 9. A pistol grip switch, remote start/stop and frame rate control and various timing light and sync pulsing systems are all optional accessories.

No in-field maintenance required.

Camera loading

Check power supply off. Inch camera until pull-down claws fully out; hold and with other hand turn register pin reversal knob (3B) clockwise. Remove aperture and back pressure plates to clean. Number on back pressure plate tab indicates intended filmstock thickness (5: polyester, 7: triacetate).

Move footage counter arm clear, remove take-up spool key, place spool of film on inner spindle.

Pull grooved knobs to open outer and inner speed sprocket shoes. Thread film over servo roller, under auxiliary roller, over inner supply idler and down under inner supply sprocket. Pull film end back around and between timing light block and housing. Check perforations engaged on sprocket teeth and close inner shoe.

Measure 10 perf. film loop and thread over outer sprocket. Pull end back around inner supply index pin shaft, check engagement and close outer shoe. Open back pressure plate, slide film into gate, check movement freedom, make 5 perf. top loop, inch camera and pull down film until claws engage perforation. Retract register pins. Form 5 perf. lower loop, feed film over take-up sprocket and close shoe checking index pin locks.

Replace take-up spool key (spare located inside camera if required), thread film clockwise onto take-up spool, replace spool in camera and take-up slack. Inch camera by 'film advance' knob to check. Replace and lock door. Set required frame rate by control at camera rear. Do not operate continuously below 2fps.

158

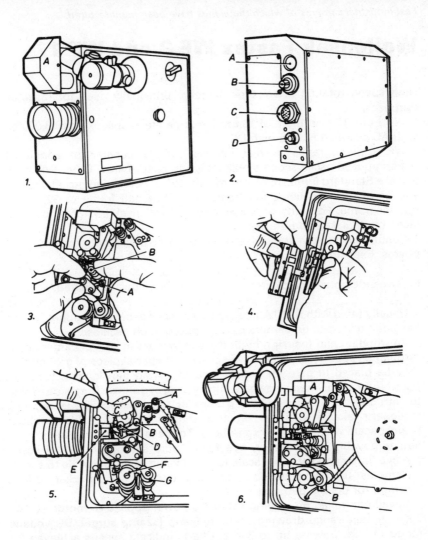

REDLAKE LOCAM

1. Locam model 51. A. Reflex viewfinder system. 2. A. Footage indicator;
B. Frame rate selector; C. Power and timing light connections; D. Film
advance knob.

3. A. Pull-down claws held in fully retracted position; B. Register pin reversal
knob turned clockwise until register pins also fully retracted. 4. Aperture and
back pressure plates removed for cleaning.

5. Forming ten perf. upper loop. A. Servo brake roller; B. Outer supply
sprocket; C. Ten perf. climbing loop; D. Inner supply sprocket release;
E. Engraved film thickness marking; F. Take-up sprocket, G. Take-up idlers.
6. Film completely threaded (100 ft. spools shown, 400 ft. normally used.)
A. Timing block; B. Cut-out switch.

Wollensak Fastax WF 3 and WF 17

High speed rotating prism type cameras principally used for research purposes.

WF 3 and 17 take 100ft. of 16mm film, operate at speeds up to 8,000fps with AC power, 1,600fps with DC.

WF 3 photographs normal images, WF 17 capable of additional superimposed oscilloscope streak image in picture area. Other WF models take Standard 8mm, 16 or 35mm film, 100 or 400ft. loadings and run at speeds of up to 8,000fps full frame, 16,000fps half frame or 32,000fps quarter frame. Formerly manufactured by Wollensak and 3M, now serviced by Redlake Laboratories.

Continuous motion shutterless type movement with two- or four-sided prisms. Exposure

$$\text{for two-sided prism calculated:}\ \frac{1}{5 \times fps}\quad \text{for four-sided calculated:}\ \frac{1}{3 \times fps}$$

Usually fitted with RAPTAR 2in. *f*2 lens in special bayonet mount. WF 17 has additional lens on camera door to photograph oscilloscope.

Viewfinding and focusing by finder which looks at rear of camera gate through an aperture in main drive sprocket. A special piece of ground film may be placed in gate for critical focusing. If no film loaded, focusing possible by aerial image viewed while moving eye slowly from side to side to introduce artificial parallax, picture in focus when image remains stationary relative to finder reticle markings (it is advisable to check against scale when using this method). To focus oscilloscope lens; position removable reflex finder, eye focus, note setting on yellow scale, remove finder and set white scale to same value as yellow scale to shoot.

Cameras usually supplied with long pitch drive sprocket (0.3in., 7.62mm) for double perf. stock.

Speed controlled by varying AC or DC power applied to motor AC 30–280v, voltage range drawing up to 15.5amp (32amp surge), DC voltage range 11–28v drawing up to 3amp. Charts indicate speeds achieved for voltage applied. A goose control unit used with AC supply to produce required operating voltage from 110–130 or 220–240v supply in a progressive manner to ensure smooth film acceleration and prevent film breakage.

Operational maintenance

After each roll clean camera interior of film chips and check no emulsion build-up under hold-down roller (clean only with orange stick or similar), check no dust on lenses.

Do not run camera without film.

Drive assembly must be lubricated after every 1,000ft. of film by oil filled atomiser applied to filler cap on camera right front.

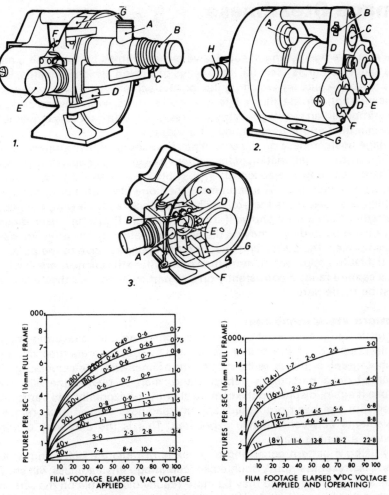

LAPSED TIME IN SECONDS SHOWN AT 50,60,80 and 100 FT.

WOLLENSAK FASTAX

1. Fastax type WF 17. A. Removable reflex finder for oscilloscope lens;
B. Oscilloscope lens; C. Viewfinder eyepiece; D. Subject focus plane;
E. Subject lens; F. Oil cup; G. Oscilloscope focus plane. 2. Fastax type WF 3.
A. Feed spindle assembly; B. 'On/off' switch; C. Camera power input;
D. Timing light input; E. Drive motor; F. Take-up motor; G. Tripod socket.
3. A. Rotating prism assembly; B. Hold-down release; C. Hold-down roller
assembly; D. Stripper; E. Drive sprocket; F. Timing marker; G. Cut-off
switch.

4. Film footage elapsed/pictures per second achieved for AC voltage applied
graph. 5. Film footage elapsed/pictures per second achieved for DC voltage
applied graph.

161

Image Steadiness

The accurate positioning of successive picture frames on the screen, relative to each other, is essential if the sense of illusion, which is cinema, is to be created. A picture which jiggles on the screen disturbs the viewer's concentration on the film content. Process shots, with several images superimposed on the single frame are less believable if there is movement between the various components of a scene.

Image unsteadiness on the screen has four sources: inaccurately perforated filmstock, malfunction of the camera movement, image shift in printing and unsteady projection. It is possible to pinpoint the cause by a process of elimination. A test on more than one film batch or perf. punch highlights or discounts the probability of a stock fault. Viewing the negative rather than a print shows if it is a print fault. Projector unsteadiness may be discounted by removing the aperture plate from the projector gate to also project the perfs., and checking the image relative to the perfs.

If the fault is apparent on more than one camera the chances are that it is not a camera fault; if consistently on one particular camera then a search must be made here.

Camera steadiness test

Sophisticated means exist for accurately checking and measuring image displacement. But a practical method used by most camera mechanics is to photograph a grid or radiating pattern of lines with the camera rigidly mounted on a particularly robust stand, then to rewind the film and expose it again, displacing the camera slightly, horizontally and vertically. When film has been processed, any unsteadiness shows up as relative movements between the two exposures. This is the only way of pinpointing a camera fault.

By using a pattern consisting of a series of radiating black and white lines, a 'chrysanthemum', double exposed image unsteadiness will show up as a moiré pattern and may be more readily discernible on the screen. Another system uses cranked lines which are reversed between takes thus giving an arrow-like pattern from which unsteadiness may not only be seen but also quantified.

The degree of image steadiness to be expected of a camera may vary according to the make, type, state of serviceability and frames per second rate required. A simple camera movement employing a pull-down claw only can never produce images as steadily as a camera with double pull-down claws on each side and double close-fitting register pins. Some cameras are acceptably steady at 24–60fps but not at 80fps while others, in good condition, can be expected to be steady, even for double exposure process printing, at 128fps.

162

IMAGE STEADINESS

1. Typical camera steadiness test chart.

2. Result of double exposure and moving camera diagonally between takes. Note moiré effect on centre pattern. Any image unsteadiness will show up as slight movements between parallel lines and considerable changes in moiré effect.

One of the worst accidents that can happen to a camera.

When a Camera is Dropped in Sea Water

Accidents occur even to the most careful people and one of the worst things that can happen is for a camera to be contaminated by sea water or other corrosive liquid.

First aid
Should an accident involving sea water occur on location, when no camera engineer who can carry out a complete strip down is present, the first aid treatment done by the cameraman or assistant may be the difference between a camera being saved or totally destroyed.

If the camera has been completely soaked in salt water, it is better to take the camera back to the hotel and submerge it in a bath of fresh water than to do nothing at all. Methylated spirits is perhaps more suitable.

Having washed off all the salt, the camera should be dried out and liberally sprayed with a penetrating oil aerosol. WD40, often used for surface care of cameras and cases, is highly suitable.

The lens (es), movement, motor, mags., mattebox and other movable parts of the camera should be separated from the camera body to ensure that any salt that may have penetrated the space between adjoining surfaces may be thoroughly cleaned away.

Save the movement
The most valuable part of a camera is the film transport mechanism and if this is a removable sub-assembly, as in a Mitchell or Panavision camera, it should be accorded special treatment, and if necessary, immersed in oil to prevent any corrosion.

Insurance
Severe damage to a camera will invariably involve an insurance claim. It is a wise precaution therefore, to take eye-witness statements which may be used subsequently to back up any claim. It should be borne in mind that if there has been gross negligence, there is always a possibility that the underwriters may refuse to pay compensation.

WHEN A CAMERA IS DROPPED IN SEA WATER

1. In the event that a camera has been totally immersed in sea water, remove all detachable components and wash body with methylated spirit or clean water.

1.

2. After any type of wetting a camera must be thoroughly dried.

2.

3. Whenever wetting is likely to occur, or has occurred, spray camera body with anti-corrosive spray.

3.

Camera Trouble Shooting I

Camera door will not close
Film gate sprocket guide rollers not properly closed.
Registration pin not engaged.

Camera will not run, runs only slowly or intermittently
Battery does not produce full voltage on load (poor connections between individual cells).
Battery fused or circuit breaker open.
Battery not fully charged (insufficient time, charger current inadequate, mains voltage wrong).
Battery not delivering full power due to cold.
Battery to camera cable has internal fault (flex to check).
Battery to camera cable too thin or too long for current.
Battery self discharged due to excessive heat during storage.
Camera buckle and trip switches not set.
Camera not sufficiently winterised for cold conditions.
Camera not switched on (more than one switch).
Camera seized up or very stiff (try inching by hand).
Mains power supply voltage or frequency not correct for camera motor (if mains).
Poor electric contact somewhere (use test meter to test voltage at motor).
Camera electronic circuits faulty (plug in spare boards if available).

Film cannot be threaded through camera gate
Camera not inched until register pins are withdrawn.
Pull-down claws of a Mitchell or Panavision type movement not withdrawn.

Film does not take up or jams
Bent spindle.
Bent spool on spool loading cameras.
Film end has become detached from take-up core.
Film in either side of mag. became loose during transportation.
Incorrect loop sizes, faulty film lacing.
Mag. not seated on camera correctly.
Mag. with electric take-up motor has faulty electric connection.
Reversible mag. direction not set correctly.
Take-up belt, drive or motor not fitted or set incorrectly.
Take-up belt stretched or tight.
Take-up tension set incorrectly.

Camera Trouble Shooting II

Film fogged
Baffles removed from Arri II ground glass.
Camera door or mag. lid not completely closed or faulty.
Eyepiece not covered or eye not close enough to eyepiece.
Faulty filmstock.
Faulty handling, processing or printing at laboratory.
Film loaded in less than absolutely dark conditions.
Mag. aperture not in place on spool loaded camera.
Mag. aperture not in place on camera with two mag. positions.
Plugs not fitted into unused ports of a turret camera.
Rubber light seals on mag. camera interface damaged or missing.
Screw missing from camera body.
Spool loaded film has bent spool flanges.
Stray light coming through other lenses on a turret camera (use sunshade).
Tips of plastic mechanism cover on rear of Arri 35 Mk II mag. broken.

Film loses loop
Damaged sprocket or pull-down claw.
Film incorrectly threaded.
Film not over sprocket teeth correctly.
Loops incorrect size.
Sprocket guides not engaged.
Film perf. pitch wrong size.

Film scratched
Abrasive or scratched gate and pressure plates.
Careless handling at laboratory.
Careless rewinding.
Dirt in the mag. or camera wherever the film may touch.
Faulty camera loading.
Faulty filmstock.
Loops too large or too small.
Pressure plate rollers jammed.

Image unsteadiness
Bad print.
Bent camera pull-down claw caused by starting camera at too high a speed.
Camera running faster than designed to do so by manufacturer.
Gate side guidance rails or gate back pressure plates spring tension incorrect.
Emulsion build up in gate or chip of film stuck in film path.
Faulty filmstock.
Loop size incorrect, faulty camera or mag. threading.
Unsteady projector.

Camera Trouble Shooting III

Incorrect exposure
Adjustable shutter incorrectly set.
Lens iris incorrectly set.
Lens iris inoperative.
Light loss through beam splitter or pellicle reflex not allowed for.
Light loss through filter not allowed for.

Picture flicker or double image
Camera speed/shutter opening incompatible for frequency of HMI lighting.
Panning too fast for length of lens.
Shutter angle set too small for length of lens/speed of pan.
Shutter out of synchronism.

Unsharp pictures
Artist or camera moved position unbeknown.
Dirt on lens seating.
Film gate not seated correctly.
Film not held flat in gate.
Film gate not closed correctly.
Film grossly overexposed.
Film overdeveloped or printed out of focus.
Flange focal depth incorrect.
Fog or diffusion filter used.
Gelatine filter behind wide angle/wide aperture lens.
Ground glass incorrectly seated.
Heavy zoom lens not supported sufficiently.
Incorrect or indeterminate lens calibration markings.
Lens incorrectly focused.
Lens not capable of good definition.
Lens faulty or dirty.
Lens not pushed fully into lens mounting.
Lens turret malformed or loose.
Loose lens elements only displaced if camera tilted up or down.
Optically bad or dirty filter.
Over-optimistic depth of field calculation.
Moisture condensation between lens elements in cold conditions.
Projector out of focus, screen not square to projector.
Projector lens poor or dirty, dirty projector room port.
Shooting into the sun or bright light without sufficient sunshading.
Wrong or inaccurate blimp focus strip (Arri 35BL and lens blimp).
Water on lens surface.
Smoke or fog between camera and subject.

Instruction Manuals and Manufacturer's Addresses

Motion picture cameras are precision instruments and should be treated as such. The user is advised to read the handbook thoroughly especially if using a camera for the first time or taking it away on location and away from camera maintenance facilities.

If a manual is not available from the local camera supplier it may be necessary to write directly to the manufacturer. A knowledge of the addresses, phone and telex numbers of a manufacturer may also be useful when it is necessary to seek advice on camera usage or fault rectification.

The following are the names, addresses, phone and telex numbers of some of the principal manufacturers and suppliers of professional motion picture cameras.

AÄTON S.A. – B.P. 31, 2 Rue President Carnot, F–38001, Grenoble, France.
Tel:- (76) 42 64 09: Telex Publi 320245/0004

ARNOLD & RICHTER K. G. – Türkenstr. 89, D–8000 München 40, W. Germany.
Tel:- (089) 38 09–1: Telex 524317

BACH AURICON INC. – 6902 Romaine Street, Hollywood, Calif. 90038, U.S.A.
Tel:- (213) 462–0931

BAUER: ROBERT BOSCH GmBH. – Geschäftsbereich Photokino, Postfach 109, D7000 Stuttgart 60 (Untertürkheim), W. Germany.
Tel:- (0711) 30131: Telex 7-253457

BEAULIEU CINEMA – 16 Rue de lay Cerisaie, F–94220, Charenton le Pont, France.
Tel:- 893 18 30: Telex 230577

BELL & HOWELL: ALAN GORDON ENTERPRISES INC. – 1430 N. Camvenca Blvd., Hollywood, Calif. 90028, U.S.A.
Tel:- (213) 466 3561: Telex 910 321 4526

BOLEX INTERNATIONAL S.A. – 15 Route de Lausanne, GH–1401, Yverdon, Switzerland.
Tel:- (024) 21602: Telex 24460

BRAUN AG. – Rüsselsheimer Strasse, 6000 Frankfurt (Main), W. Germany.
Tel:- (0611) 730011: Telex 04–1209

CANON U.S.A. INC. – 10 Nevada Drive, Lake Success, Long Island, NY 10040.
Tel:- (516) 488 6700: Telex 961333

CINEMA PRODUCTS CORP. – 2037 Granville Avenue, Los Angeles, CA 90025, U.S.A.
Tel:- (213) 478 0711: Telex 691339

ECLAIR – Soremec-Cehess, 41–45 Rue Galilee, F–75116 Paris, France.
Tel:- (1) 723 7856: Telex 610663

FREZZOLINI – General Research Laboratories, 7 Valley Street, Hawthorne, N.J. 07506.
Tel:- (201) 427 1160: Telex: 13–8875

GENERAL CAMERA CORP. – 471 Eleventh Avenue, New York, NY 10018, U.S.A.
Tel:- (212) 594 8700: Telex 147136

GORDON AUDIOVISUAL LTD. – 28/30 Market Place, London W1N 8PH.
Tel:- (01) 580 9191: Telex 264413

JOHN HADLAND (PHOTOGRAPHIC INSTRUMENTATION) LTD. – Newhouse Laboratories, Bovingdon, Herts. HP1 0EL, U.K.
Tel:- (0442) 832 2525: Telex 82344

MITCHELL CAMERA CORP. – P.O. Box 279, 11630 Tuxford Street, Sun Valley, CA 91352, U.S.A.
Tel:- (213) 768 6400: Telex 677108

PANAVISION INC. – 18618 Oxnard Street, Tarzana, California 91356, U.S.A.
Tel:- (213) 881 1702: Telex 651497

PHOTOSONICS INC. – 820 South Mariposa Street, Burbank, CA 91506 U.S.A.
Tel:- (213) 849 6251: Telex 67–3205

REDLAKE CORPORATION – 1711 Dell Avenue, Campbell, CA 95008, U.S.A.
Tel:- (408) 866 1010: Telex 910 590 2694

TELEDYNE CAMERA SYSTEMS – 131 North 5th Avenue, Arcadia, CA 91006.
Tel:- (213) 277 3311: Telex 674181

SAMUELSON FILM SERVICE LTD. – 303–315 Cricklewood Broadway, Edgware Road, London, NW2 6PQ.
Tel:- (01) 452 8090: Telex 21430

SAMUELSON ALGA-CINEMA SARL – 24–26 Rue Jean Moulin, 94 Vincennes, Paris, France.
Tel:- (1) 328 5830: Telex 670260

SAMUELSON FILM SERVICE AUSTRALIA (PTY) LTD. – 25 Sirius Road, Lane Cove, Sidney 2066, N.S.W. Australia.
Tel:- 428 5477: Telex 71 25188
25 Lothian Street, North Melbourne, Victoria 3051, Australia.
Tel:- 329 5155: Telex 35861

SAMUELSON GENOP (PTY) Ltd. – Genop House, 15 Hulbert Road, New Centre, Johannesburg South Africa.
Tel:- 836 4275: Telex 80057

170

In the last resort.

Postcript

Of all the instruction manuals I have read during the course of researching this book, this preface in a U.S. Army Technical Manual for the PH–274 Mitchell Standard camera is the most drastic of all.

Even when all about him is going wrong the present day cameraman should never resort to such means, no matter how he feels at the time.

WAR DEPARTMENT
WASHINGTON 25, D.C., 21 February 1946

TM 11-2386, Camera PH-274, is published for the information and guidance of all concerned.

[AG 300.7 (11 Dec. 45)]
BY ORDER OF THE SECRETARY OF WAR:

OFFICIAL:
EDWARD F. WITSELL
Major General
The Adjutant General

DWIGHT D. EISENHOWER
Chief of Staff

DESTRUCTION NOTICE

WHY—To prevent the enemy from using or salvaging this equipment for his benefit.

WHEN—When ordered by your commander.

HOW—1. Smash—Use sledges, axes, handaxes, pickaxes, hammers, crowbars, heavy tools.
2. Cut—Use axes, handaxes, machetes.
3. Burn—Use gasoline, kerosene, oil, flame throwers, incendiary grenades.
4. Explosives—Use firearms, grenades, TNT.
5. Disposal—Bury in slit trenches, fox holes, other holes. Throw in streams. Scatter.

USE ANYTHING IMMEDIATELY AVAILABLE FOR DESTRUCTION OF THIS EQUIPMENT.

WHAT—1. Smash—All lenses, batteries, sunshade and matte box, viewfinder, cases, magazines, and the motor.
2. Cut—All cords and connections, straps, and belts.
3. Burn—All film, tripods, triangle, barney, fabric cover, changing bag, and this manual.
4. Bend—All reels and cans.
5. Bury or scatter—All that remains.

DESTROY EVERYTHING

Further Reading

HAPPÉ, BERNARD,
Basic Motion Picture Technology. (2nd edn.) 1975 Focal Press, London Focal/Hastings House, New York.
A comprehensive survey of the technique of film; a non-technical approach for production executives, creative artists and technicians alike.

MILLERSON, GERALD.
The Technique of Lighting for Television and Motion Pictures.
1976 Focal Press, London, Focal/Hastings House, New York.
The first comprehensive study of the art and techniques of lighting for the TV and film cameras. Suitable for students and specialist alike.

YOUNG, FREDDIE, & PETZOLD, PAUL,
The Work of the Motion Picture Cameraman. 1972 Focal Press, London, Focal/Hastings House, New York.
An authoritative source of information on camera technique in large scale feature productions.

ENGLANDER, A. ARTHUR, & PETZOLD, PAUL,
Filming for Television. 1976 Focal Press, London, Focal/Hastings House, New York.
A detailed account of the whole spectrum of filming for television programmes drawn from over twenty-five years' experience.

MILLERSON, GERALD,
TV Lighting Methods. 1975 Focal Press, London, Focal/Hastings House, New York.
A rapid guide to the practical techniques of using lighting equipment in television studios.

SAMUELSON, DAVID, W.
Motion Picture Camera and Lighting Equipment. 1977 Focal Press, London, Focal/Hastings House, New York.
An impartial survey of the entire range of professional motion picture cameras and lighting equipment which weighs up the cost, versatility, reliability and other practical aspects.

SAMUELSON, DAVID, W.
Motion Picture Camera Techniques. 1978 Focal Press, Focal/Hastings House, New York.
A comprehensive study of the needs of the cinematographer in terms of needs and practice.